FLIGHT

VOLUME THREE

Ballantine Books • New York

A Ballantine Books Trade Paperback Original

Compilation copyright © 2006 by Flight Comics, LLC
All contents and characters contained within are ™ and © 2006 by their respective creators.

Published in the United States by Ballantine Books, an imprint of The Random House Publishing Group, a division of Random House, Inc., New York.

BALLANTINE and colophon are registered trademarks of Random House, Inc.

Library of Congress Cataloging-in-Publication Data

Flight / [editor/art director, Kazu Kibuishi].
 p. cm.
 Description based on: v. 3 (2006).
 ISBN: 0-345-49039-8 (v. 3)
 I. Kazu, Kibuishi, 1978–

PN6720.F65 2006
741.5'9—dc22 2006045883

This edition published by arrangement with Flight Comics, LLC.

Printed in the United States of America

www.ballantinebooks.com

9 8 7 6 5 4 3

Illustration on pages 2–3 by Chris Appelhans
Illustration on pages 4–5 by Catia Chien
Cover illustration by Kazu Kibuishi

Editor/Art Director: Kazu Kibuishi
Assistant Editors: Kean Soo and Phil Craven
Our Editor at Ballantine Books: Chris Schluep

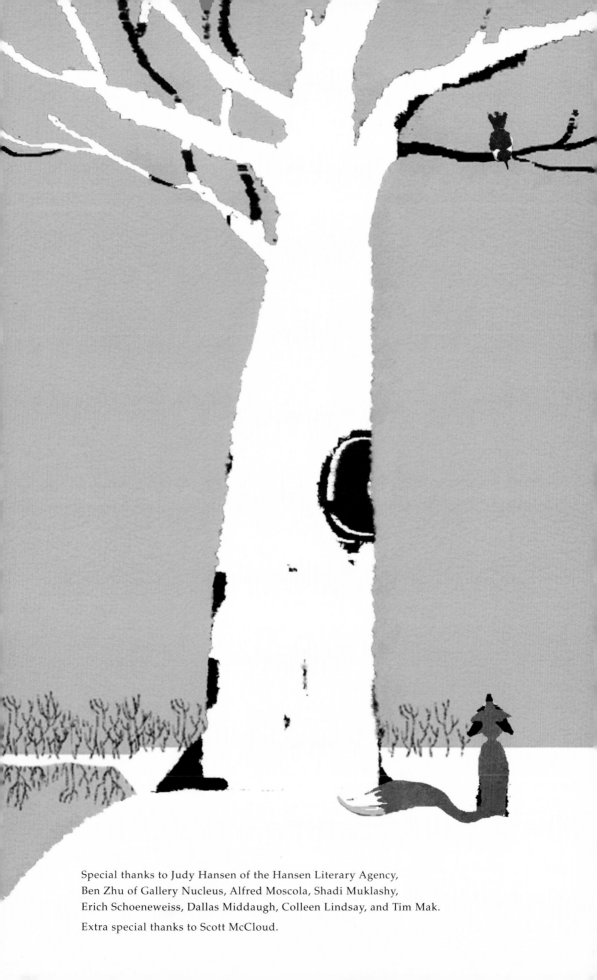

Special thanks to Judy Hansen of the Hansen Literary Agency,
Ben Zhu of Gallery Nucleus, Alfred Moscola, Shadi Muklashy,
Erich Schoeneweiss, Dallas Middaugh, Colleen Lindsay, and Tim Mak.

Extra special thanks to Scott McCloud.

Contents

"Underworld" by Michel Gagné 6

"Old Oak Trees" by Tony Cliff 34

"The Edge" by Ben Hatke 60

"Beneath the Leaves: Lemming City" by Rad Sechrist 84

"Hunter" by Johane Matte 98

"Jellaby: The Tea Party" by Kean Soo 106

"The Rescue" by Phil Craven 116

"The Lumbering Beast" by Joey Weiser 136

"Saturday" by Israel Sanchez 154

"The Cloud" by Bill Plympton 166

"Earl D." by Yoko Tanaka 174

"Polaris" by Azad Injejikian 182

"In Due Time" by Neil Babra 190

"The Iron Gate" by Kazu Kibuishi 204

"Message in a Bottle" by Rodolphe Guenoden 222

"So Far, So Close" by Bannister 234

"Voodoo" by Matthew Forsythe 244

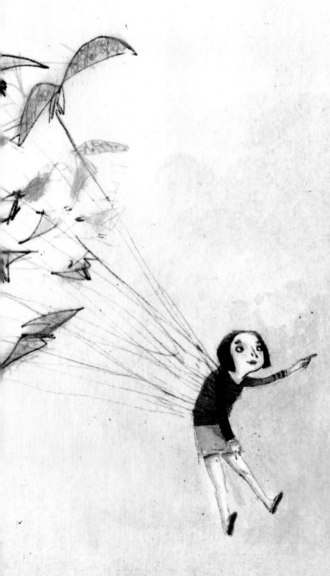

"Ad Astra" by Chuck BB 252

"Conquest" by Becky Cloonan 258

"Tea" by Reagan Lodge 266

"One Little Miracle for a Hungry Swarm"
 by Alex Fuentes 282

"Wurmler of the West" by Paul Harmon 298

"The Brave Sea" by Steve Hamaker 310

"The Great Bunny Migration" by Dave Roman 326

"Snow Cap" by Matthew S. Armstrong 338

"Lala and the Bean" by Khang Le 344

Contributors 346

underworld

Michel Gagné

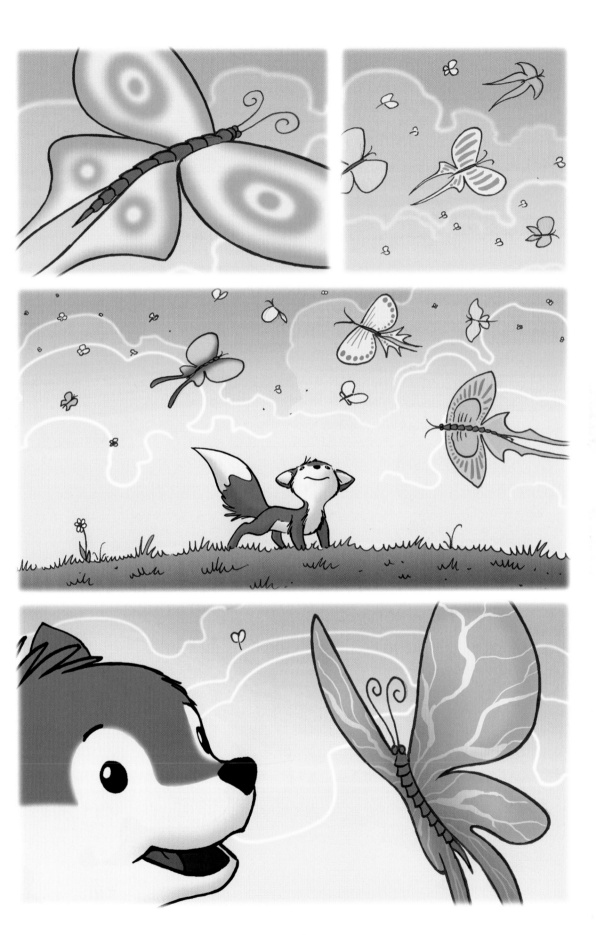

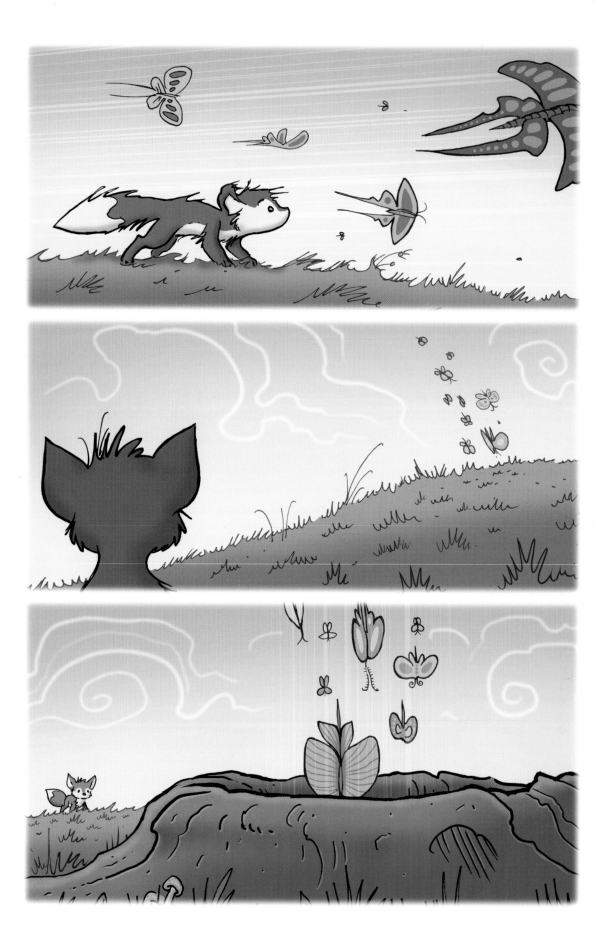

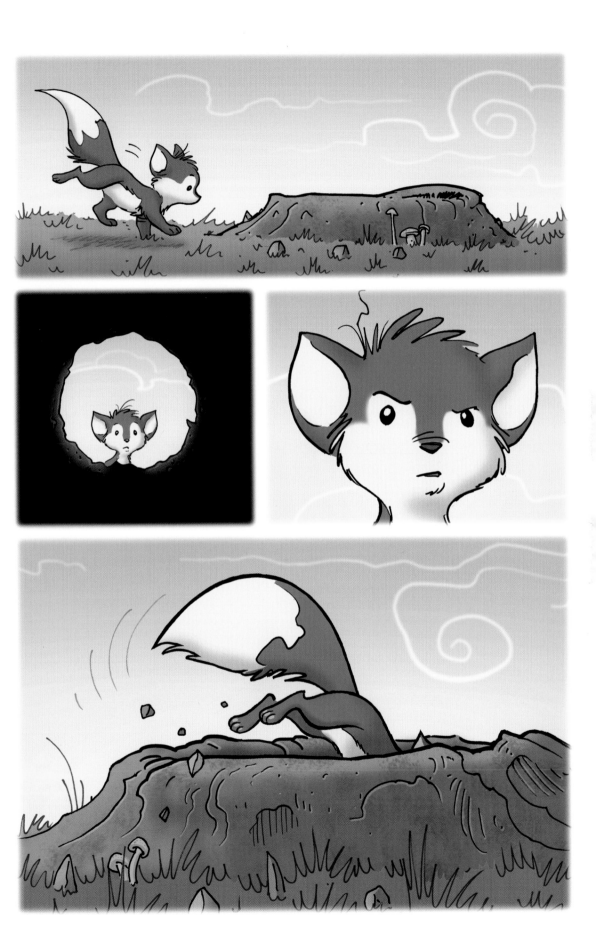

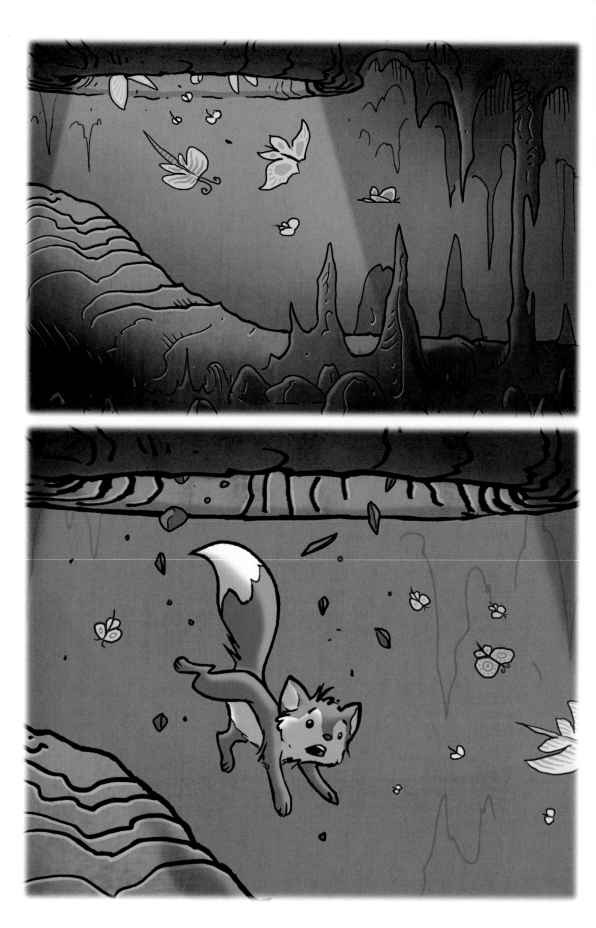

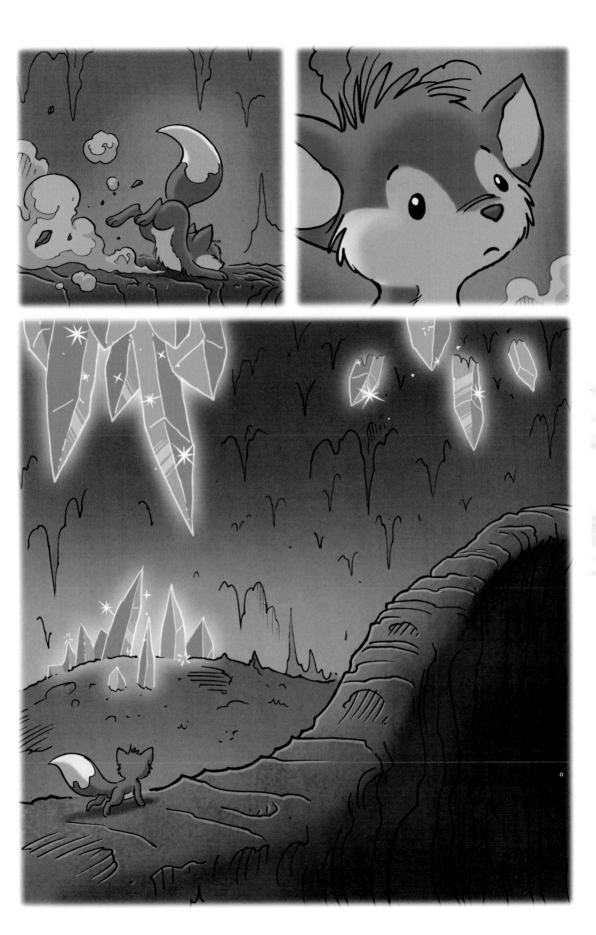

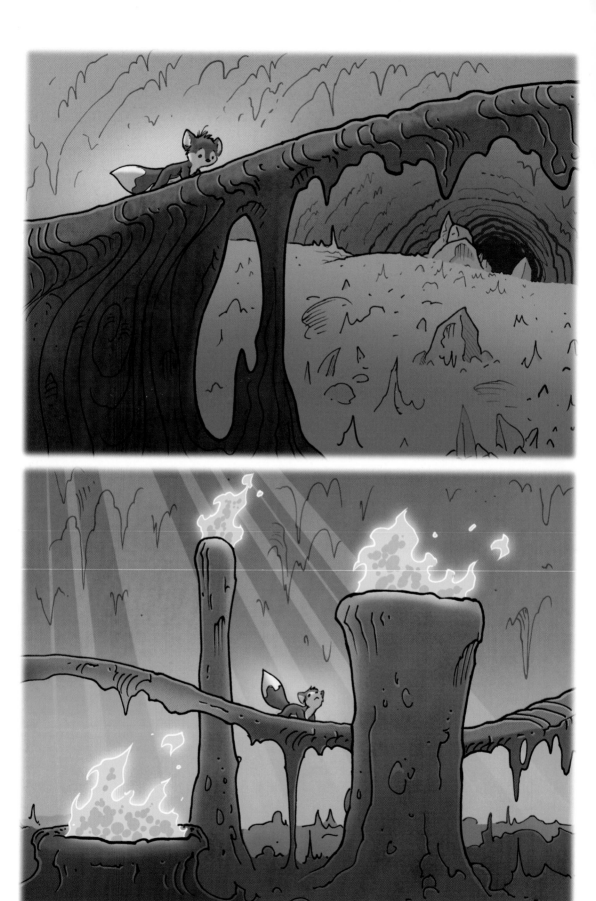

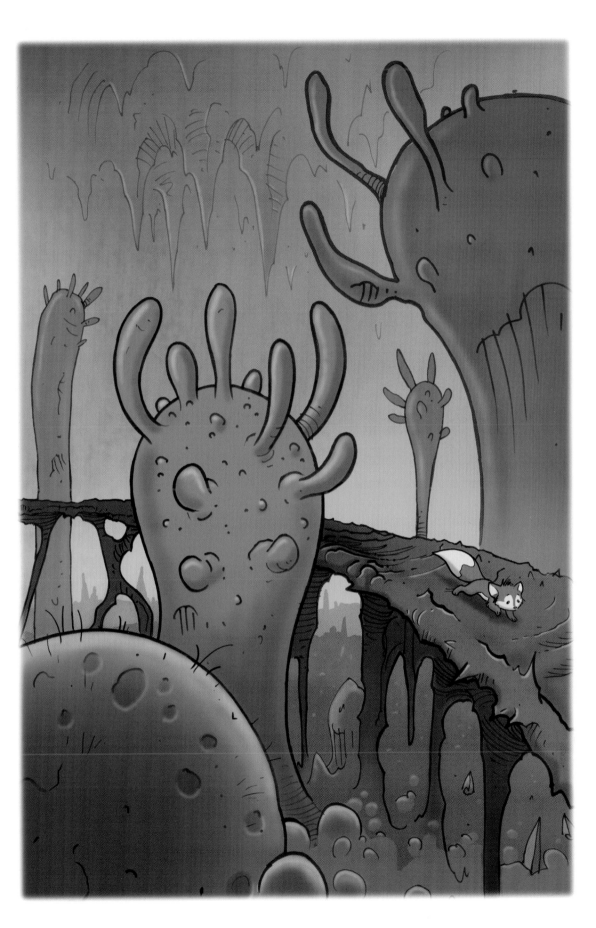

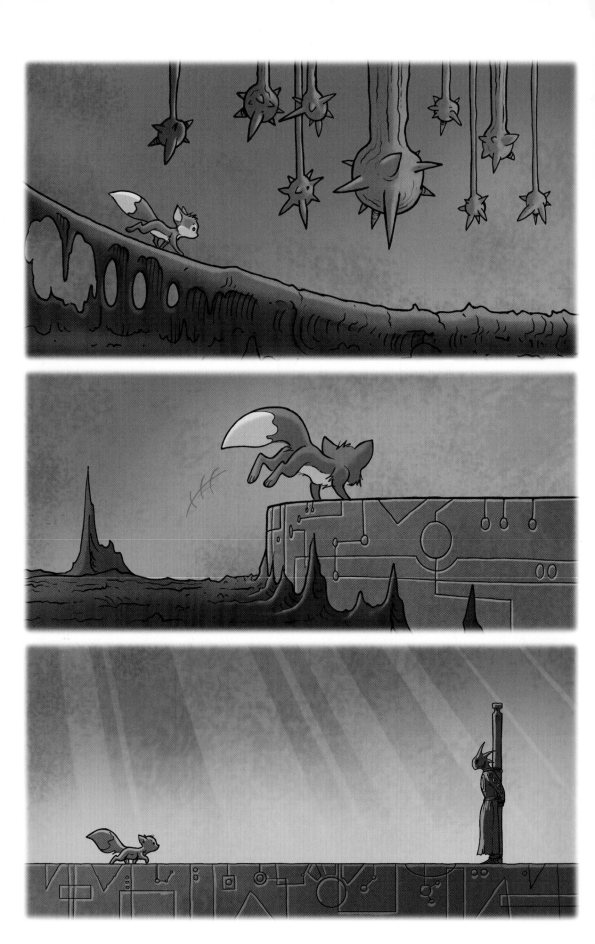

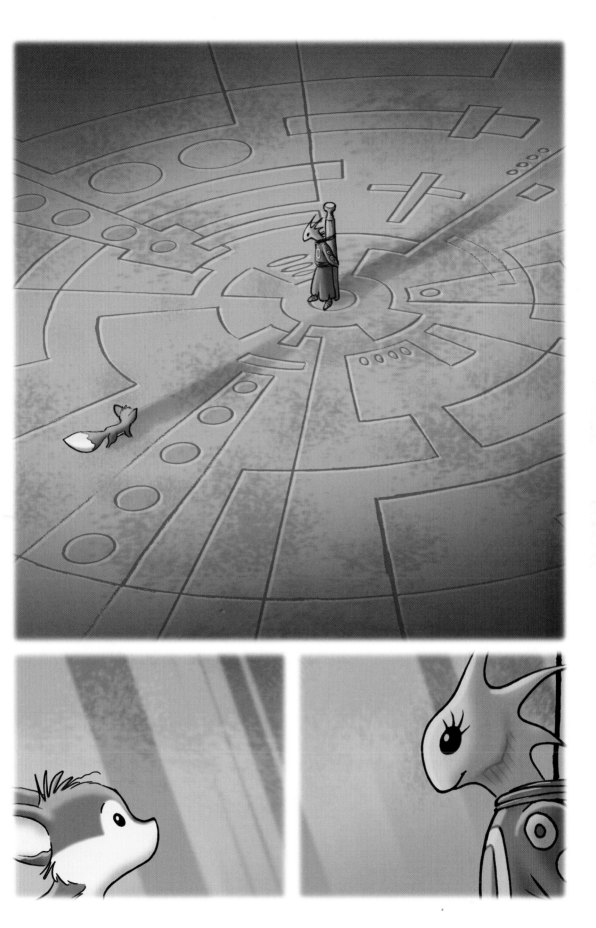

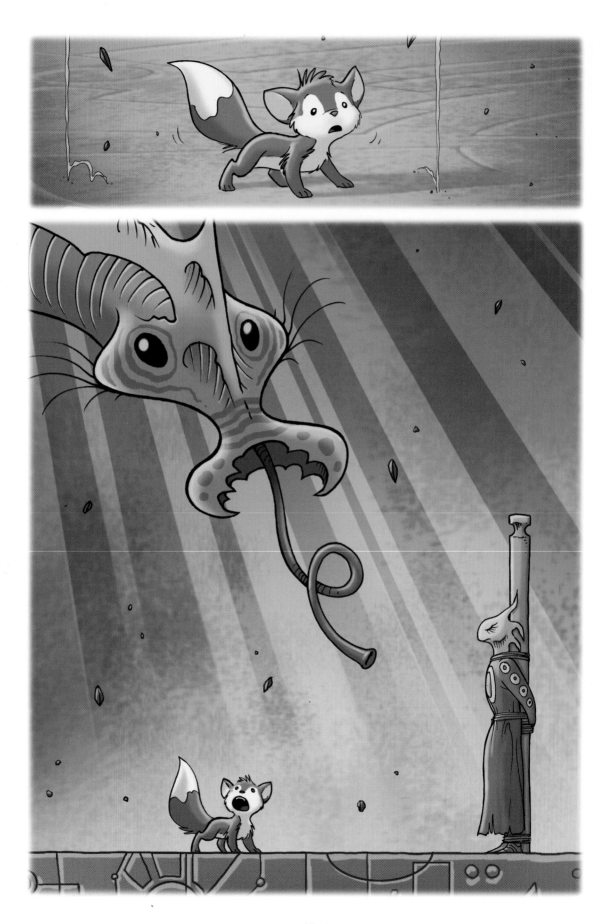

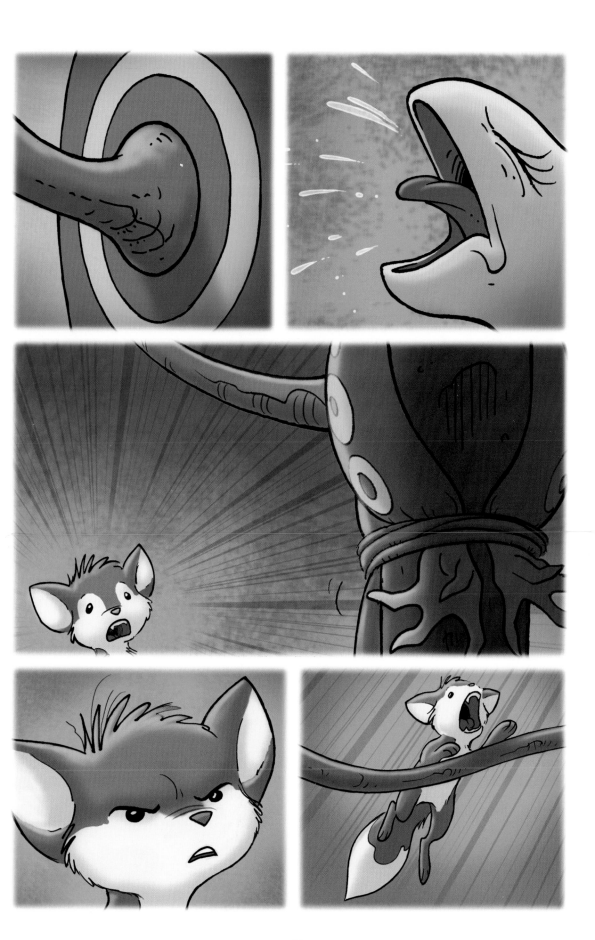

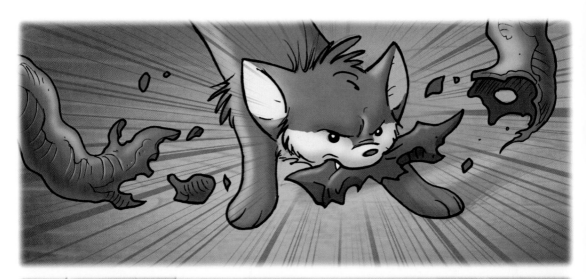

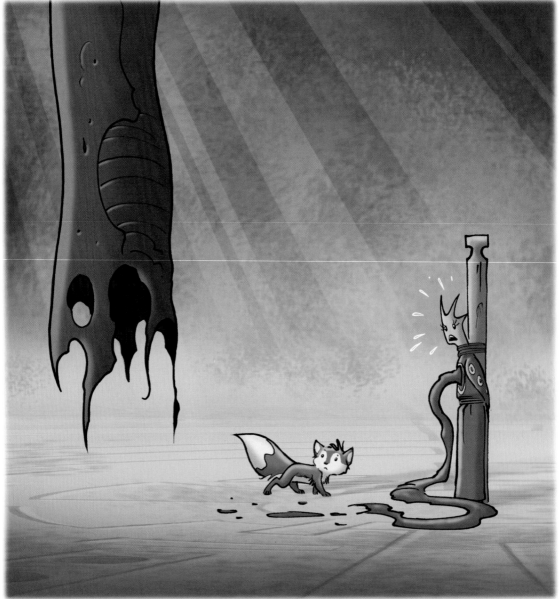

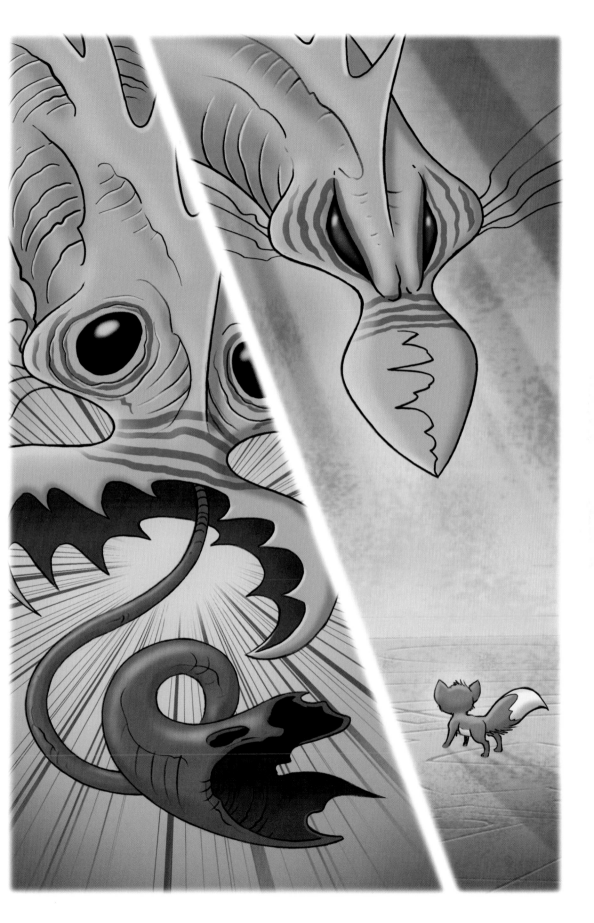

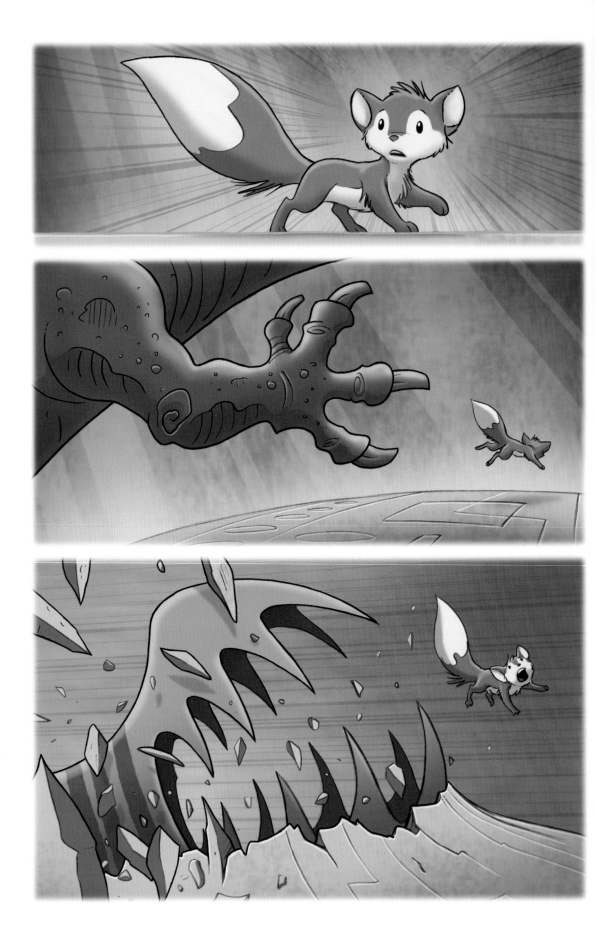

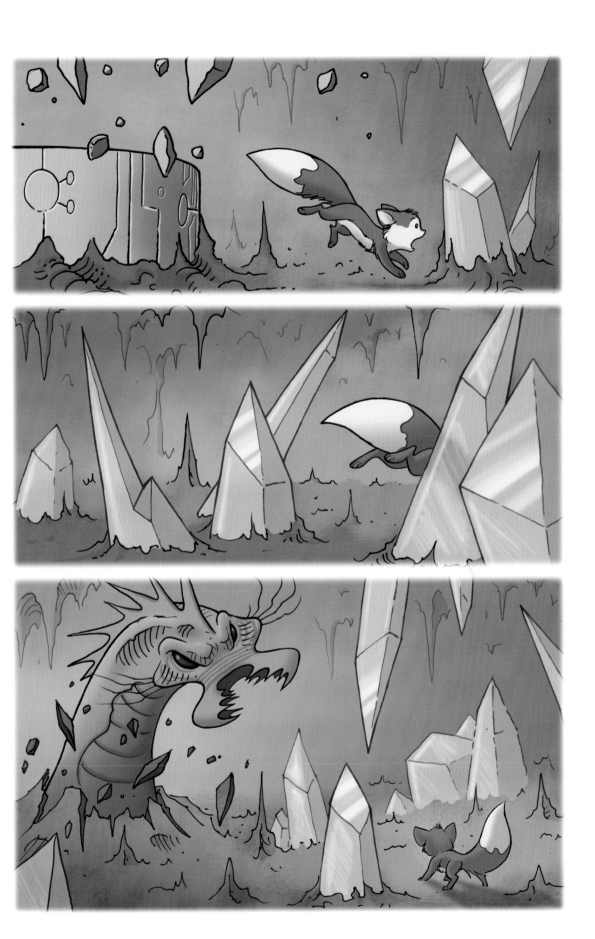

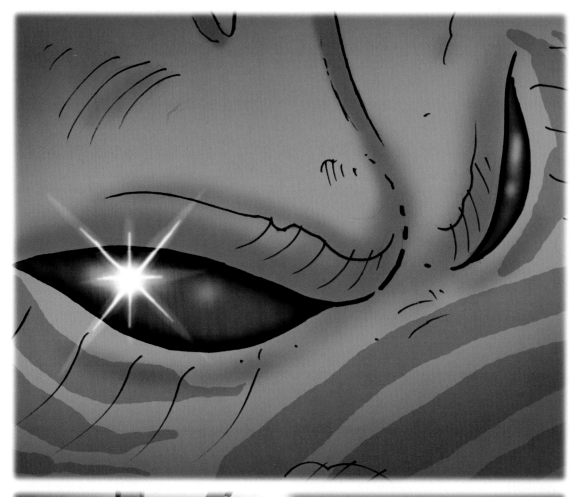

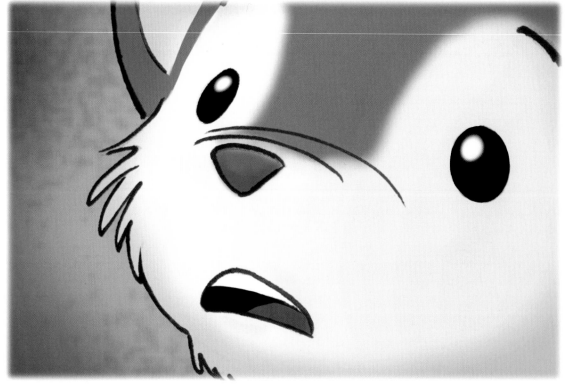

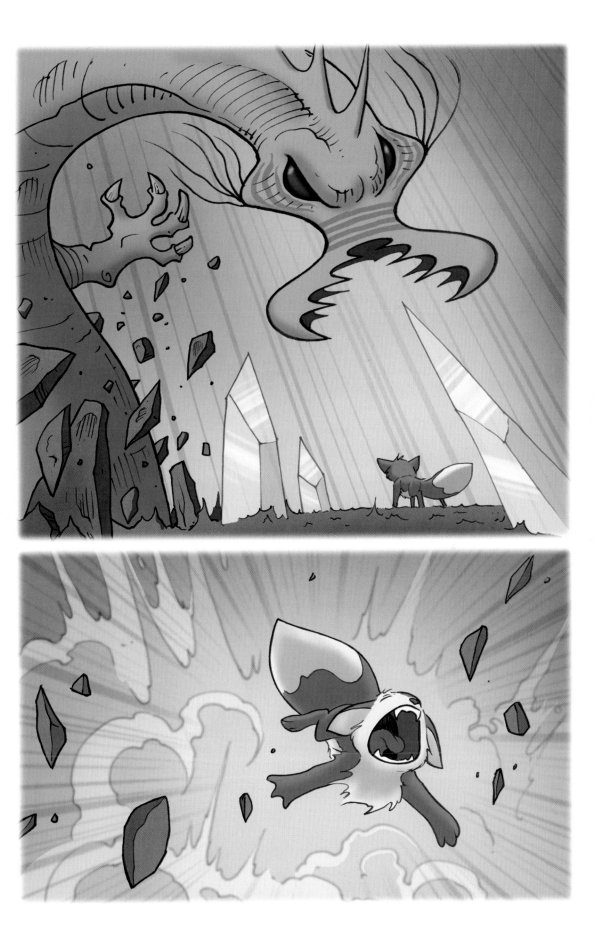

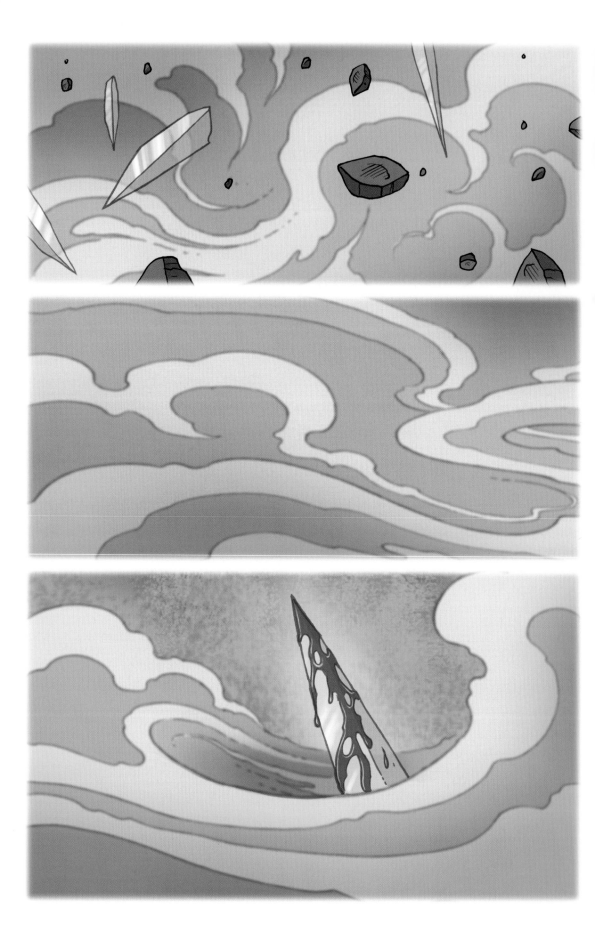

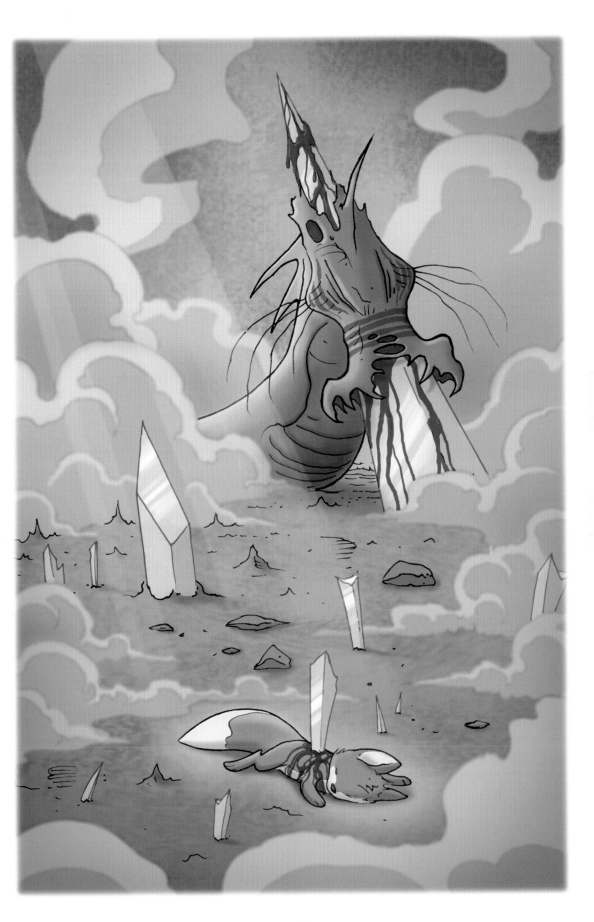

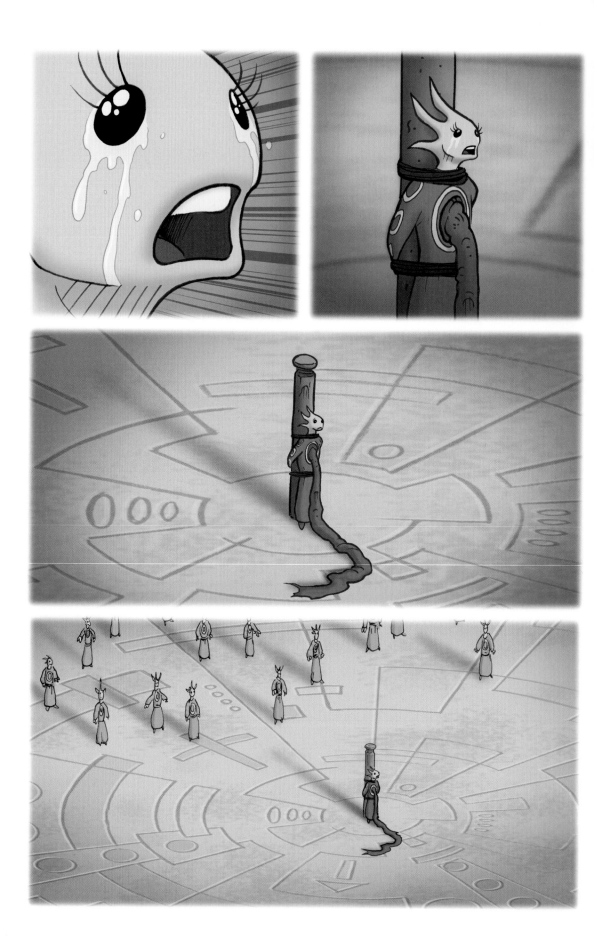

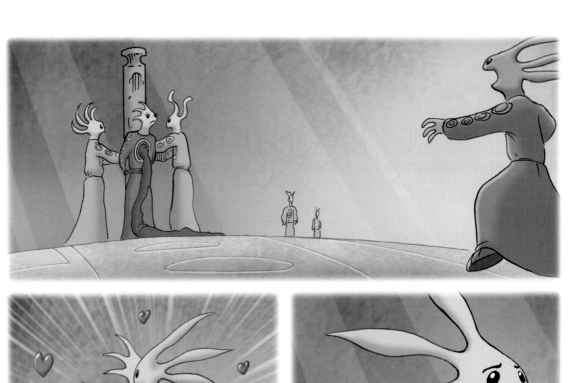

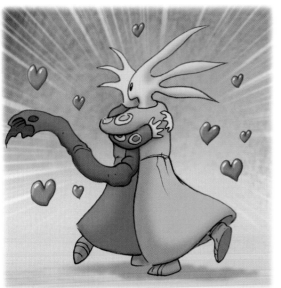

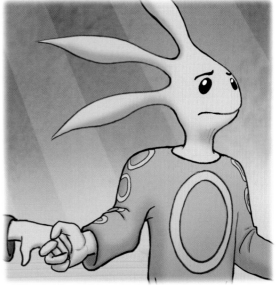

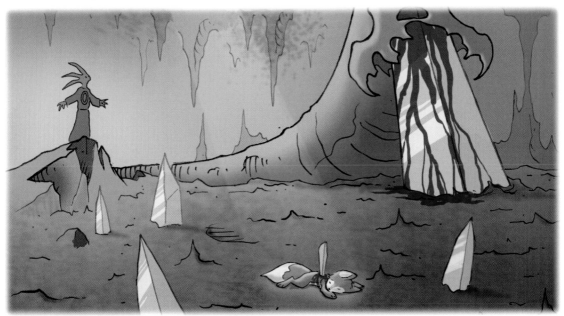

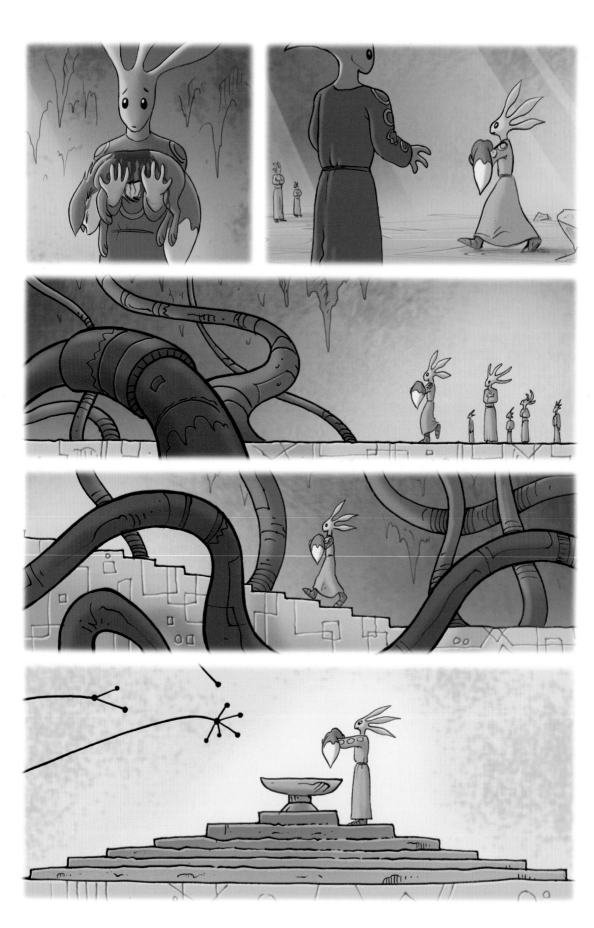

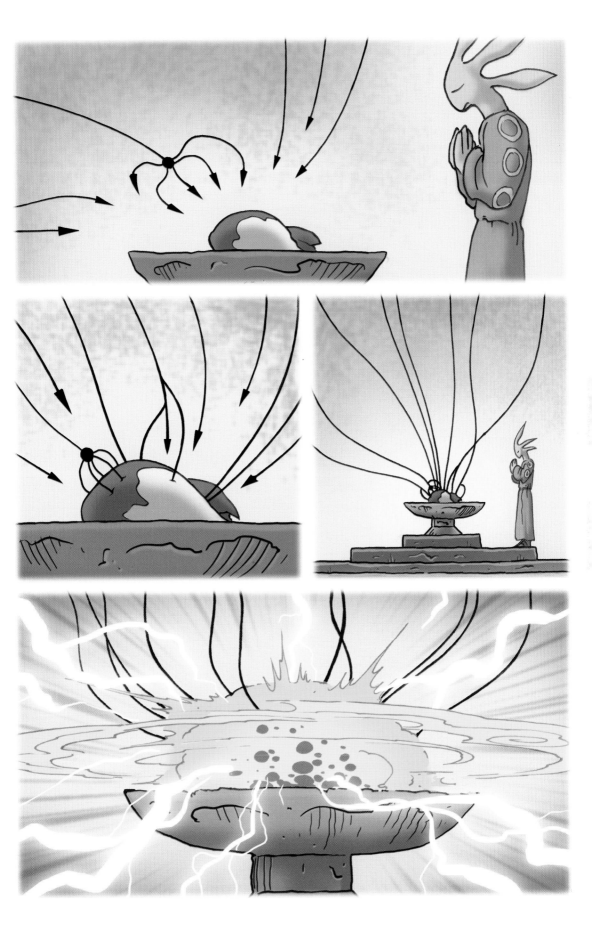

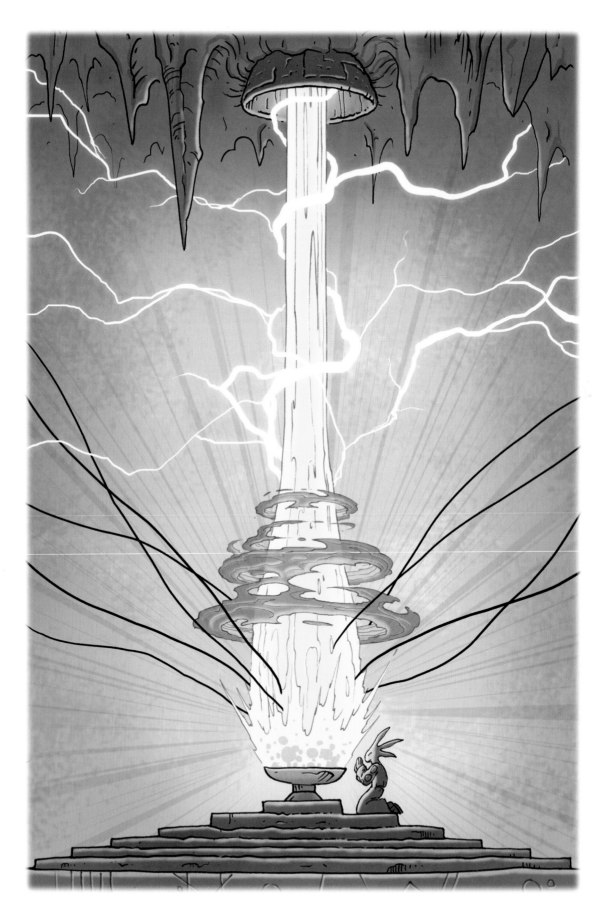

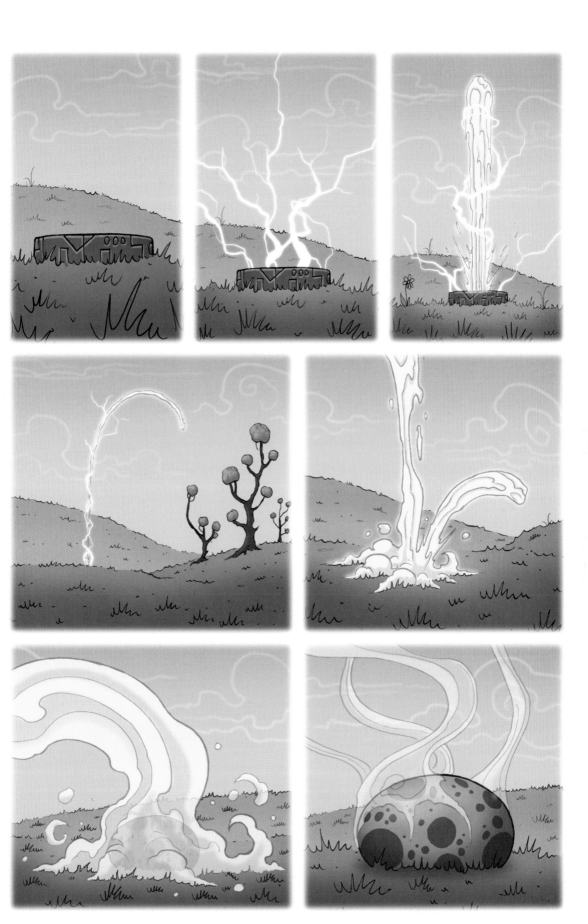

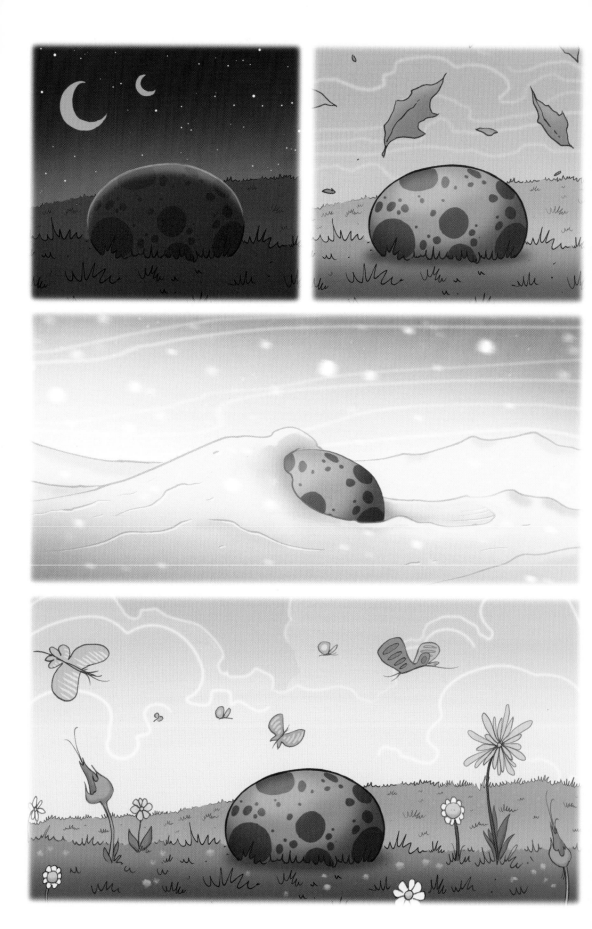

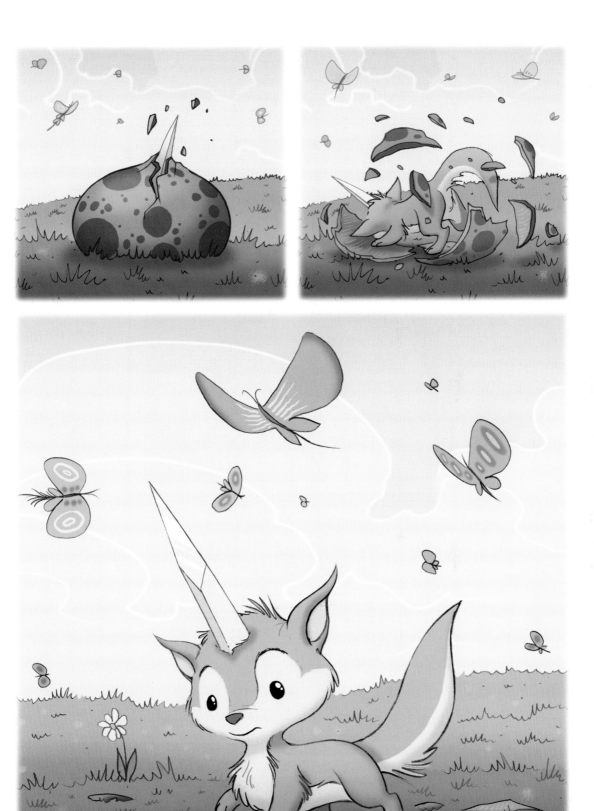

To be continued...

Old Oak Trees

True Stories of the Cheshire Woods

*An entirely factual account
from the childhood
of my grandmother*

Tony Cliff

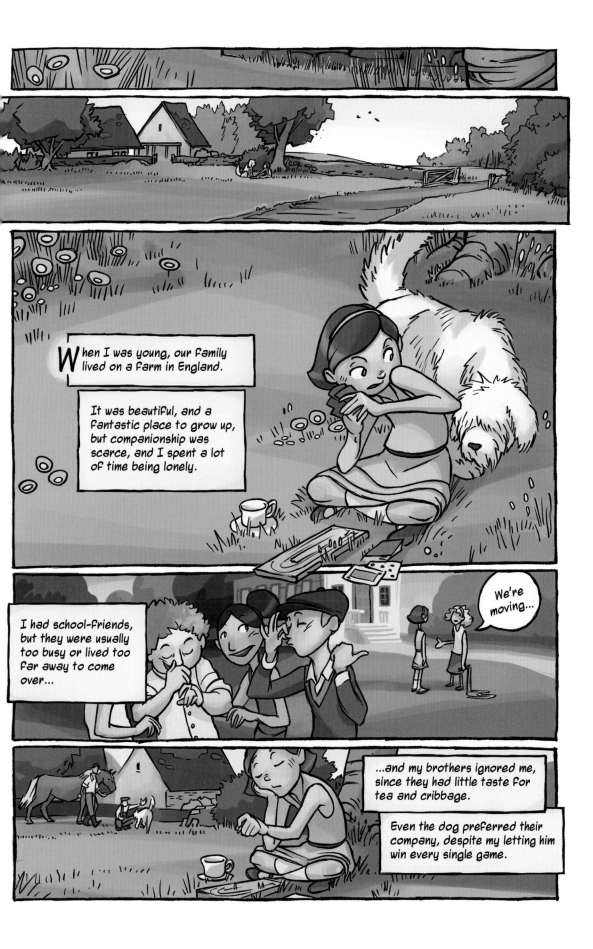

When I was young, our family lived on a farm in England.

It was beautiful, and a fantastic place to grow up, but companionship was scarce, and I spent a lot of time being lonely.

I had school-friends, but they were usually too busy or lived too far away to come over...

We're moving...

...and my brothers ignored me, since they had little taste for tea and cribbage.

Even the dog preferred their company, despite my letting him win every single game.

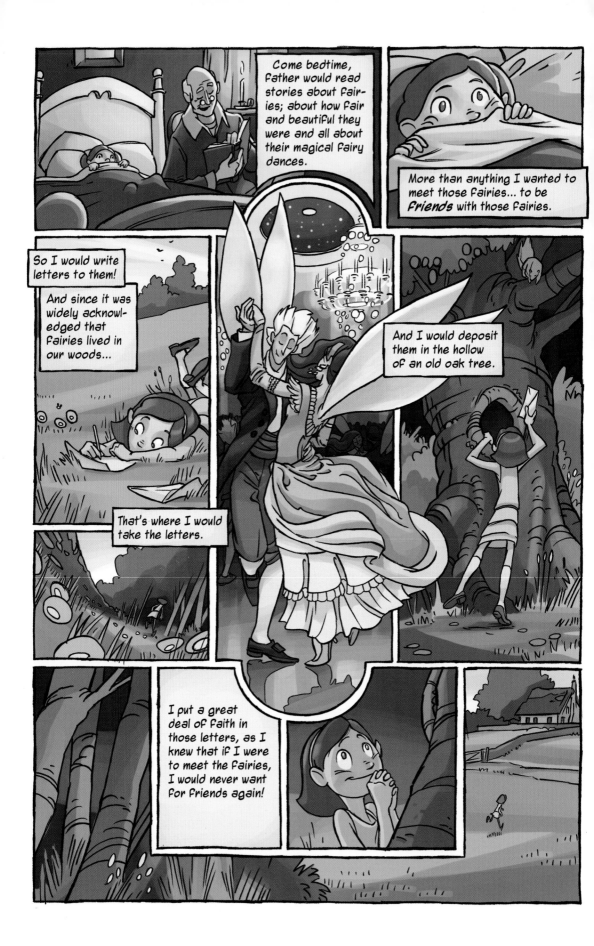

Come bedtime, Father would read stories about fairies; about how fair and beautiful they were and all about their magical fairy dances.

More than anything I wanted to meet those fairies... to be *friends* with those fairies.

So I would write letters to them!

And since it was widely acknowledged that fairies lived in our woods...

And I would deposit them in the hollow of an old oak tree.

That's where I would take the letters.

I put a great deal of faith in those letters, as I knew that if I were to meet the fairies, I would never want for friends again!

Unfortunately, my brothers were well practiced in that brand of cruelty so specific to older siblings.

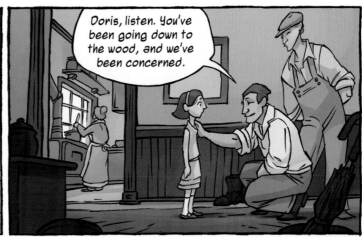

Doris, listen. You've been going down to the wood, and we've been concerned.

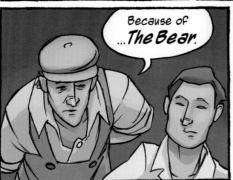

Because of ...*The Bear*.

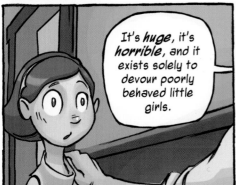

It's **huge**, it's **horrible**, and it exists solely to devour poorly behaved little girls.

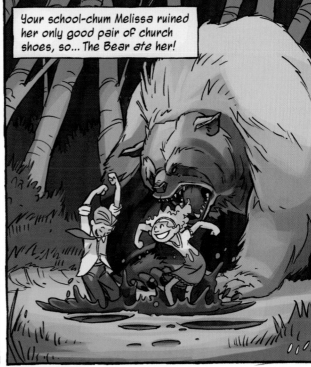

Your school-chum Melissa ruined her only good pair of church shoes, so... The Bear ate her!

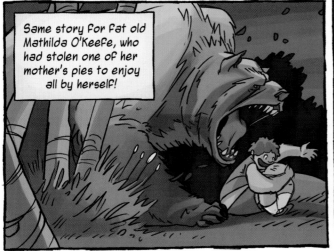

Same story for fat old Mathilda O'Keefe, who had stolen one of her mother's pies to enjoy all by herself!

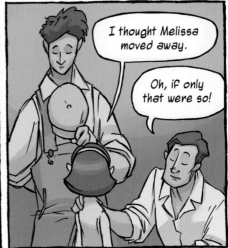

I thought Melissa moved away.

Oh, if only that were so!

But I **AM** well-behaved!

And no one knows that better than we do!

But a bear is a wild creature! If you met it, what would you do?

Would you try to reason with a wild bear?

YES!

SLAM

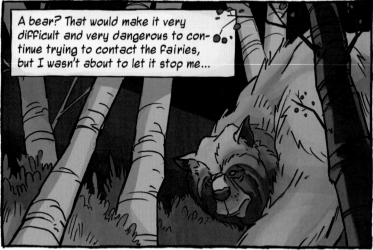

A bear? That would make it very difficult and very dangerous to continue trying to contact the fairies, but I wasn't about to let it stop me...

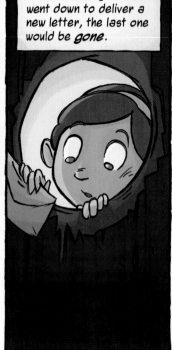

...for every time I went down to deliver a new letter, the last one would be *gone*.

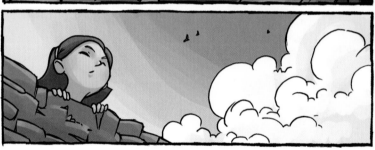

Obviously, the fairies were reading my letters, but if that were so, then it wouldn't do to stay out of the wood. What if they wanted to say hello?

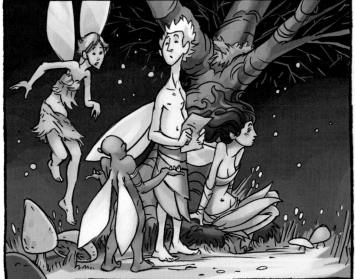

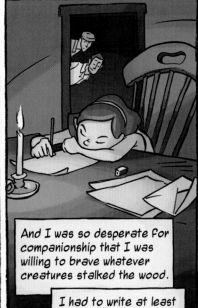

And I was so desperate for companionship that I was willing to brave whatever creatures stalked the wood.

I had to write at least one more letter.

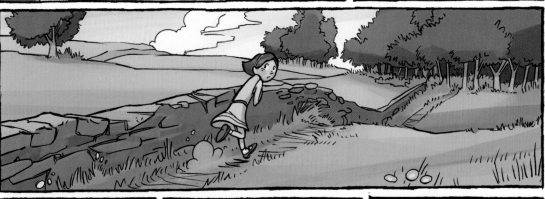

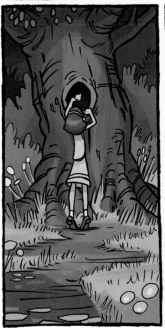

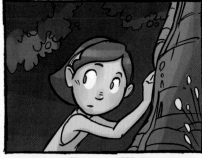

Hallo

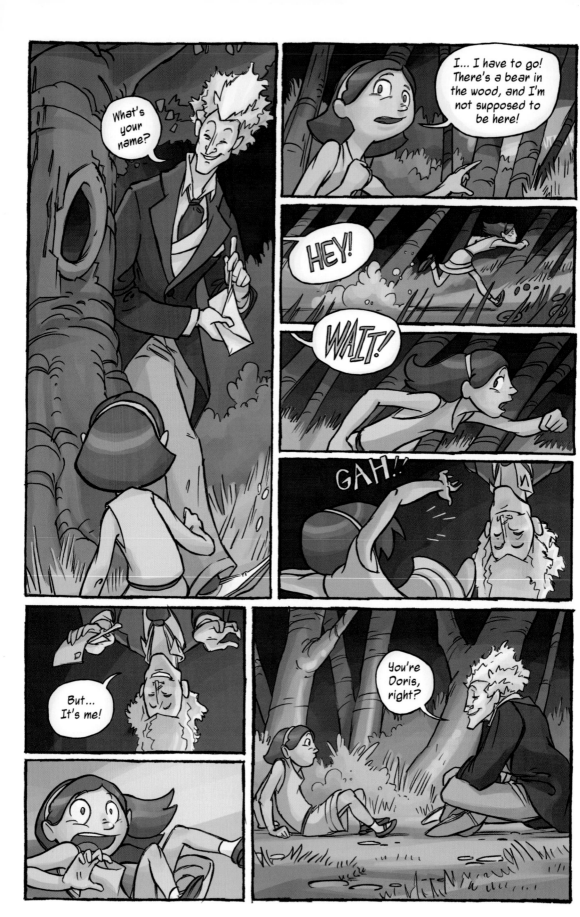

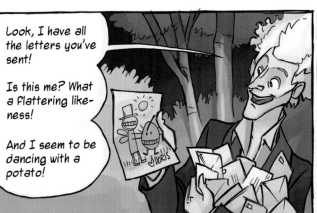

Look, I have all the letters you've sent!

Is this me? What a flattering like- ness!

And I seem to be dancing with a potato!

But... but where are your wings?

Where are yours?

Ha. I don't *have*...

I have wings!

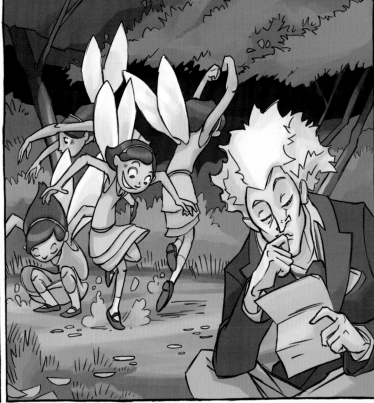

So... what's all this business about a bear?

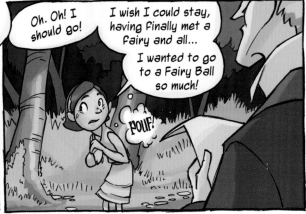

Oh. Oh! I should go!

I wish I could stay, having finally met a fairy and all...

I wanted to go to a Fairy Ball so much!

POUF!

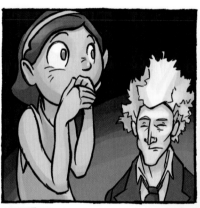

Yes. That would be all of the best kinds of fun.

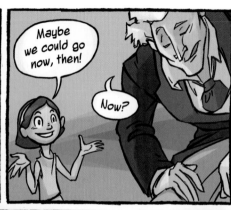
Maybe we could go now, then!

Now?

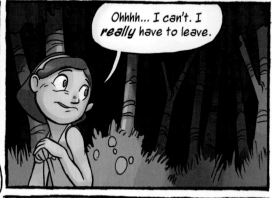
Ohhhh... I can't. I *really* have to leave.

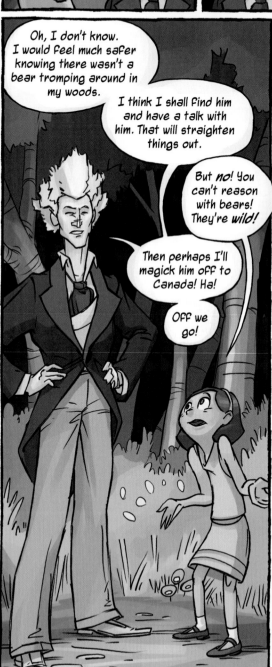
Oh, I don't know. I would feel much safer knowing there wasn't a bear tromping around in my woods.

I think I shall find him and have a talk with him. That will straighten things out.

But *no!* You can't reason with bears! They're *wild!*

Then perhaps I'll magick him off to Canada! Ha!

Off we go!

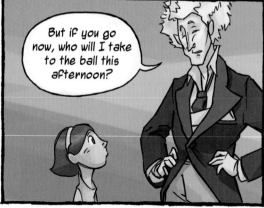
But if you go now, who will I take to the ball this afternoon?

BUT I'LL BE EATEN!!

Certainly not! So long as you stick with me, everything will be alright.

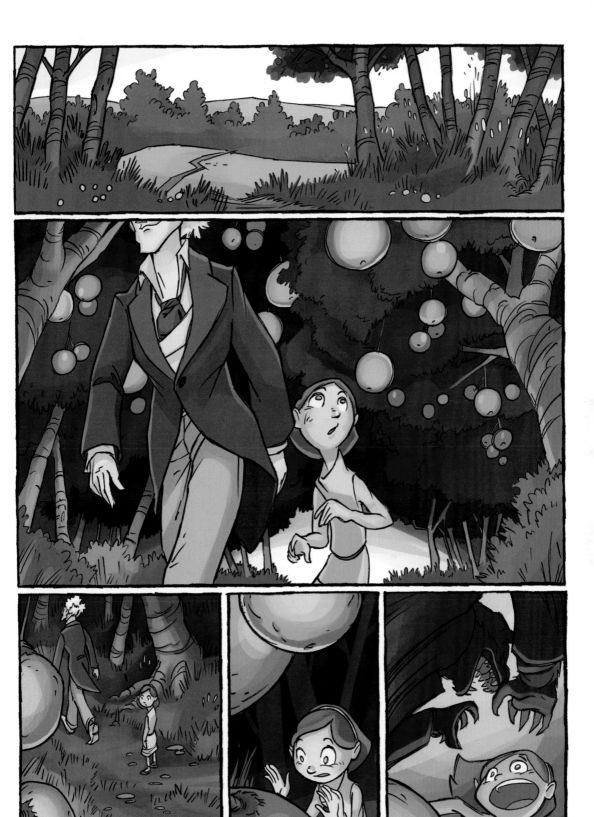

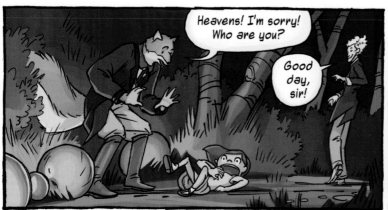

Heavens! I'm sorry! Who are you?

Good day, sir!

My quivering friend here is Ms. Doris Longdon!

She and I are on the trail of a horrible bear!

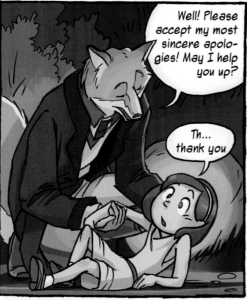

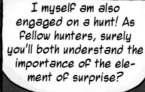

Well! Please accept my most sincere apologies! May I help you up?

Th... thank you

I myself am also engaged on a hunt! As fellow hunters, surely you'll both understand the importance of the element of surprise?

Oh?

YAHHHHH

YAHHH

HAHAA!! WHOA!!

YA

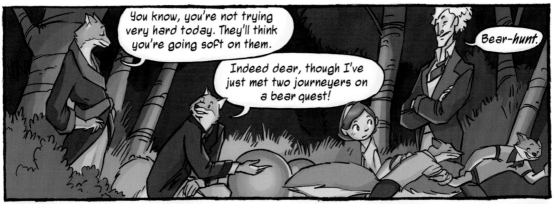

You know, you're not trying very hard today. They'll think you're going soft on them.

Indeed dear, though I've just met two journeyers on a bear quest!

Bear-hunt.

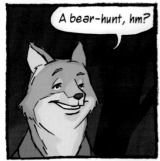

A bear-hunt, hm?

He threatens the safety of little girls like young Ms. Doris here.

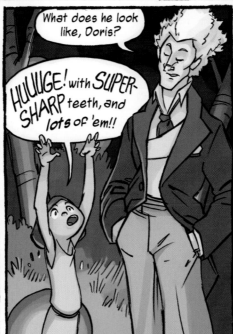

What does he look like, Doris?

HUUUGE! with SUPER-SHARP teeth, and lots of 'em!!

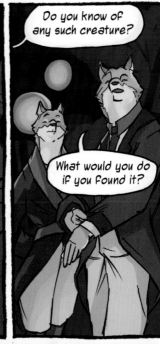

Do you know of any such creature?

What would you do if you found it?

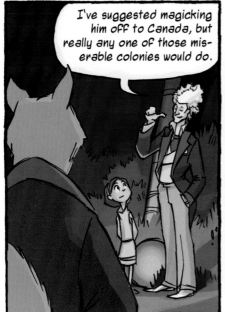

I've suggested magicking him off to Canada, but really any one of those miserable colonies would do.

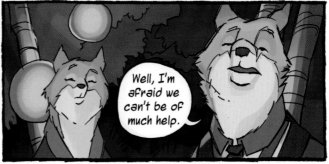

Well, I'm afraid we can't be of much help.

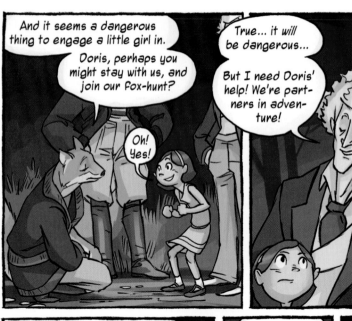

And it seems a dangerous thing to engage a little girl in.

Doris, perhaps you might stay with us, and join our fox-hunt?

Oh! Yes!

True... it *will* be dangerous...

But I need Doris' help! We're partners in adventure!

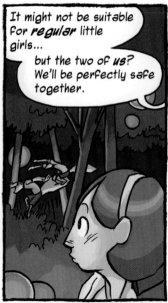

It might not be suitable for *regular* little girls...

but the two of *us?* We'll be perfectly safe together.

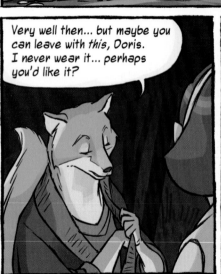

Very well then... but maybe you can leave with *this*, Doris. I never wear it... perhaps you'd like it?

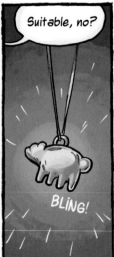

Suitable, no?

BLING!

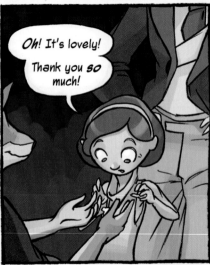

Oh! It's lovely!

Thank you *so* much!

Wonderful.

Well, we're off.

Thank you!

Alright. Best head Badger's way. Talk to him.

Good luck! Stay safe, Doris!

YAHHH HHH!!

I would like very much to visit Mr. and Mrs. Fox again!

And I'm sure they would love to see you!

Except... I've already forgotten how to get there!

And so, unfortunately, have you!

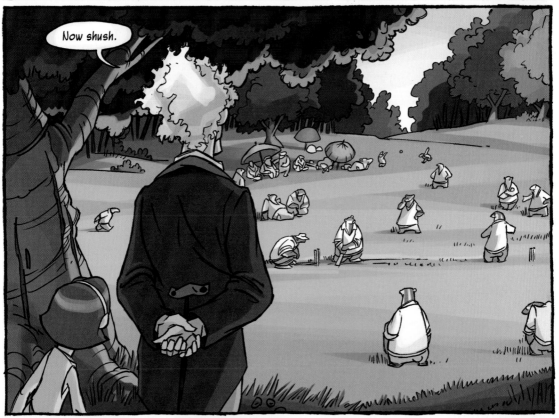

Now shush.

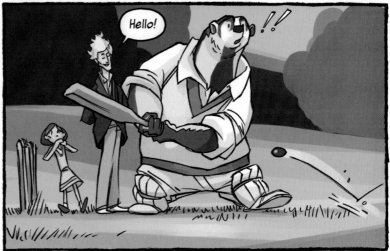

Hello!

47

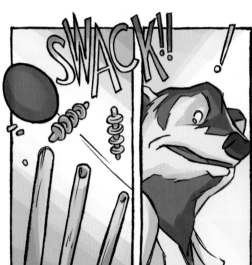

SWACK!!

GRK!

Mr. Badger, pardon the intrusion and allow me to introduce Miss Doris. She and I are searching for a bear!

A pleasure, young Miss!

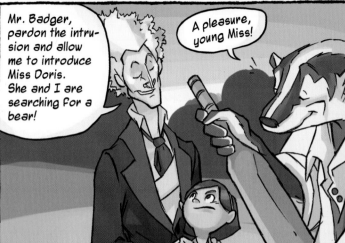

A bear, eh?

Oh, yes. Large. Cruel. Eats little girls.

Very concerning.

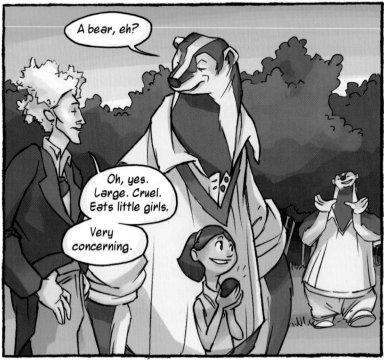

You don't **sound** very concerned.

Hm?

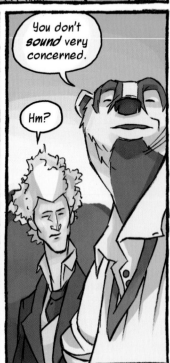

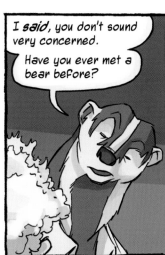

I *said*, you don't sound very concerned.

Have you ever met a bear before?

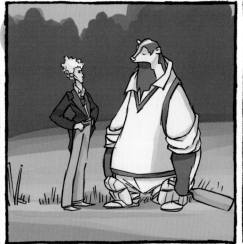

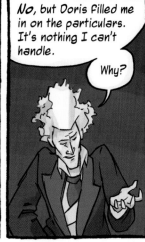

No, but Doris filled me in on the particulars. It's nothing I can't handle.

Why?

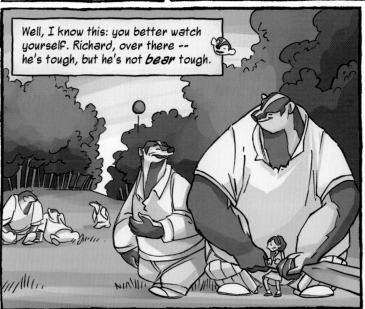

Well, I know this: you better watch yourself. Richard, over there -- he's tough, but he's not *bear* tough.

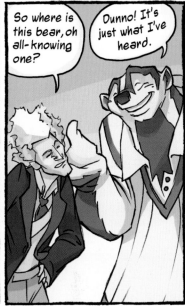

So where is this bear, oh all-knowing one?

Dunno! It's just what I've heard.

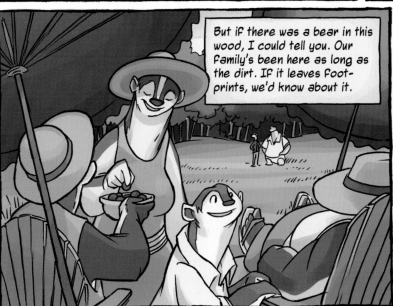

But if there was a bear in this wood, I could tell you. Our family's been here as long as the dirt. If it leaves footprints, we'd know about it.

Really.

Well, since the amassed knowledge of our generations doesn't seem to impress you, I suppose you could always talk to Mr. Raven.

Don't worry, I'll try not to be offended.

Thanks.

Doris! We're off!

Maybe she should stay with us?

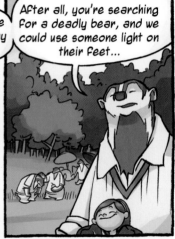

After all, you're searching for a deadly bear, and we could use someone light on their feet...

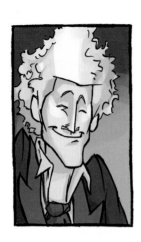

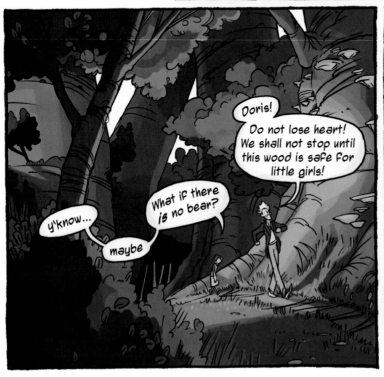

Doris! Do not lose heart! We shall not stop until this wood is safe for little girls!

What if there is no bear?

y'know... maybe

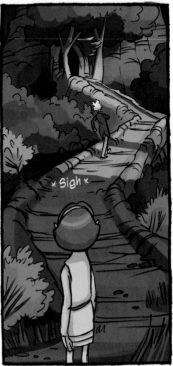

Sigh

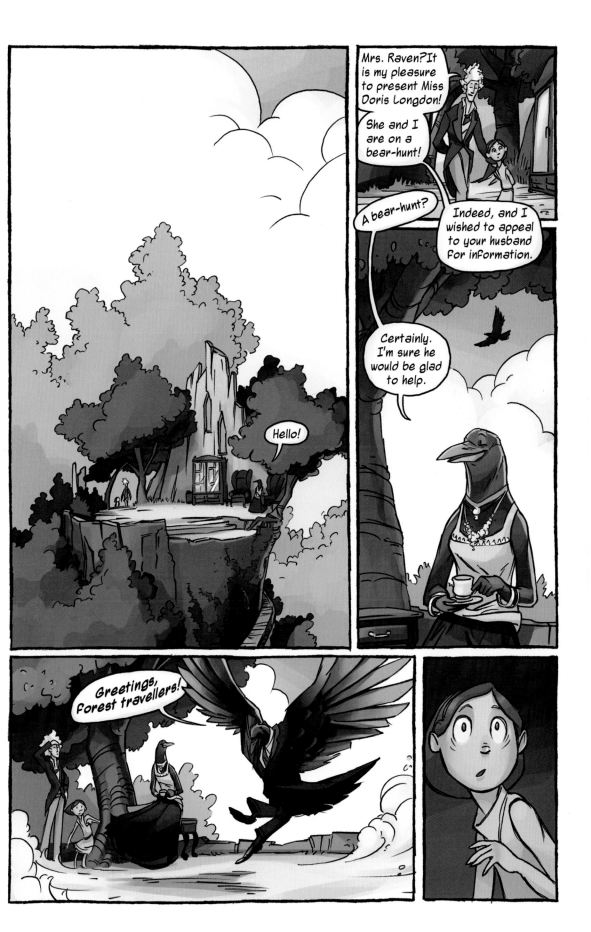

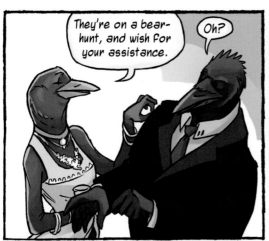

They're on a bear-hunt, and wish for your assistance.

Oh?

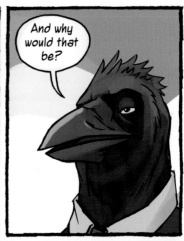

And why would that be?

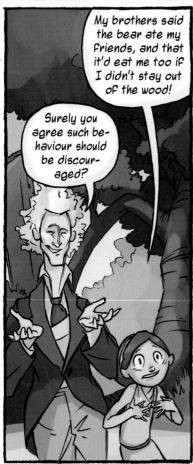

My brothers said the bear ate my friends, and that it'd eat me too if I didn't stay out of the wood!

Surely you agree such behaviour should be discouraged?

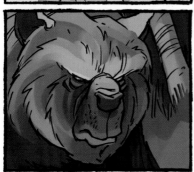

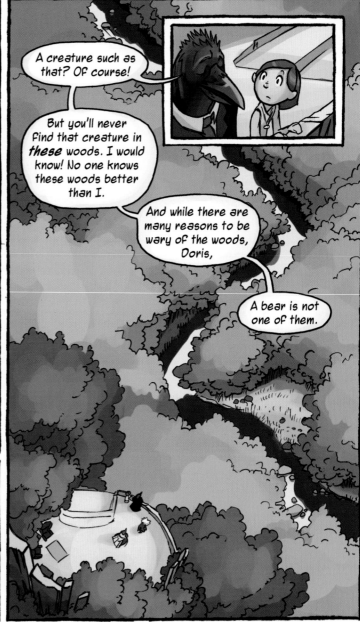

A creature such as that? Of course!

But you'll never find that creature in *these* woods. I would know! No one knows these woods better than I.

And while there are many reasons to be wary of the woods, Doris,

A bear is not one of them.

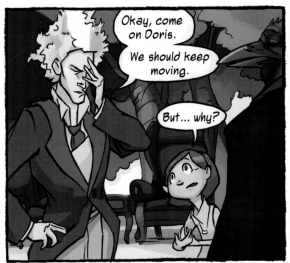

Okay, come on Doris.

We should keep moving.

But... why?

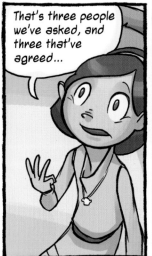

That's three people we've asked, and three that've agreed...

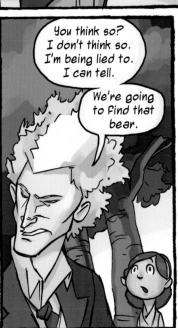

You think so? I don't think so. I'm being lied to. I can tell.

We're going to find that bear.

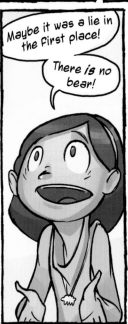

Maybe it was a lie in the first place!

There *is* no bear!

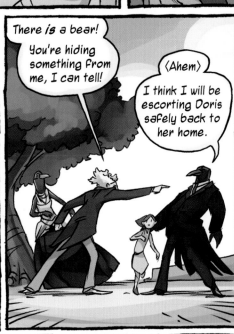

There *is* a bear!

You're hiding something from me, I can tell!

⟨Ahem⟩

I think I will be escorting Doris safely back to her home.

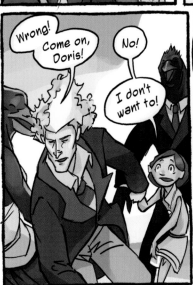

Wrong!

Come on, Doris!

No!

I don't want to!

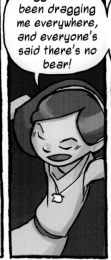

Leggo! You've been dragging me everywhere, and everyone's said there's no bear!

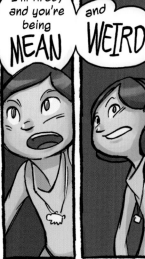

I'm tired, and you're being

MEAN

and

WEIRD

and I'm not following you *any more!*

53

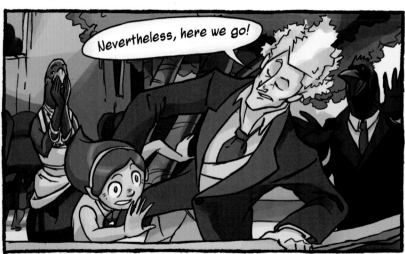

Nevertheless, here we go!

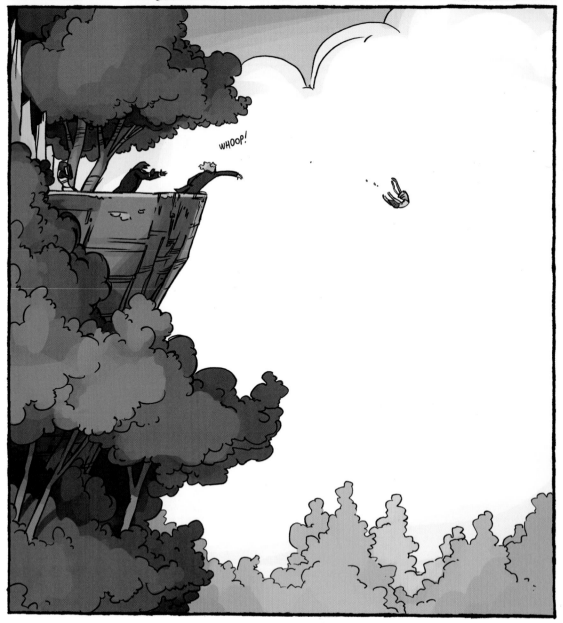

WHOOP!

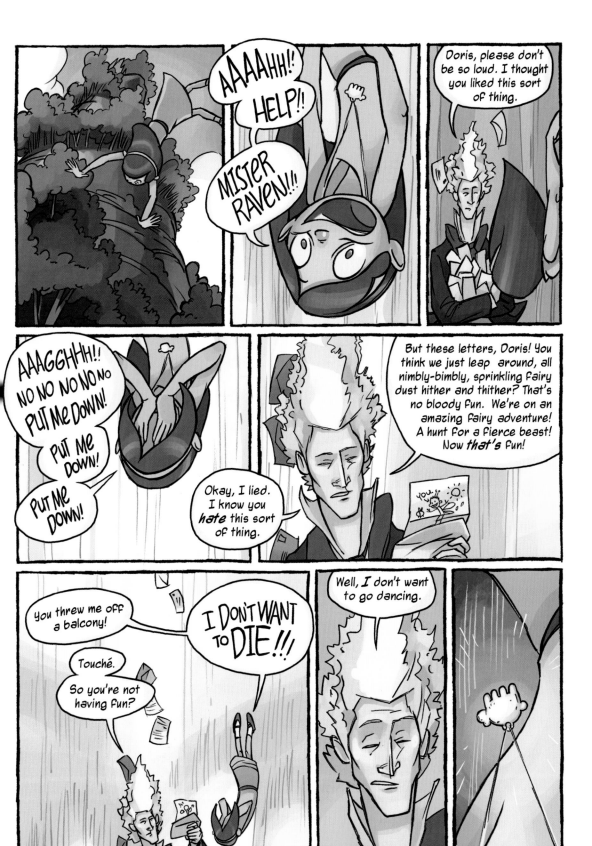

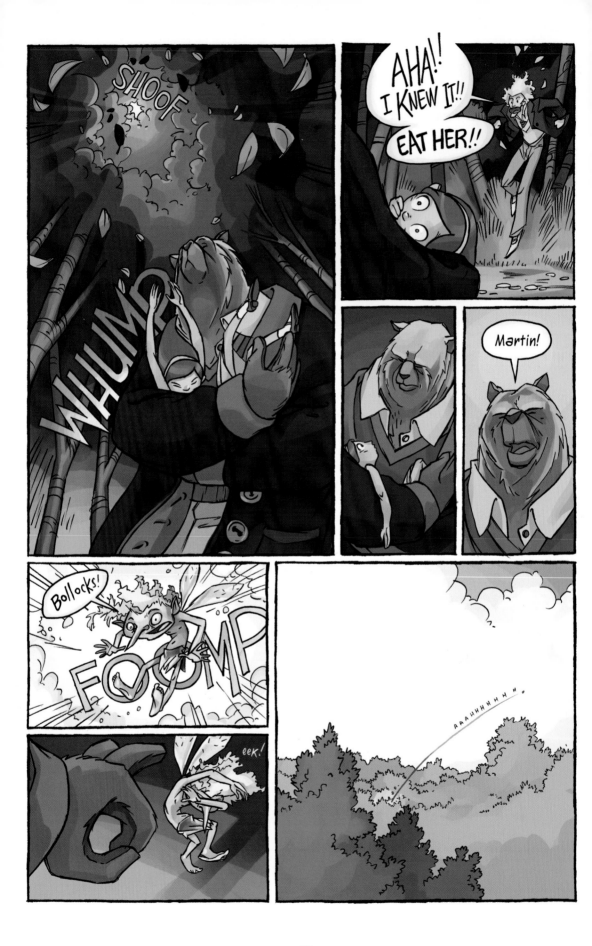

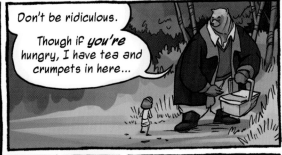

Don't be ridiculous.

Though if *you're* hungry, I have tea and crumpets in here...

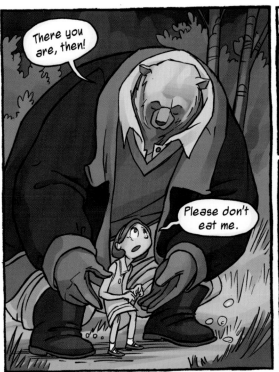

There you are, then!

Please don't eat me.

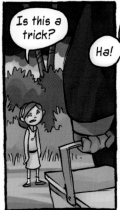

Is this a trick?

Ha!

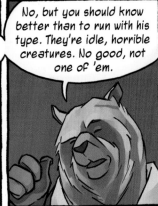

No, but you should know better than to run with his type. They're idle, horrible creatures. No good, not one of 'em.

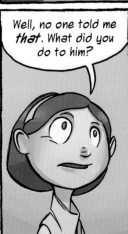

Well, no one told me *that*. What did you do to him?

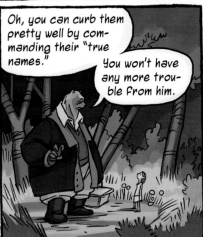

Oh, you can curb them pretty well by commanding their "true names."

You won't have any more trouble from him.

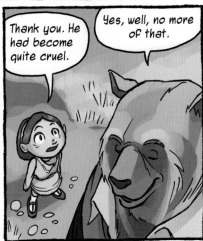

Thank you. He had become quite cruel.

Yes, well, no more of that.

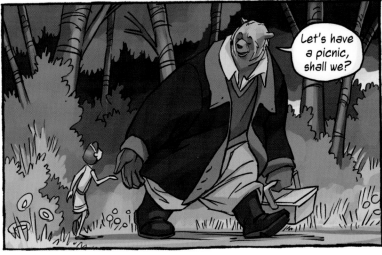

Let's have a picnic, shall we?

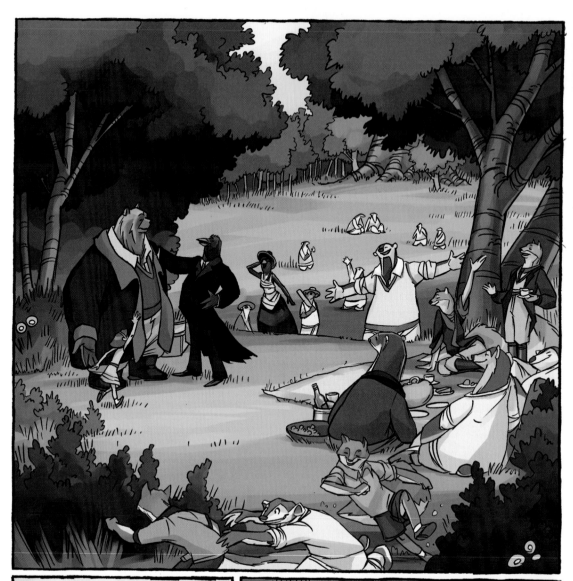

For the rest of the summer, that is how I spent my afternoons. I've had many happy times since then, but none quite so magical.

I've never told anyone about those days. I've had opportunities (I am routinely asked where my necklace is from)...but who would believe a story like that?

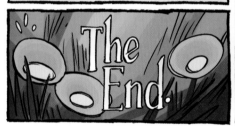

The End.

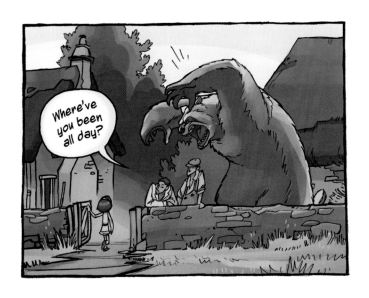

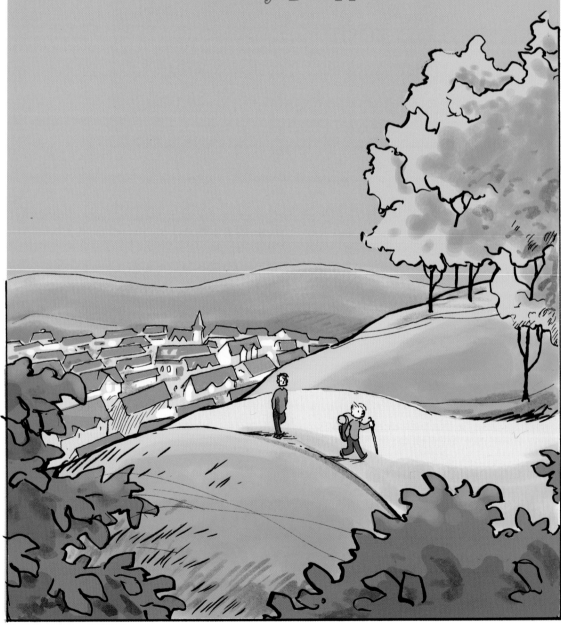

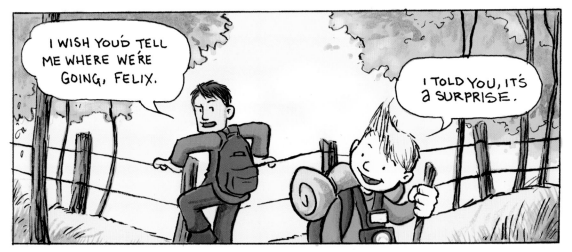

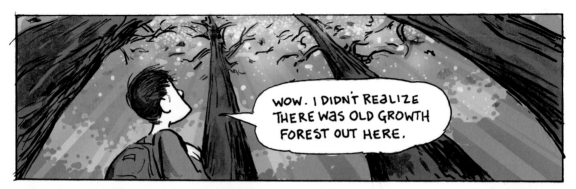

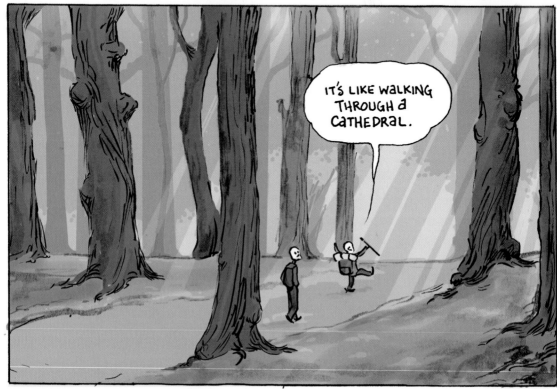

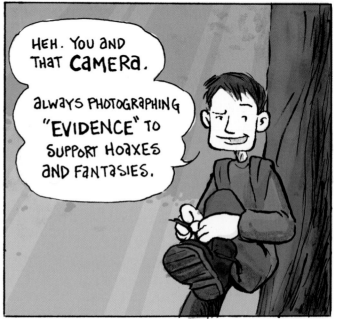

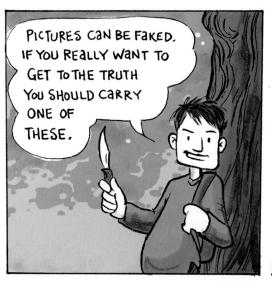

PICTURES CAN BE FAKED. IF YOU REALLY WANT TO GET TO THE TRUTH YOU SHOULD CARRY ONE OF THESE.

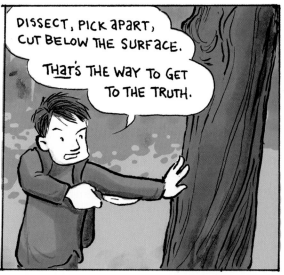

DISSECT, PICK APART, CUT BELOW THE SURFACE.

THAT'S THE WAY TO GET TO THE TRUTH.

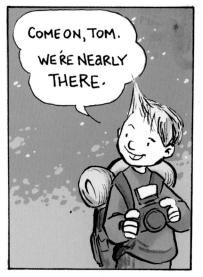

COME ON, TOM. WE'RE NEARLY THERE.

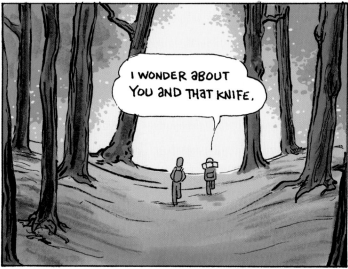

I WONDER ABOUT YOU AND THAT KNIFE.

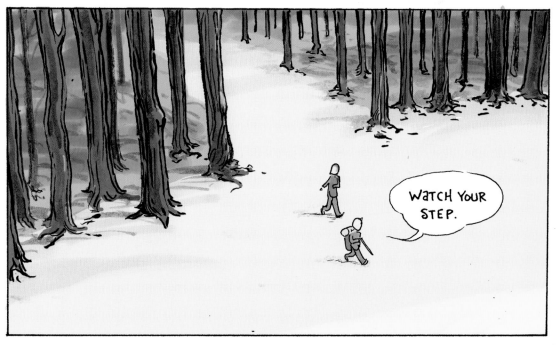

WATCH YOUR STEP.

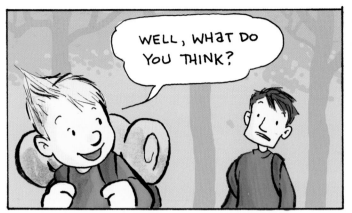

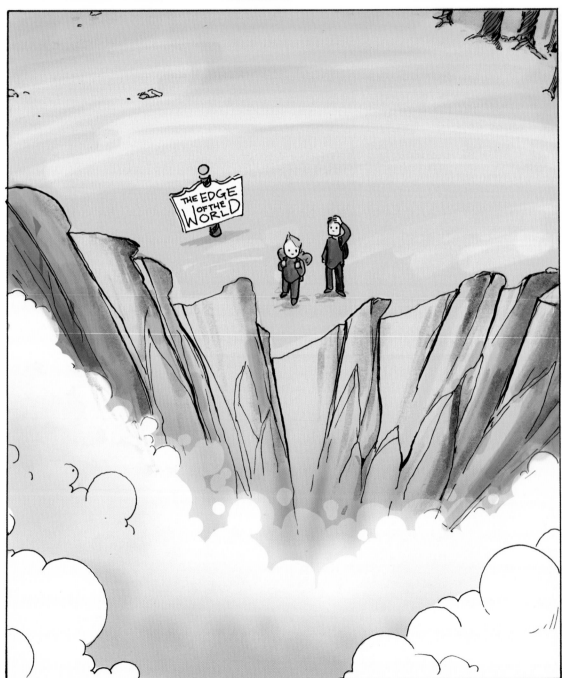

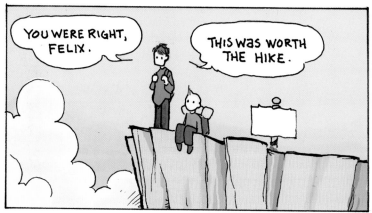

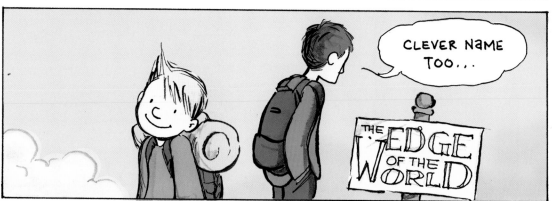

LOOK, I KNOW YOU BELIEVE IN MONSTERS AND CROP CIRCLES AND ALL, BUT TO THINK THAT THE EARTH IS **FLAT**—

IT'S **BEYOND CRAZY!**

WELL DID YOU AT LEAST THINK TO ASK WHOEVER LIVES IN THAT CREEPY HOUSE BACK THERE?

AH...

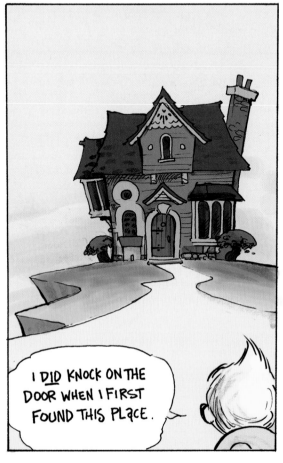

I **DID** KNOCK ON THE DOOR WHEN I FIRST FOUND THIS PLACE.

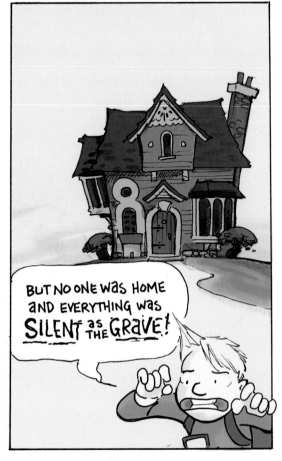

BUT NO ONE WAS HOME AND EVERYTHING WAS **SILENT** AS THE **GRAVE!**

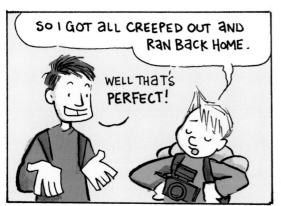

SO I GOT ALL CREEPED OUT AND RAN BACK HOME.

WELL THAT'S PERFECT!

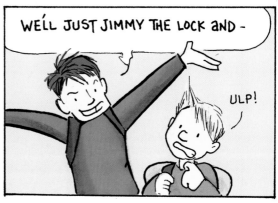

WE'LL JUST JIMMY THE LOCK AND –

ULP!

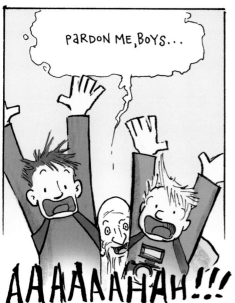

PARDON ME, BOYS...

AAAAAAHAH!!!

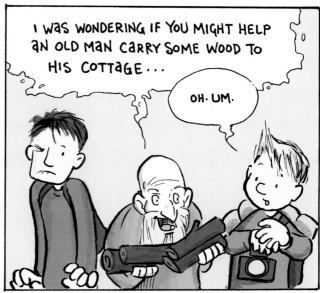

I WAS WONDERING IF YOU MIGHT HELP AN OLD MAN CARRY SOME WOOD TO HIS COTTAGE...

OH. UM.

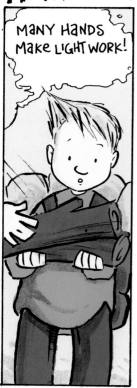

MANY HANDS MAKE LIGHT WORK!

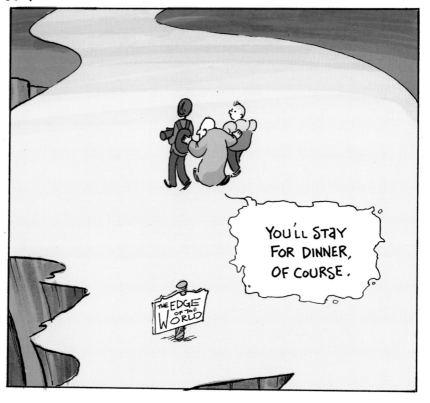

YOU'LL STAY FOR DINNER, OF COURSE.

THE EDGE OF THE WORLD

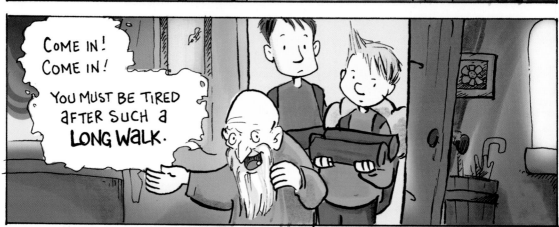

COME IN!
COME IN!

YOU MUST BE TIRED
AFTER SUCH A
LONG WALK.

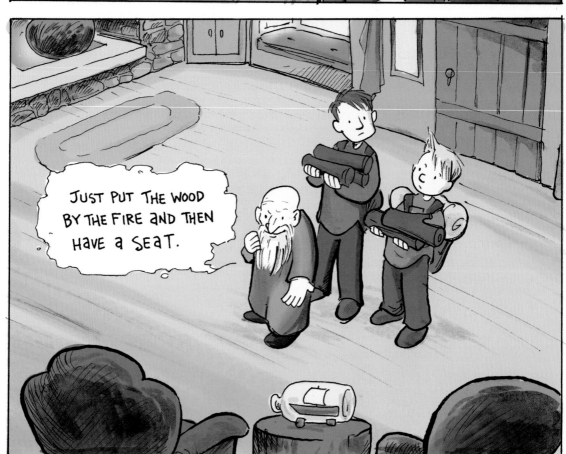

JUST PUT THE WOOD
BY THE FIRE AND THEN
HAVE A SEAT.

SSSSP! HMM. STILL MISSING SOMETHING.

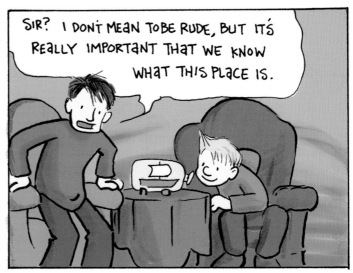

SIR? I DON'T MEAN TO BE RUDE, BUT IT'S REALLY IMPORTANT THAT WE KNOW WHAT THIS PLACE IS.

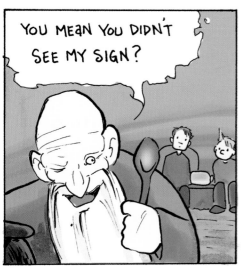

YOU MEAN YOU DIDN'T SEE MY SIGN?

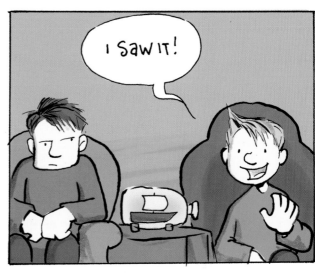

I SAW IT!

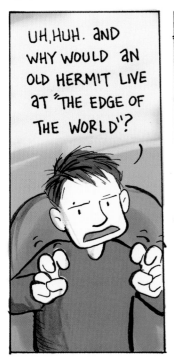

UH, HUH. AND WHY WOULD AN OLD HERMIT LIVE AT "THE EDGE OF THE WORLD"?

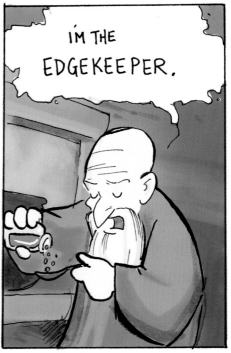

I'M THE EDGEKEEPER.

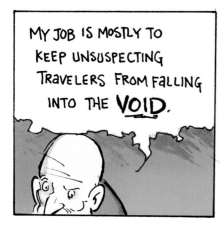

MY JOB IS MOSTLY TO KEEP UNSUSPECTING TRAVELERS FROM FALLING INTO THE **VOID**.

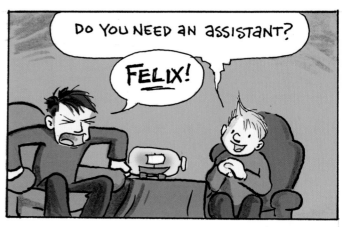

DO YOU NEED AN ASSISTANT?

FELIX!

THIS IS CRAZY! MAN HAS KNOWN FOR THOUSANDS OF YEARS THAT THE WORLD IS ROUND.

A GREAT MANY PEOPLE DO LABOR UNDER THAT MISCONCEPTION, I'M AFRAID.

BUT IT <u>IS</u> ROUND! I'LL SHOW YOU!

TOM—

I'M GOING TO CLIMB TO THE BOTTOM OF THAT CLIFF OUT THERE.

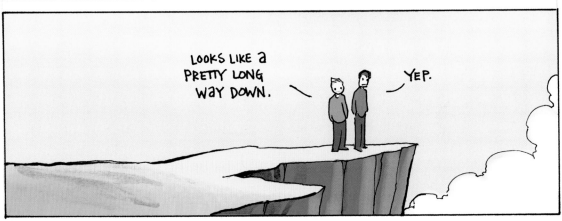

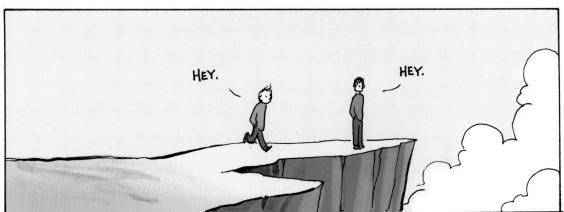

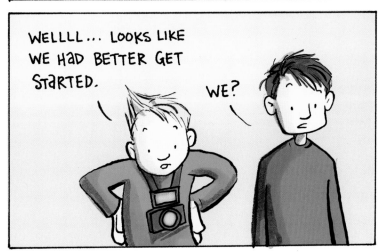

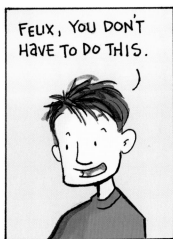

SURE I DO! IT'S NOT EVERY DAY THAT YOU GET A CHANCE TO CATCH THE WORLD'S EDGE ON FILM!

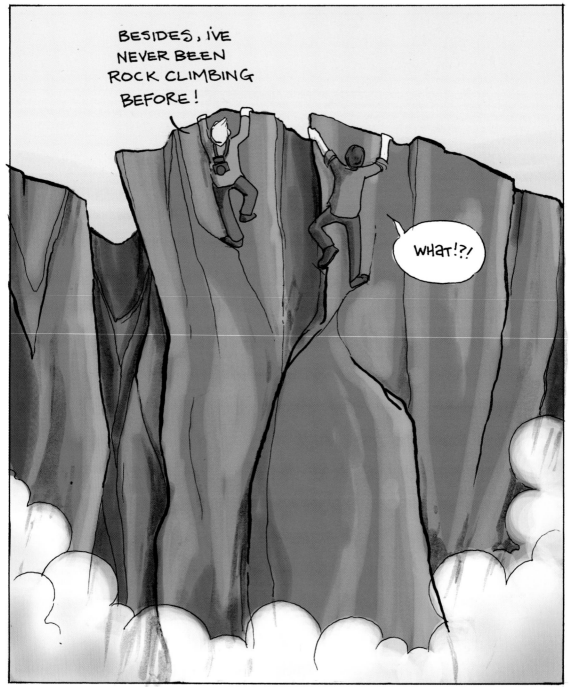

BESIDES, I'VE NEVER BEEN ROCK CLIMBING BEFORE!

WHAT!?!

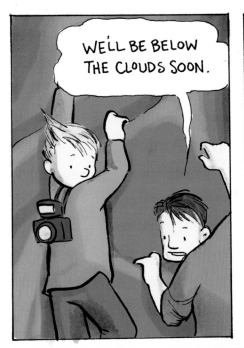

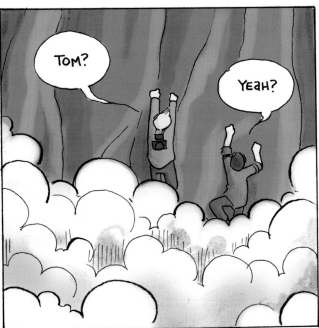

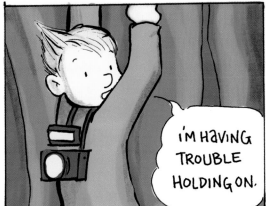

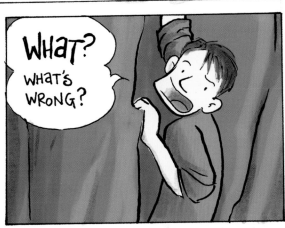

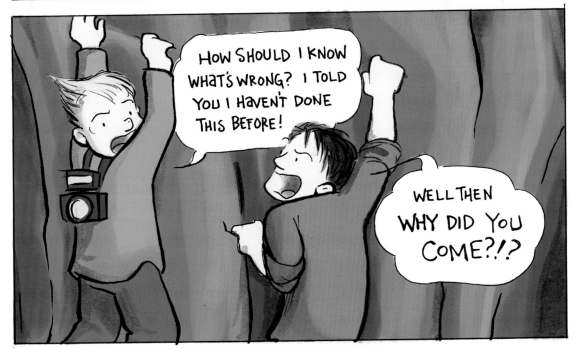

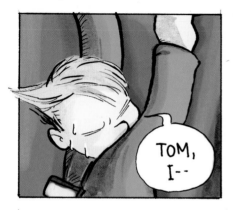

TOM, I--

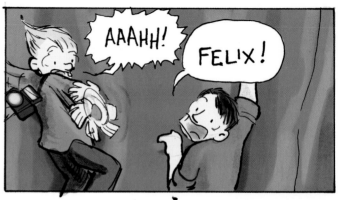

AAAHH!

FELIX!

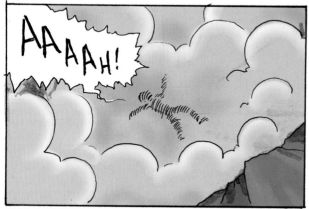

AAAAAH!

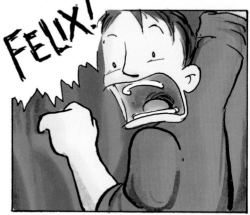

FELIX!

OOOOH... OW.

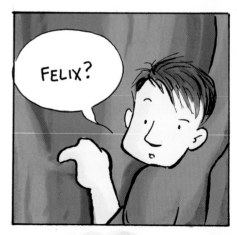

FELIX?

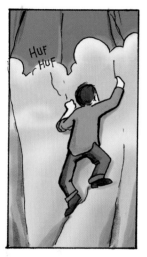

HUF HUF

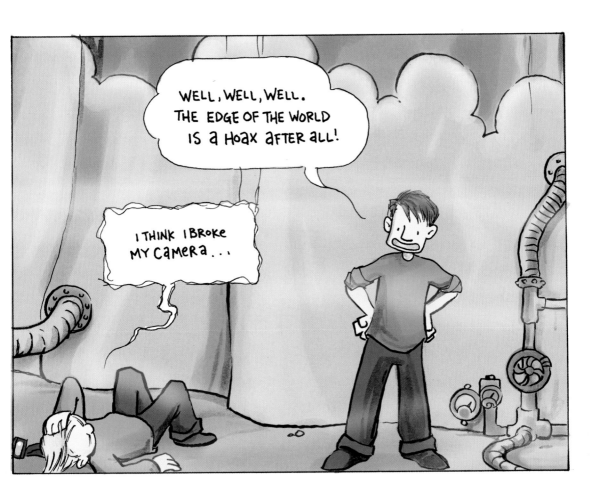

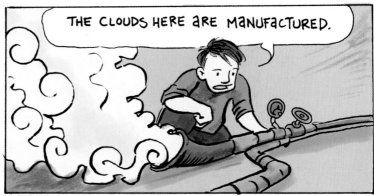

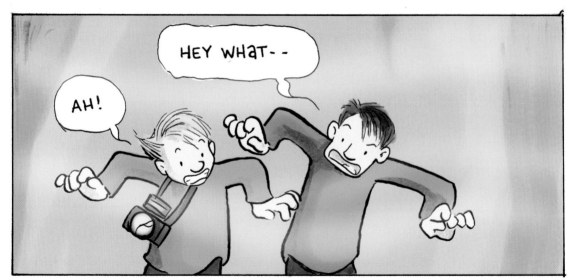

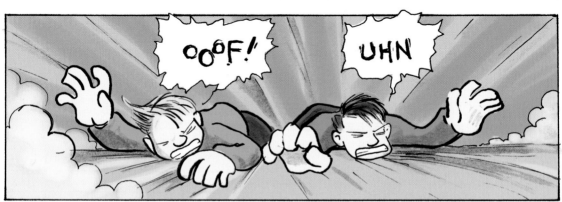

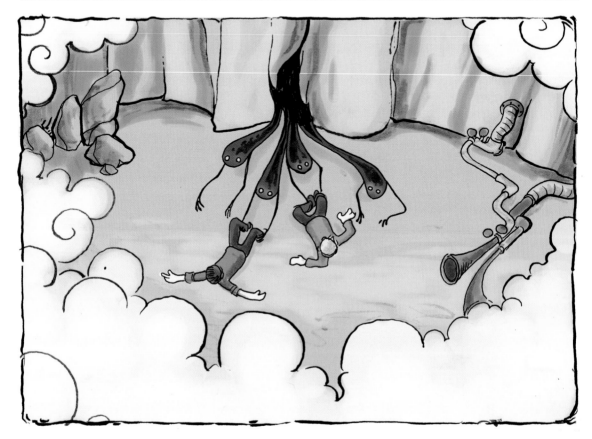

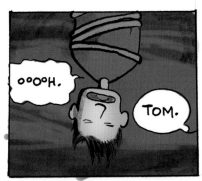
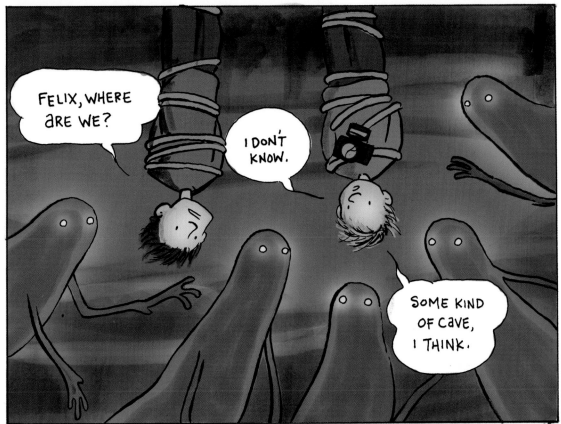
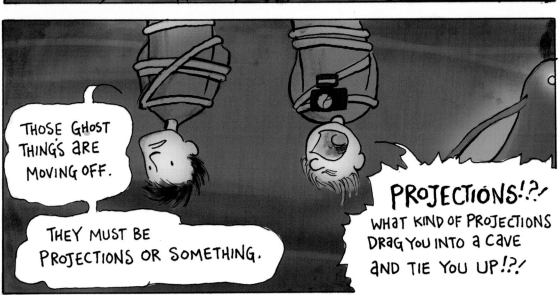

CLOP
CLOP

SOMEONE'S COMING! TOM, WE'VE GOT TO--

WHUMP

TOM?

NOW AREN'T YOU GLAD I CARRY THIS?

QUICK, BEFORE THOSE GHOSTS COME BACK.

PROJECTIONS. AND DON'T RUSH ME.

GOT IT!

OOOF!

LET'S FIND A WAY OUT OF HERE.

OH IT'S TOO LATE FOR THAT!

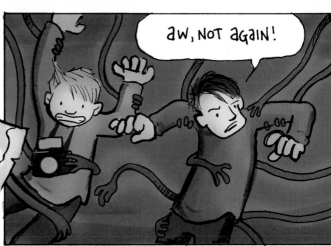

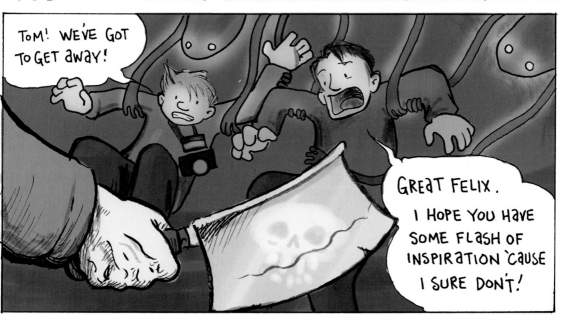

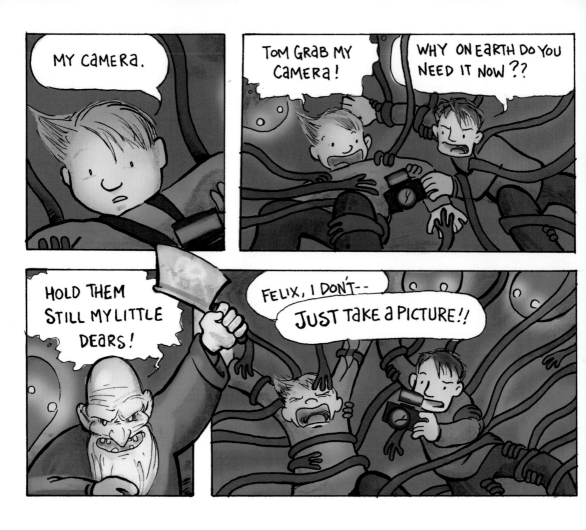

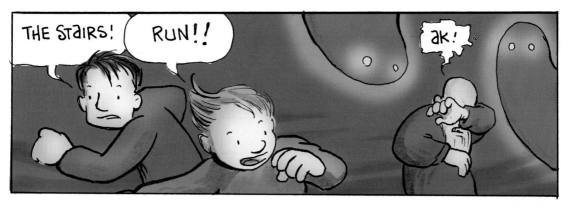

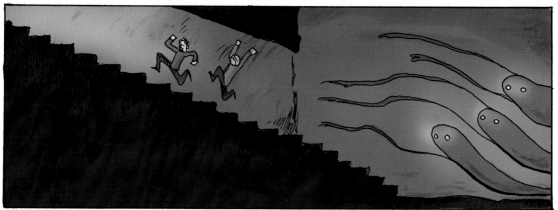

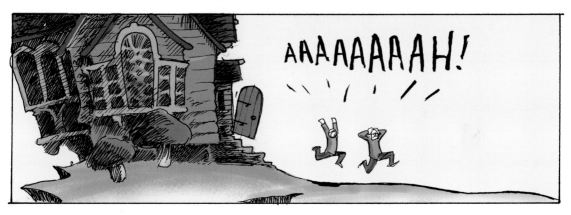

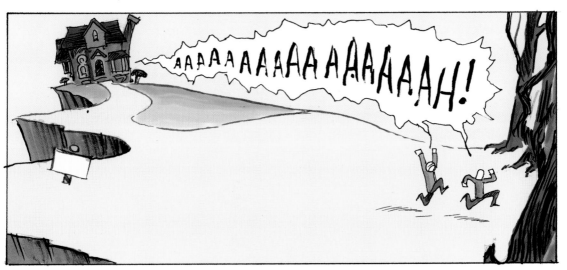

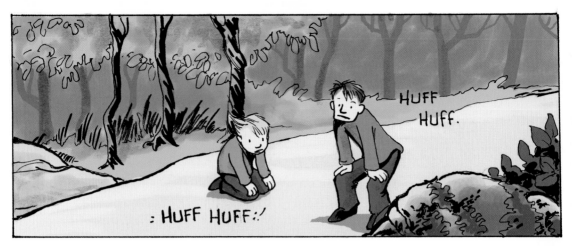

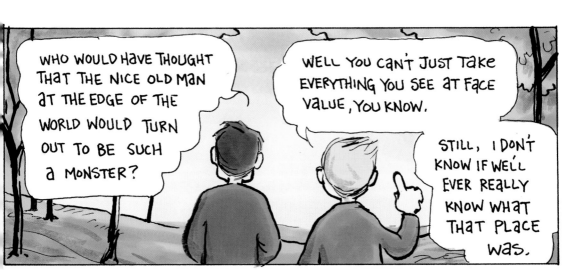

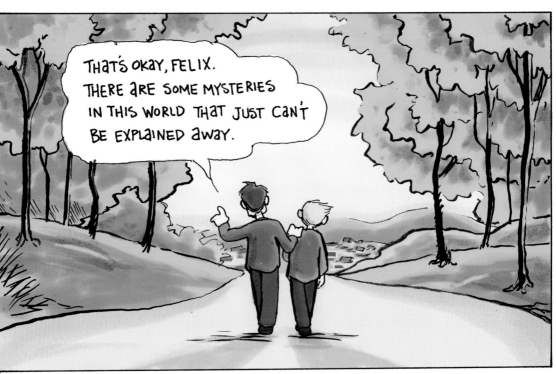

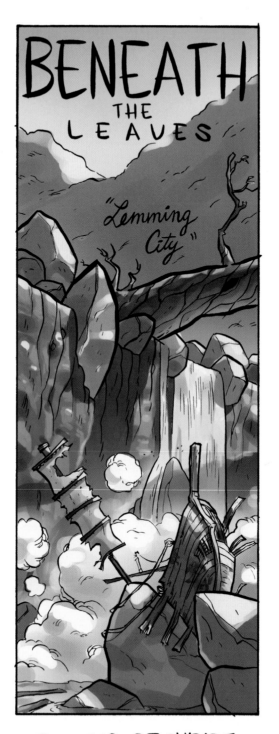

BENEATH
THE
LEAVES

"Lemming City"

BY RAD SECHRIST

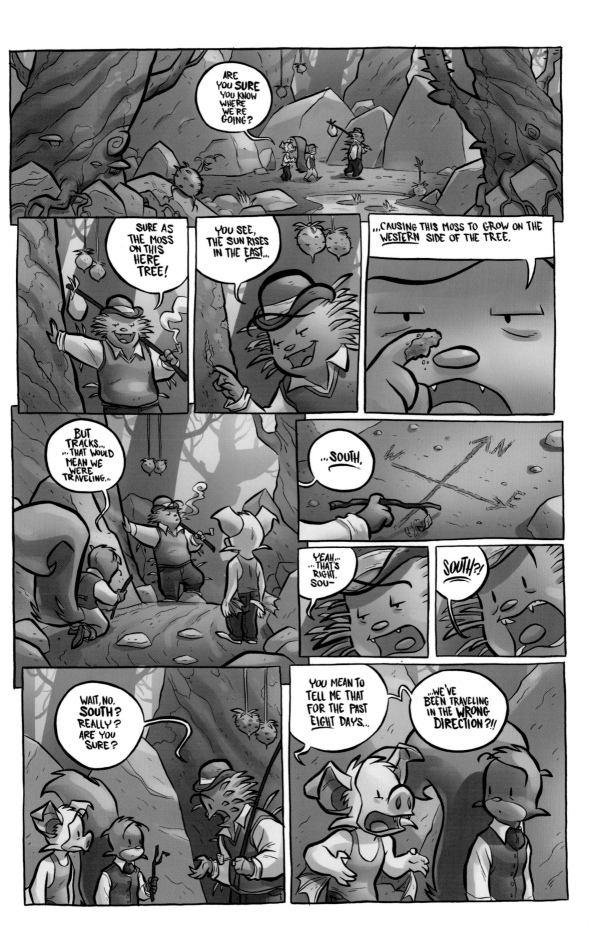

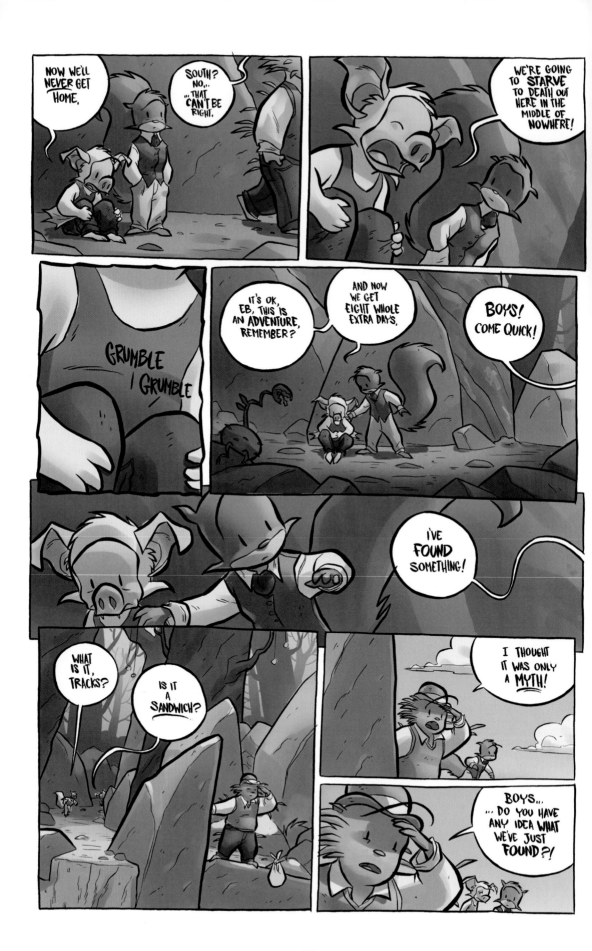

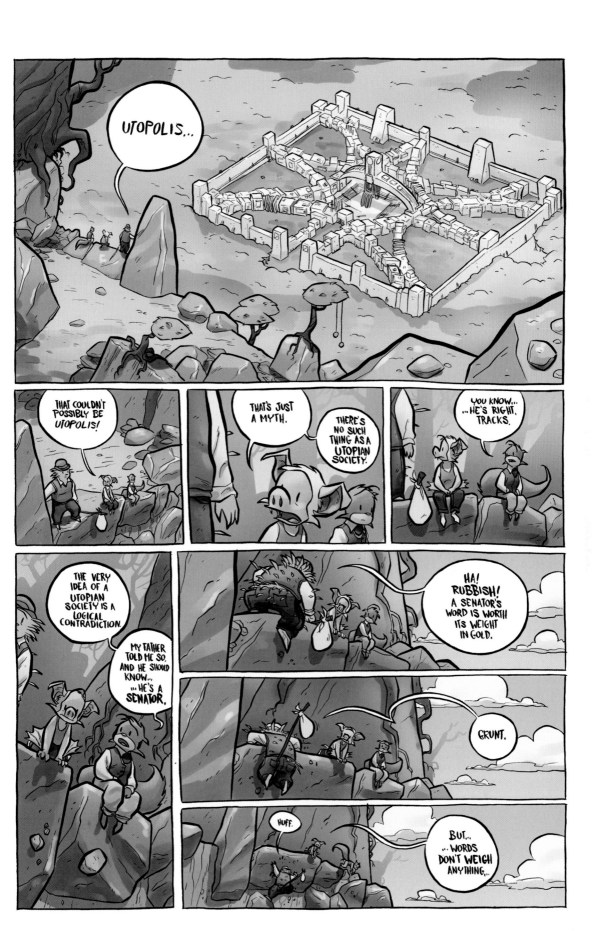

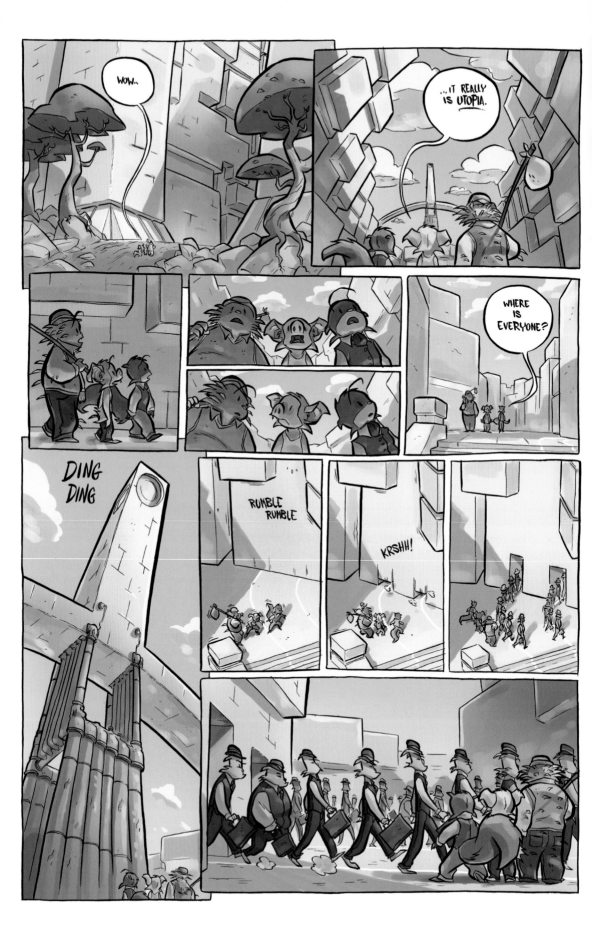

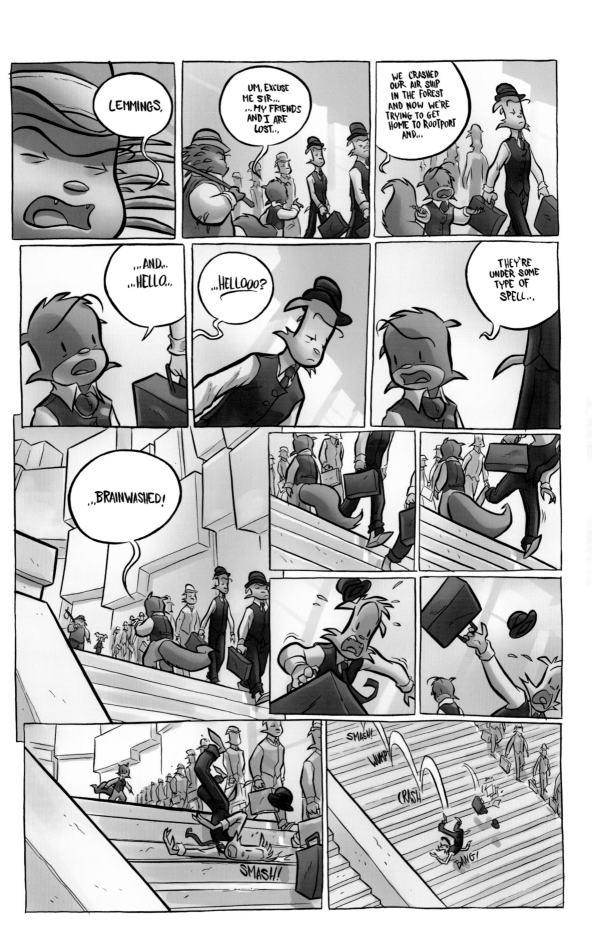

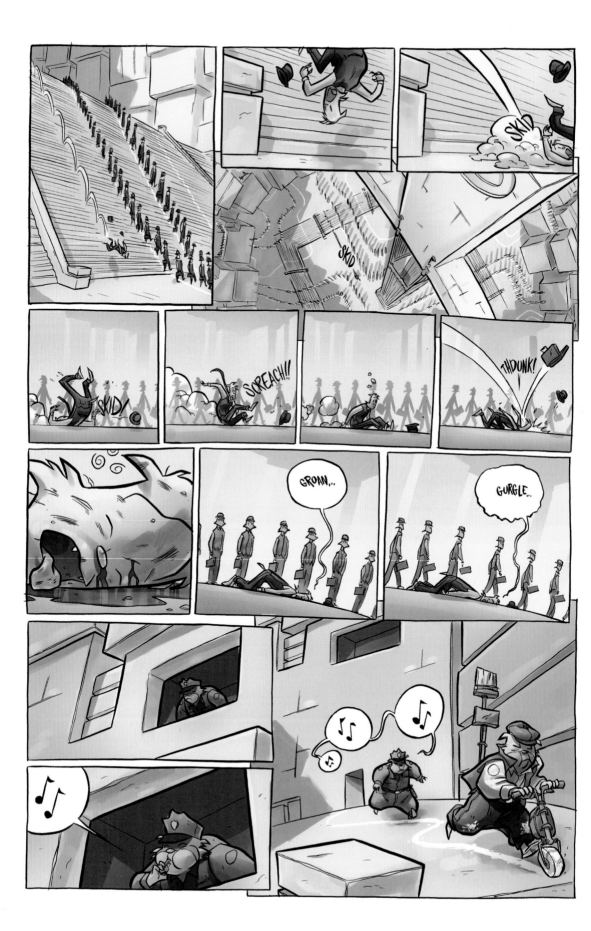

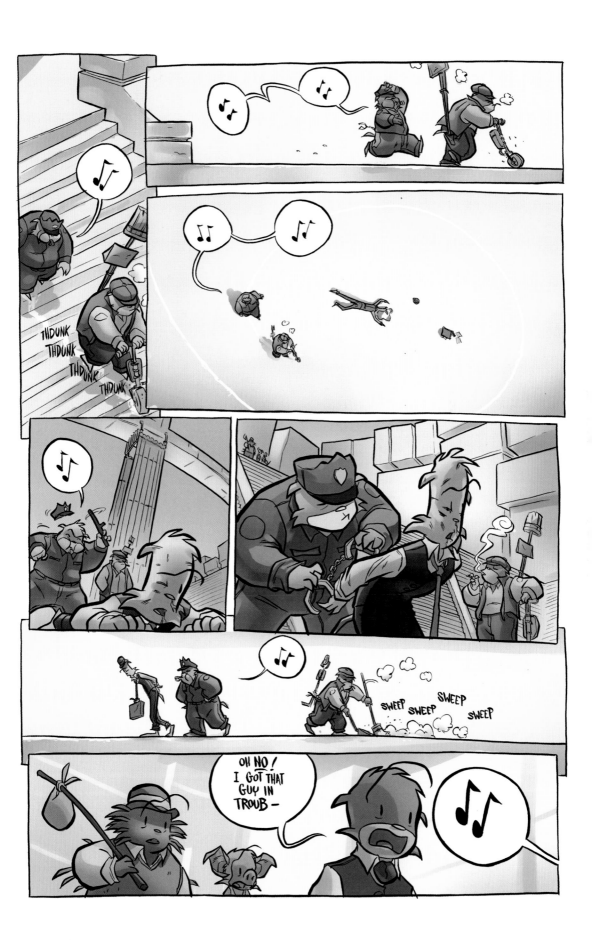

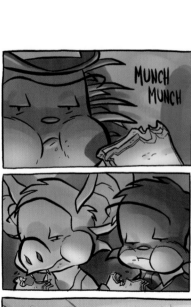
MUNCH MUNCH

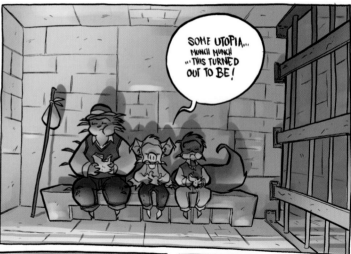
SOME UTOPIA... MUNCH MUNCH ...THIS TURNED OUT TO BE!

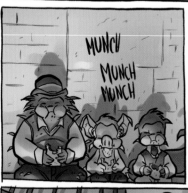

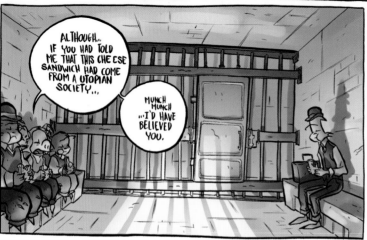
ALTHOUGH... IF YOU HAD TOLD ME THAT THIS CHEESE SANDWICH HAD COME FROM A UTOPIAN SOCIETY...

MUNCH MUNCH ...I'D HAVE BELIEVED YOU.

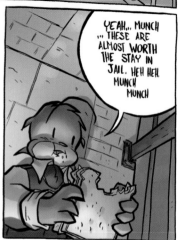
YEAH... MUNCH ...THESE ARE ALMOST WORTH THE STAY IN JAIL. HEH HEH. MUNCH MUNCH

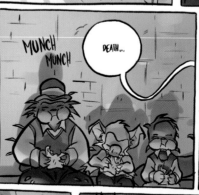
MUNCH MUNCH MUNCH

MUNCH MUNCH

DEATH...

WHAT'S THAT MY GOOD SIR? SPEAK UP.

SOUNDED LIKE YOU SAID—

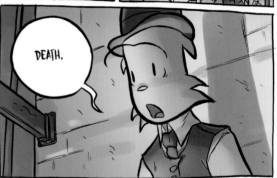
DEATH.

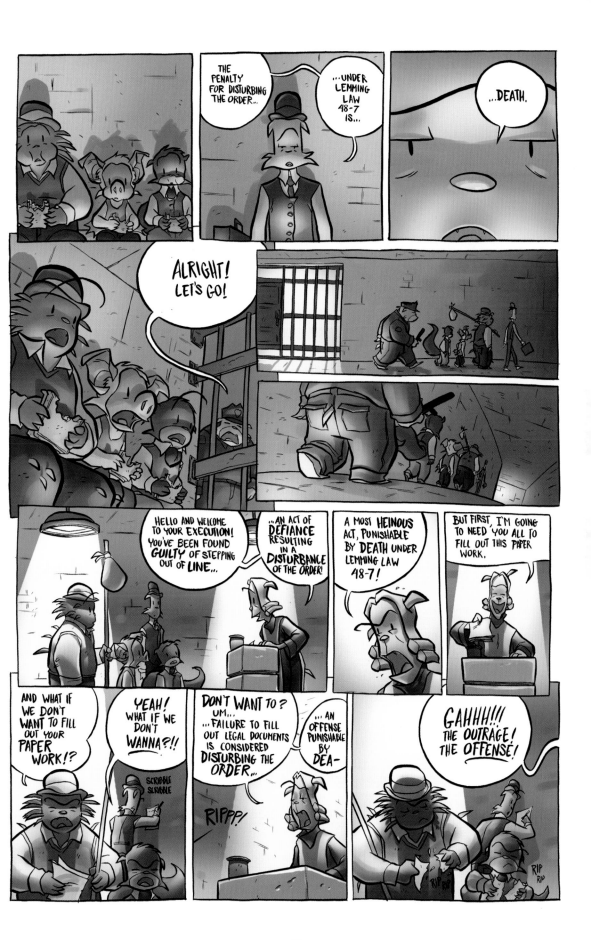

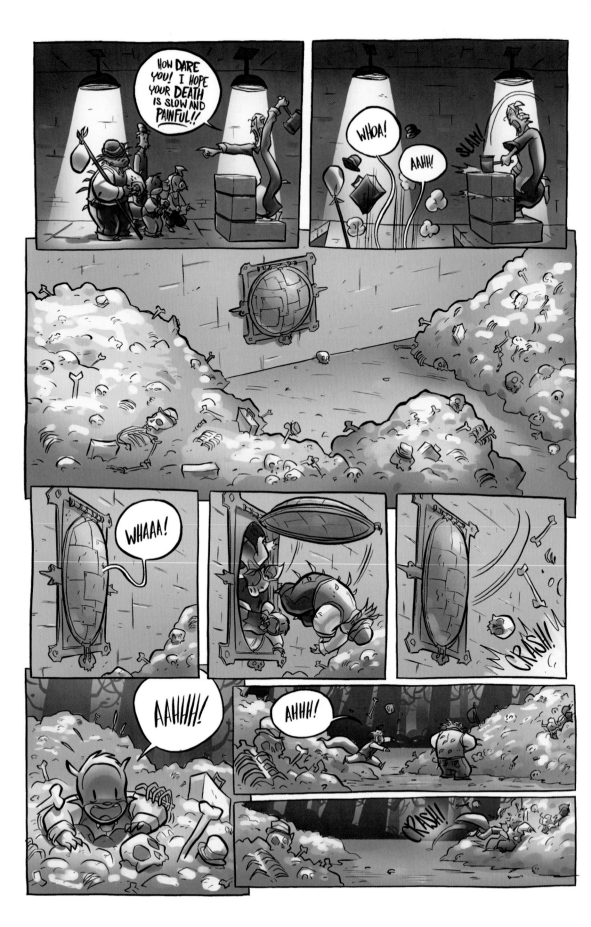

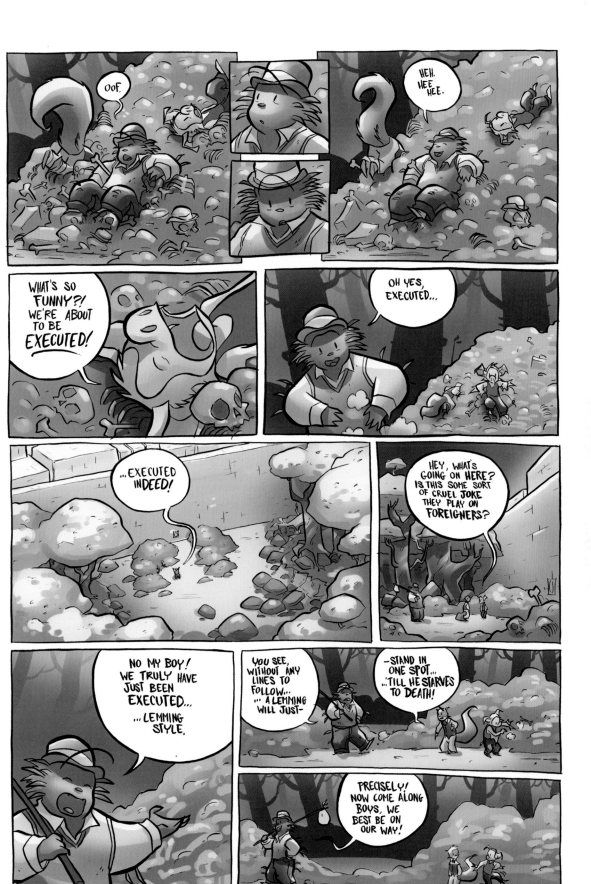

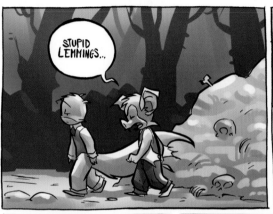

STUPID LEMMINGS...

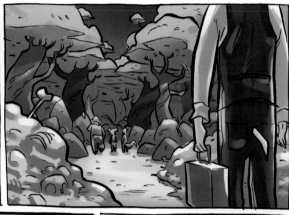

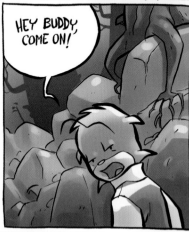

HEY BUDDY, COME ON!

YOU'LL STARVE IF YOU JUST **STAND** THERE!

C'MON BUDDY!

IT'S NO USE TIMBER... ...THERE'S NO **REASONING WITH** LEMMINGS.

COME NOW BOYS! THIS WAY IS **NORTH!** NOW I'M **SURE** OF IT!

AS **SURE** AS YOU WERE **LAST** TIME!?

KSHH..

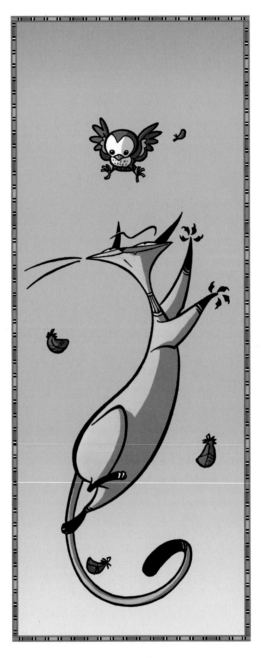

HUNTER

BY JOHANE MATTE

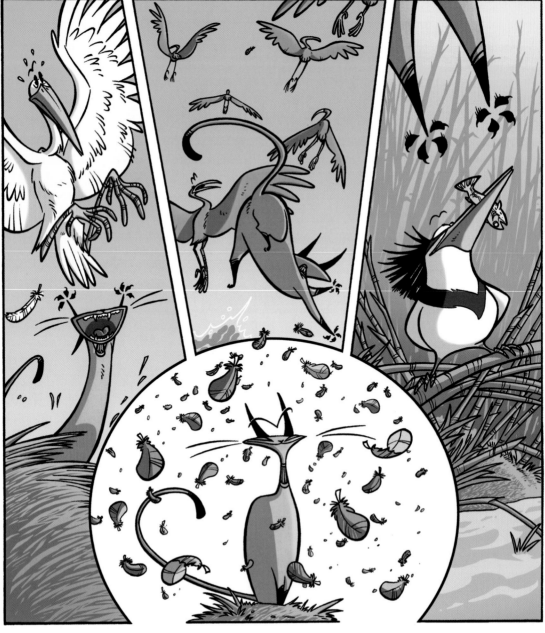

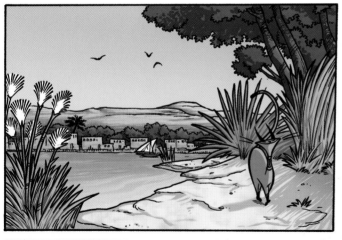

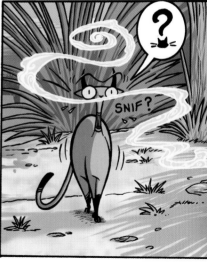

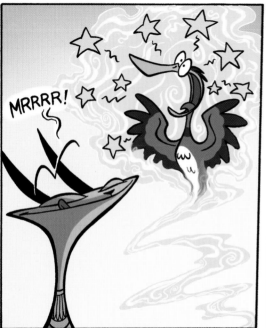

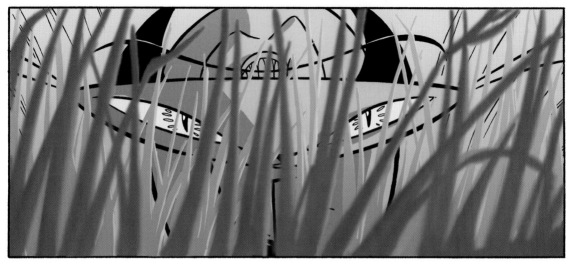

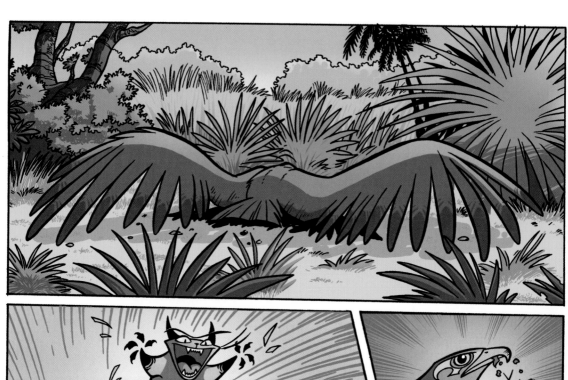

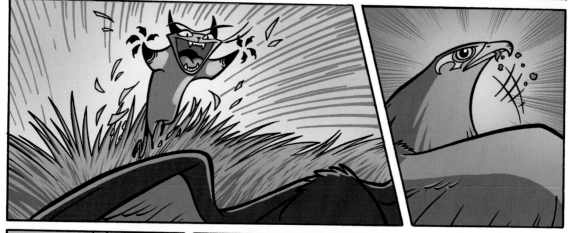

NATURE TALKS TO US, TELLING US WHAT GOOD CHOICES TO MAKE.

TODAY, YOU WILL PRACTICE READING THE FLIGHT OF BIRDS.

USE THE SCROLL! IT WILL HELP YOU DECIPHER ALL THE SIGNS

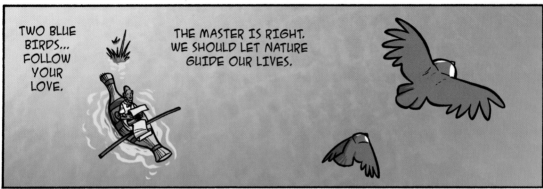

TWO BLUE BIRDS... FOLLOW YOUR LOVE.

THE MASTER IS RIGHT. WE SHOULD LET NATURE GUIDE OUR LIVES.

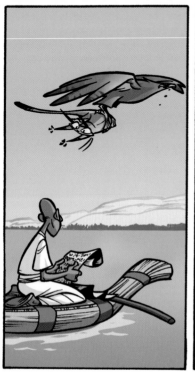

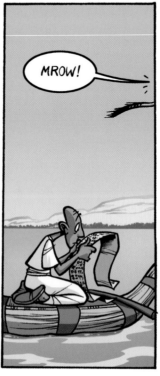

MROW!

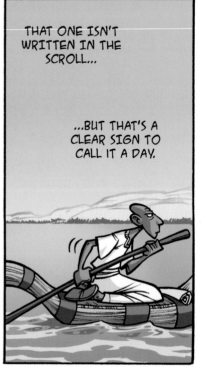

THAT ONE ISN'T WRITTEN IN THE SCROLL...

...BUT THAT'S A CLEAR SIGN TO CALL IT A DAY.

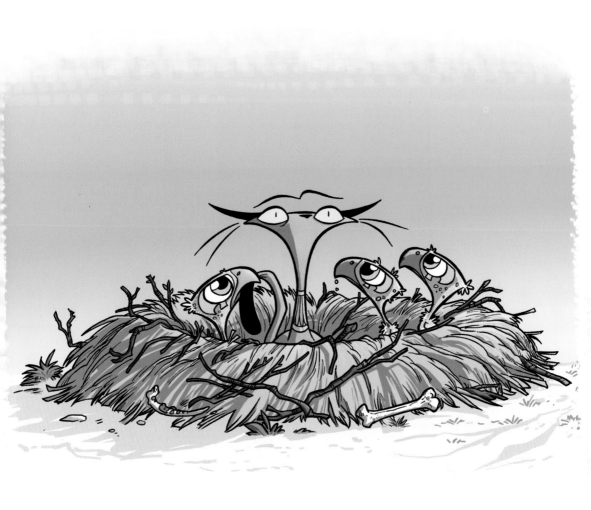

JELLABY
THE TEA PARTY

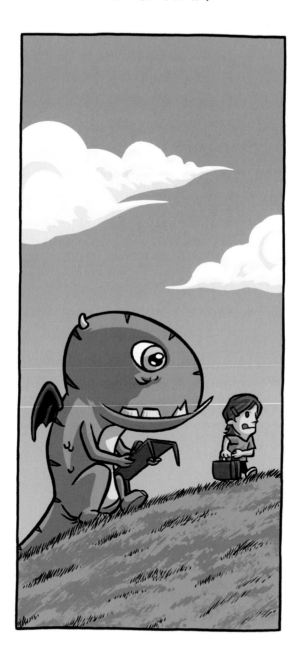

KEAN SOO

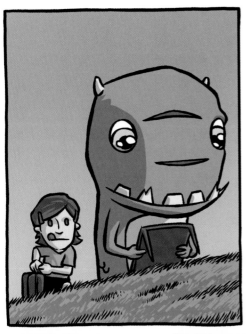

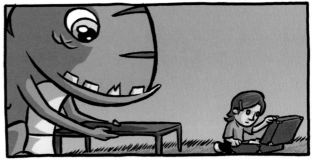

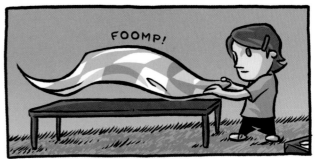

FOOMP!

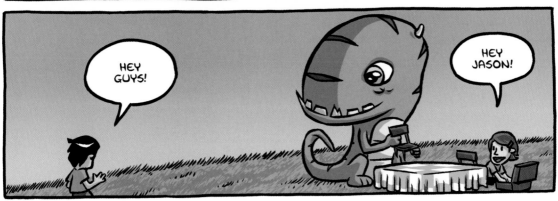

HEY GUYS!

HEY JASON!

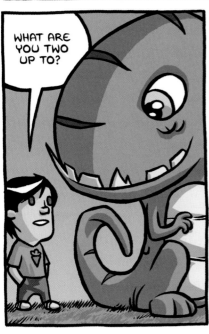

WHAT ARE YOU TWO UP TO?

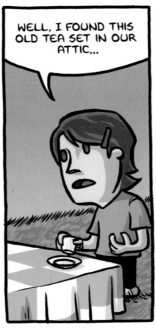

WELL, I FOUND THIS OLD TEA SET IN OUR ATTIC...

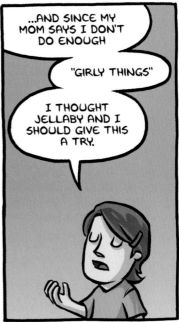

...AND SINCE MY MOM SAYS I DON'T DO ENOUGH

"GIRLY THINGS"

I THOUGHT JELLABY AND I SHOULD GIVE THIS A TRY.

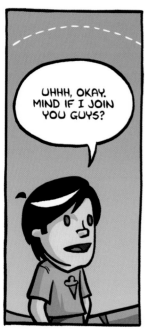

UHHH, OKAY. MIND IF I JOIN YOU GUYS?

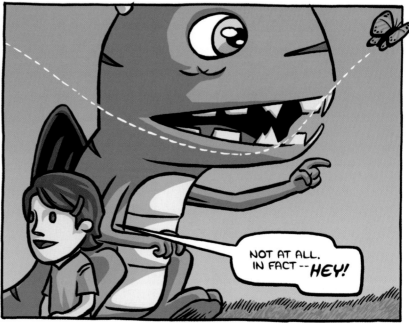

NOT AT ALL. IN FACT -- *HEY!*

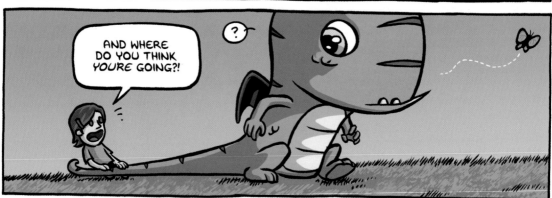

AND WHERE DO YOU THINK *YOU'RE GOING?!*

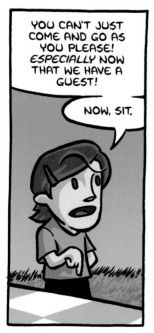

YOU CAN'T JUST COME AND GO AS YOU PLEASE! *ESPECIALLY* NOW THAT WE HAVE A GUEST!

NOW, SIT.

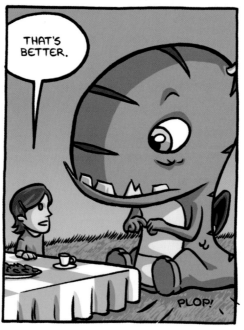

THAT'S BETTER.

PLOP!

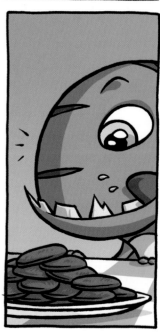

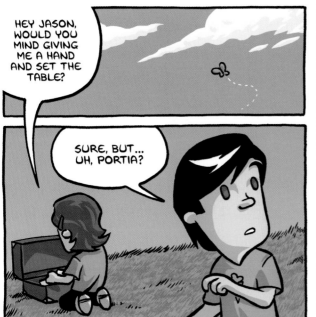

HEY JASON, WOULD YOU MIND GIVING ME A HAND AND SET THE TABLE?

SURE, BUT... UH, PORTIA?

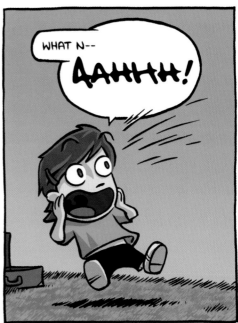

WHAT N--

AAHHH!

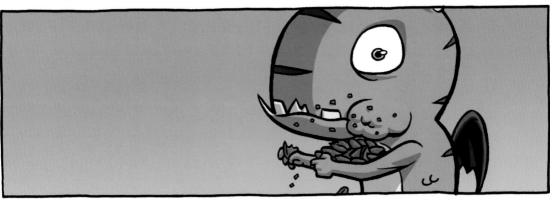

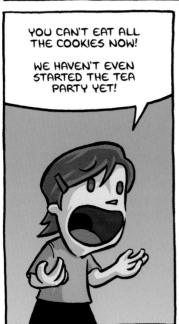

YOU CAN'T EAT ALL THE COOKIES NOW!

WE HAVEN'T EVEN STARTED THE TEA PARTY YET!

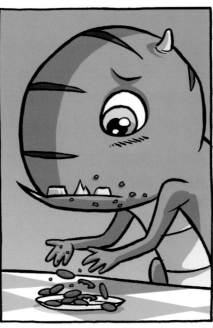

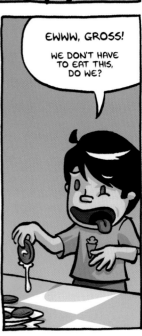

EWWW, GROSS!

WE DON'T HAVE TO EAT THIS, DO WE?

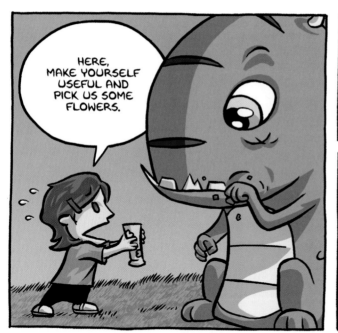

HERE, MAKE YOURSELF USEFUL AND PICK US SOME FLOWERS.

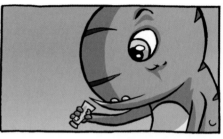

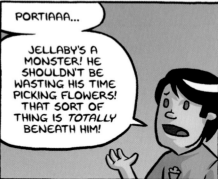

PORTIAAA...

JELLABY'S A MONSTER! HE SHOULDN'T BE WASTING HIS TIME PICKING FLOWERS! THAT SORT OF THING IS *TOTALLY* BENEATH HIM!

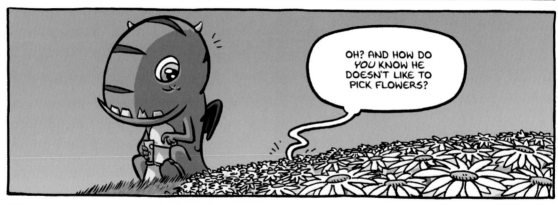

OH? AND HOW DO *YOU* KNOW HE DOESN'T LIKE TO PICK FLOWERS?

POIT!

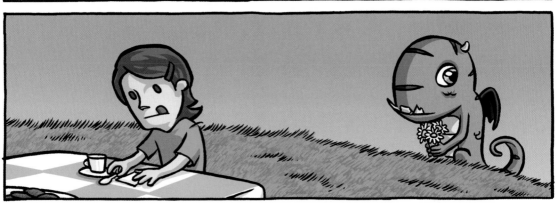

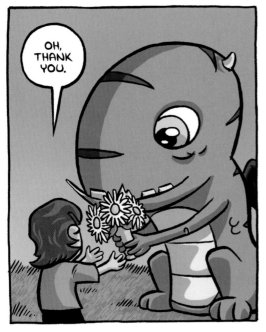

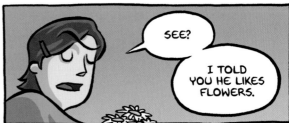

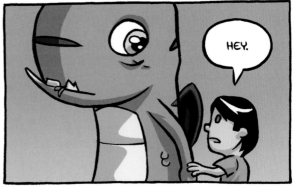

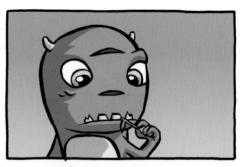

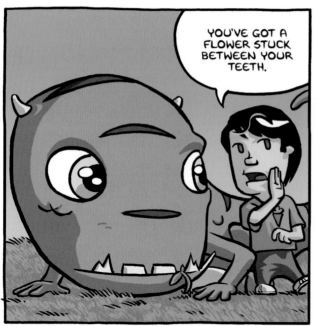

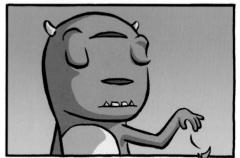

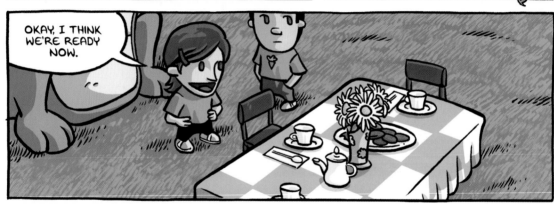

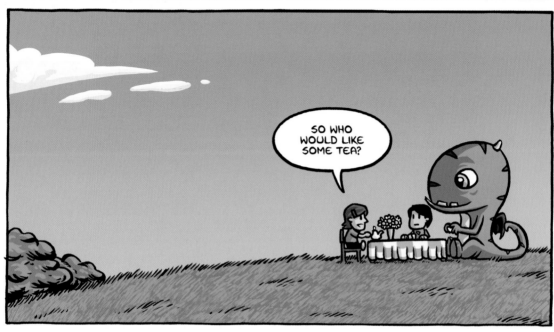

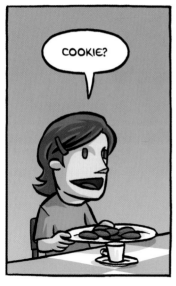

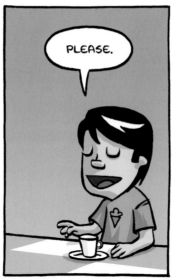

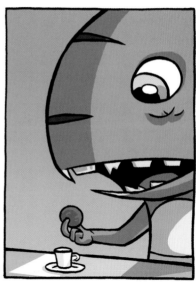

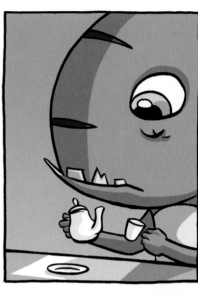
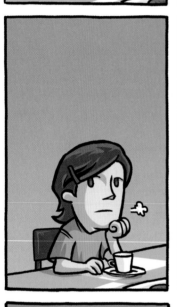
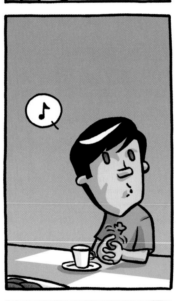
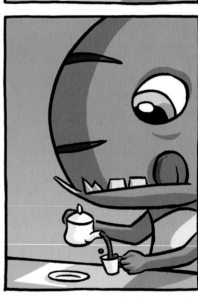
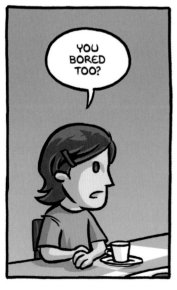
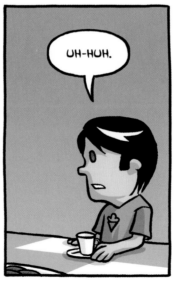
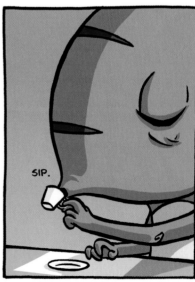

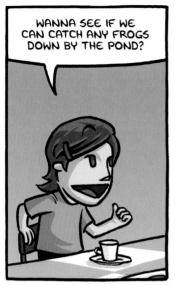

WANNA SEE IF WE CAN CATCH ANY FROGS DOWN BY THE POND?

I'LL RACE YOU TO THE BOTTOM OF THE HILL!

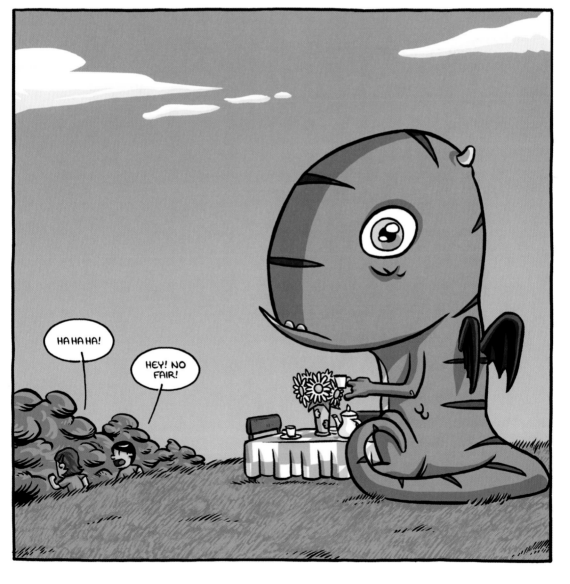

HA HA HA!

HEY! NO FAIR!

THE
RESCUE

by
Phil Craven

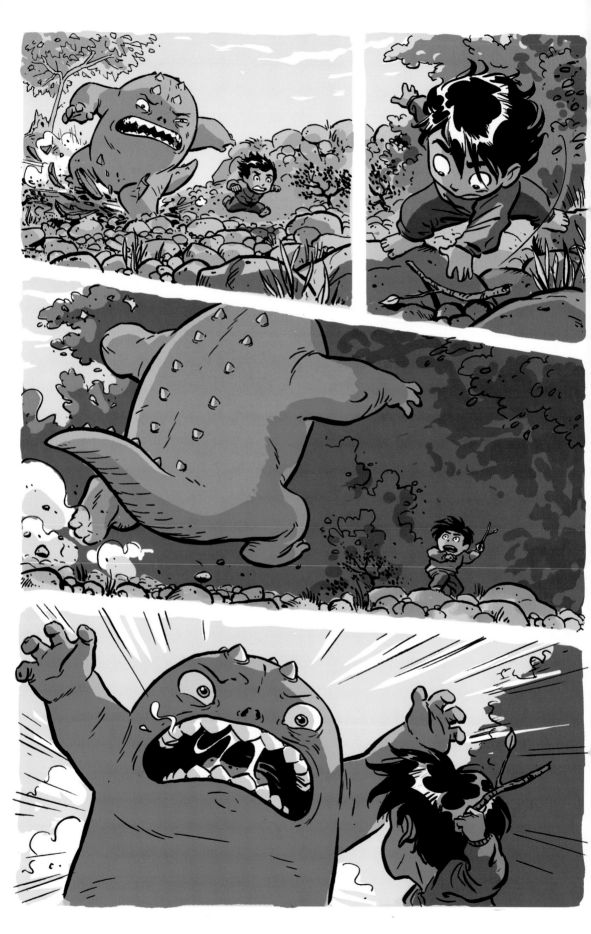

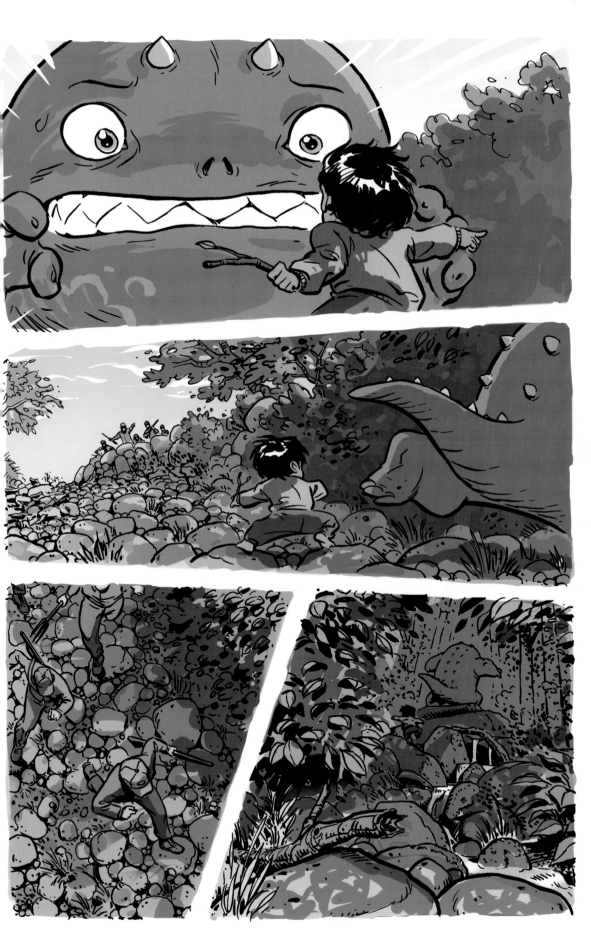

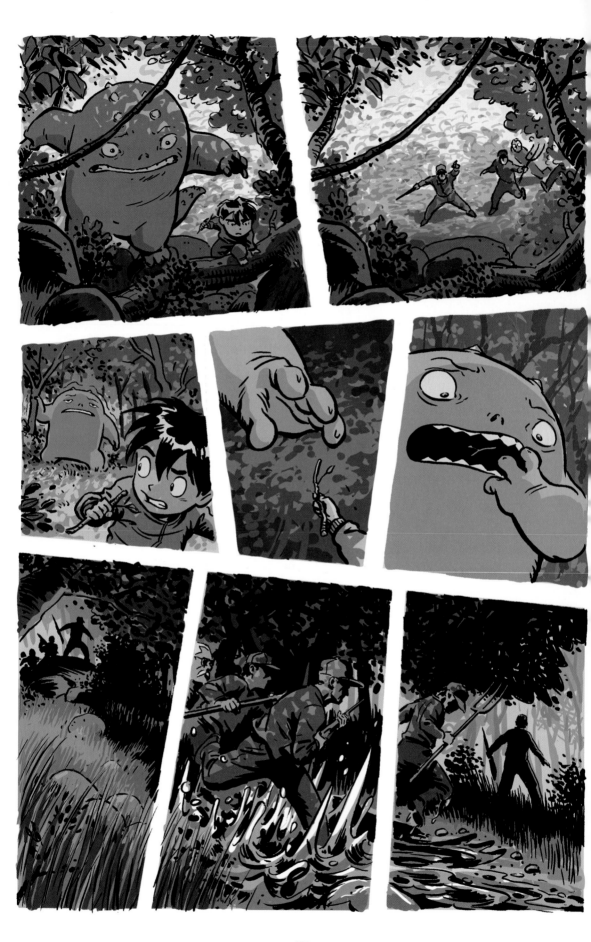

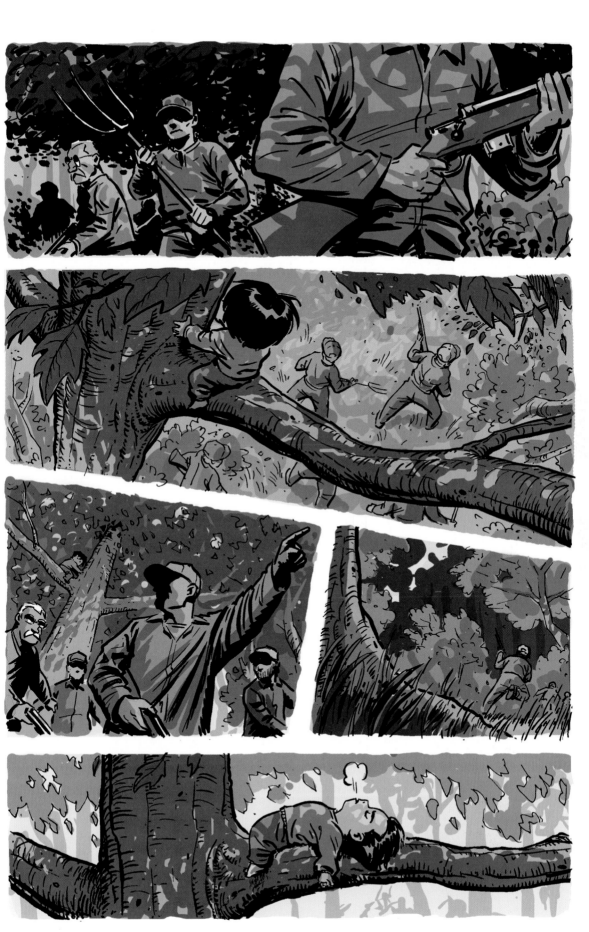

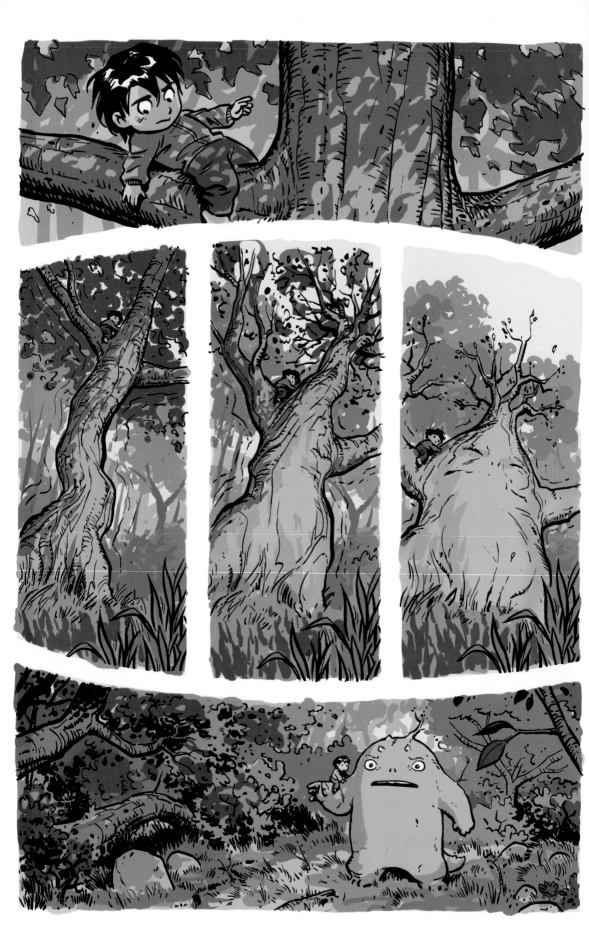

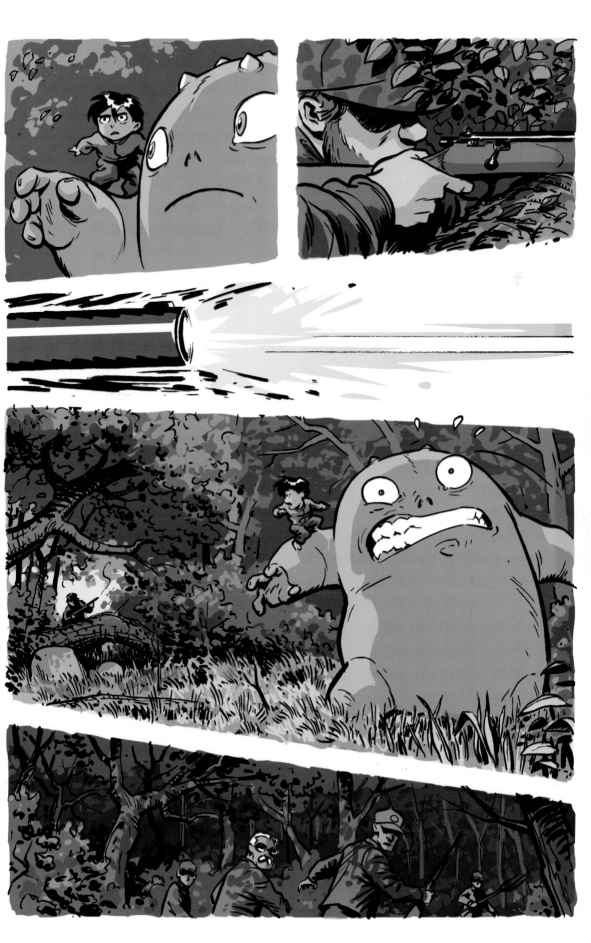

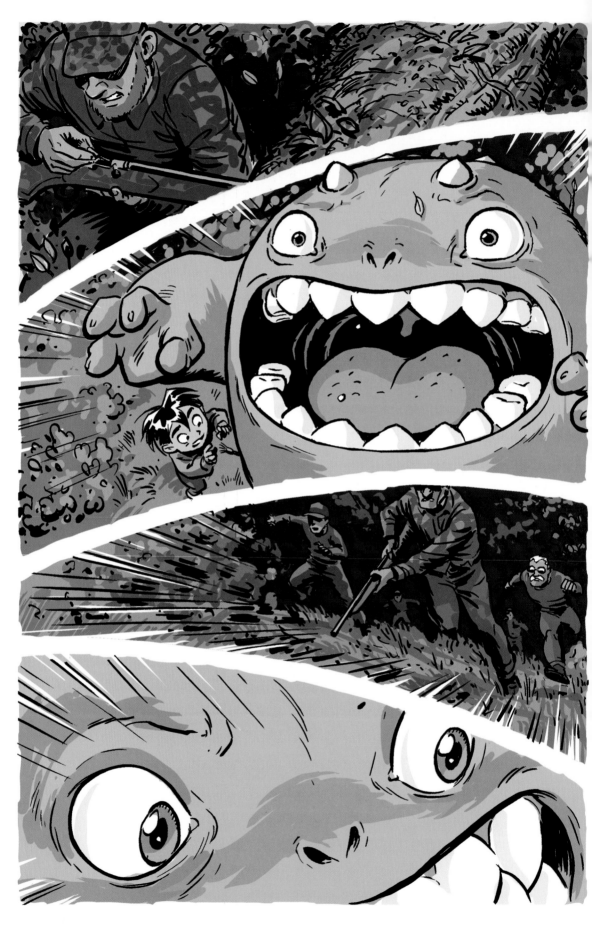

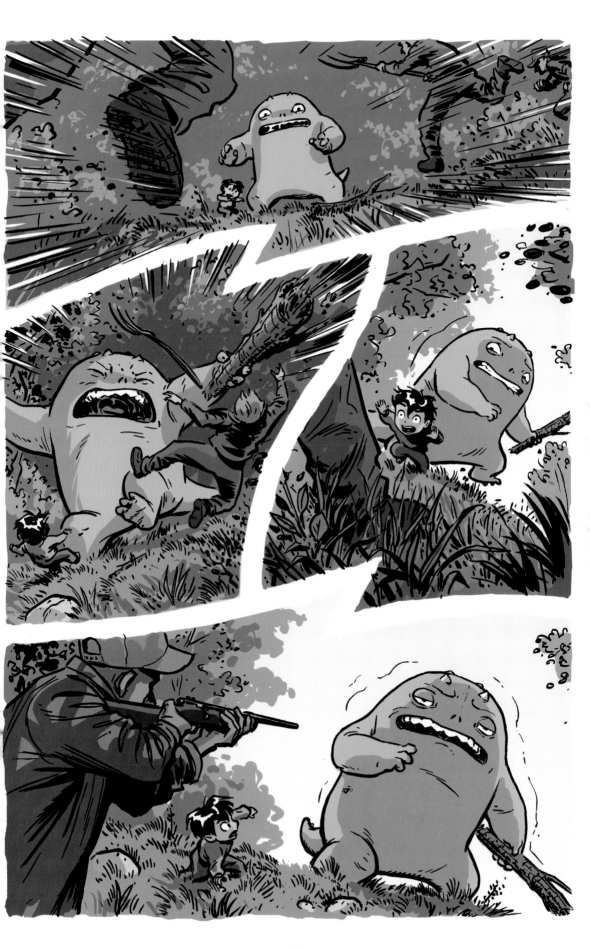

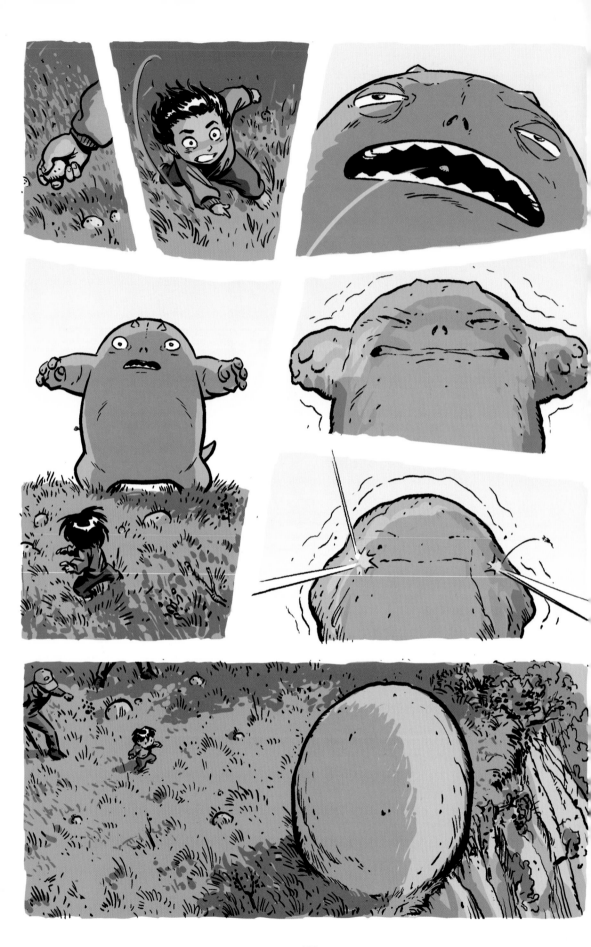

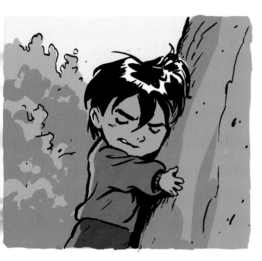
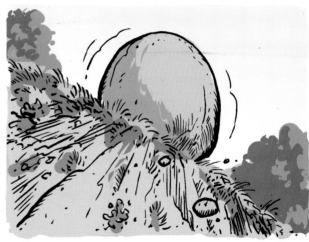
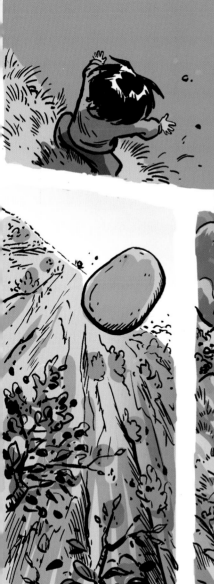
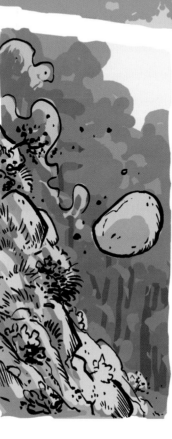

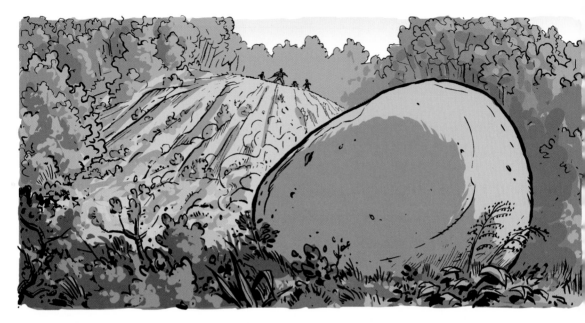

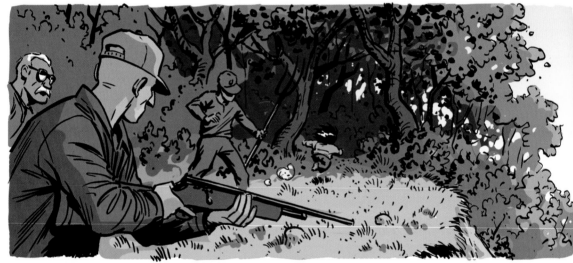

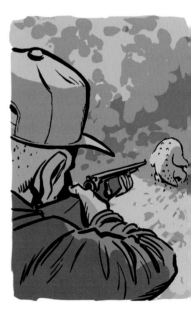

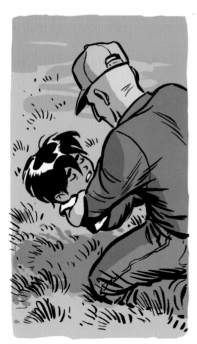
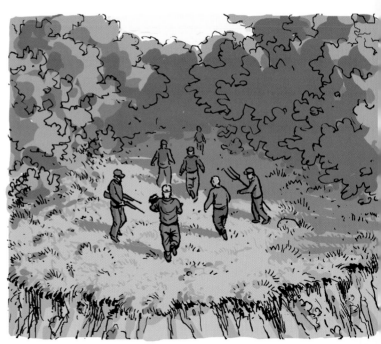

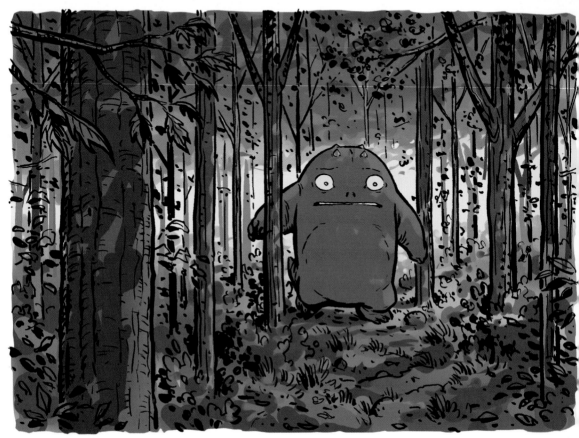

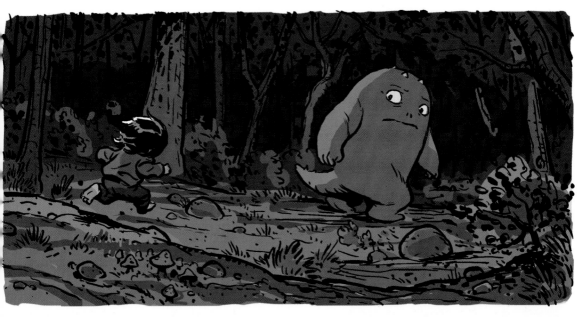

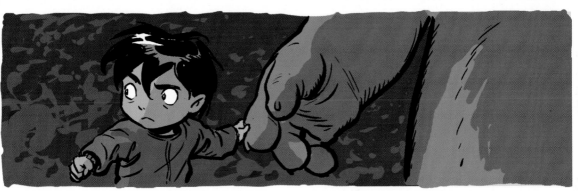

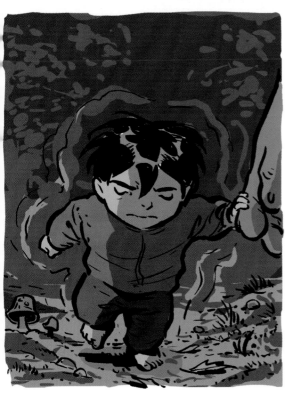

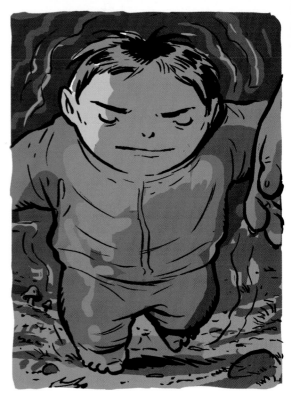

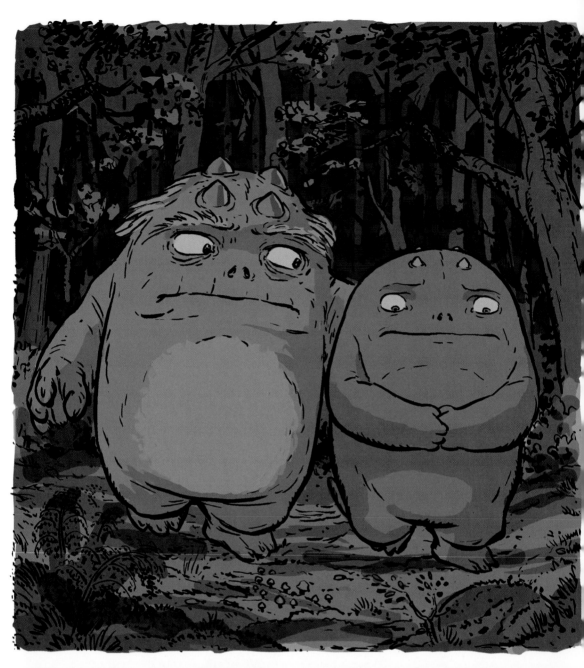

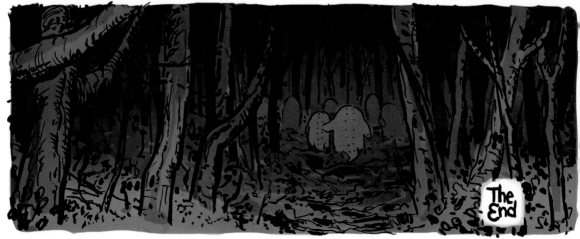

The End

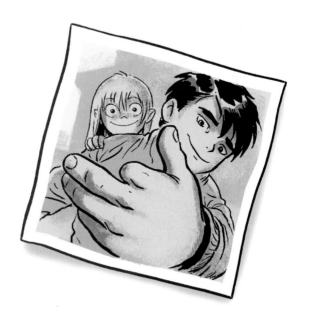

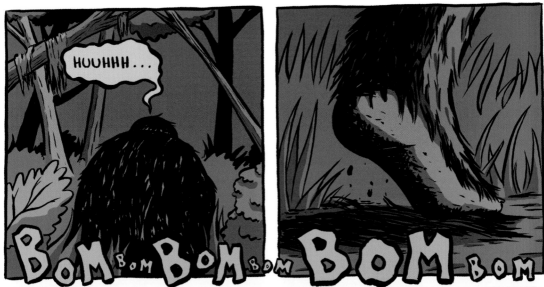

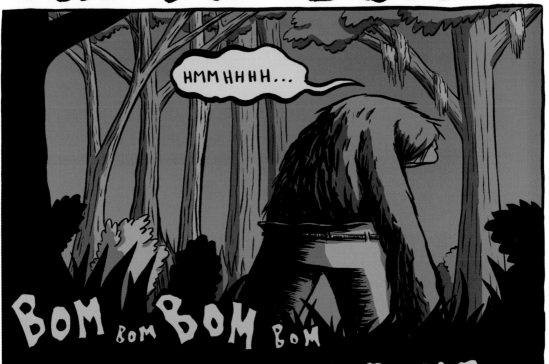

THE LUMBERING BEAST

by Joey Weiser

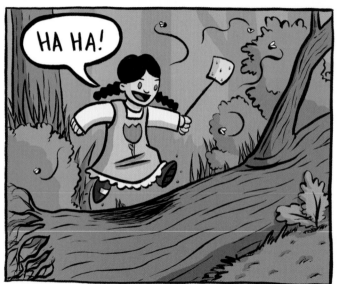

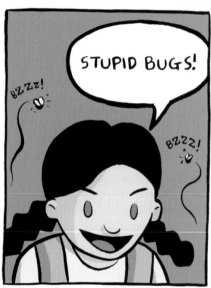

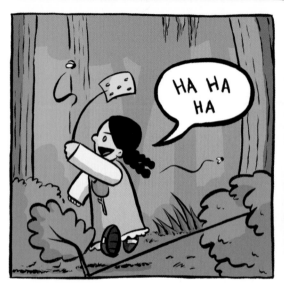

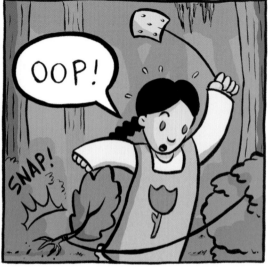

138

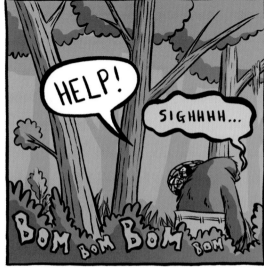

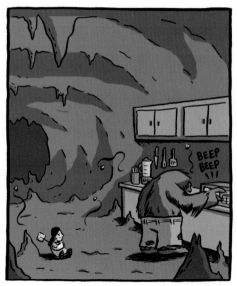

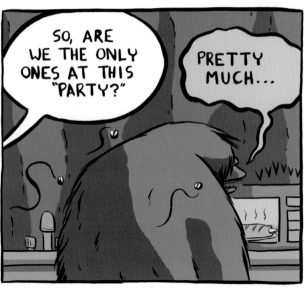

SO, ARE WE THE ONLY ONES AT THIS "PARTY?"

PRETTY MUCH...

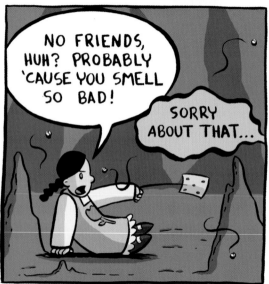

NO FRIENDS, HUH? PROBABLY 'CAUSE YOU SMELL SO BAD!

SORRY ABOUT THAT...

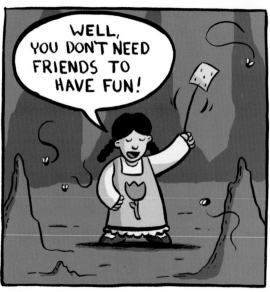

WELL, YOU DON'T NEED FRIENDS TO HAVE FUN!

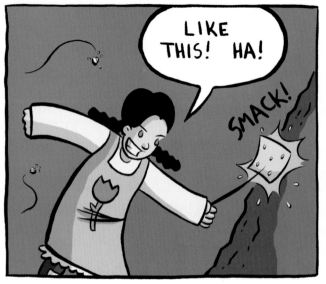

LIKE THIS! HA!

SMACK!

STOP THAT!!

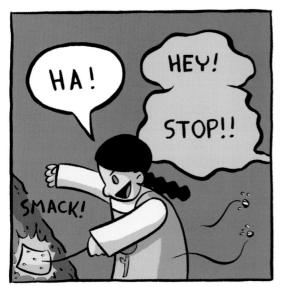

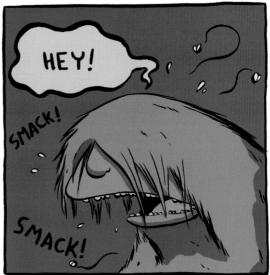

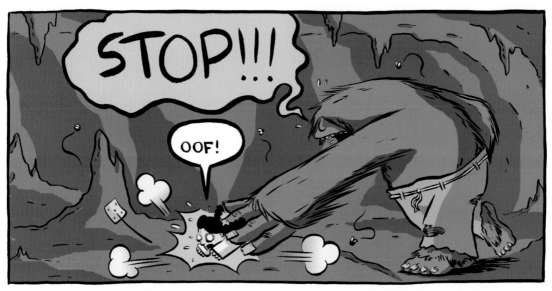

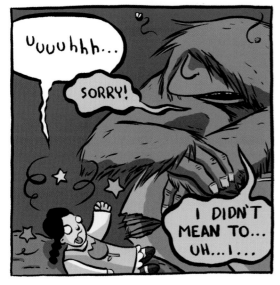

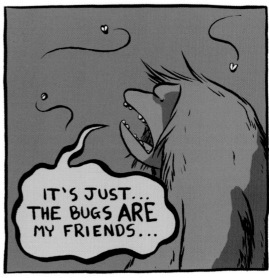

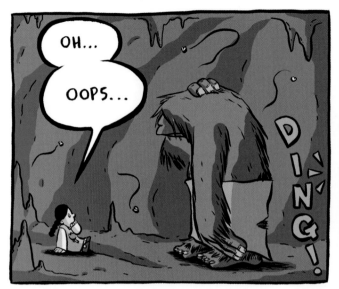

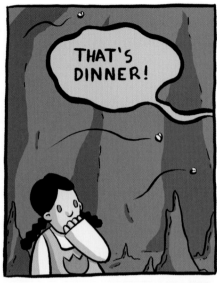

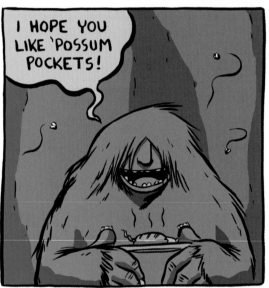

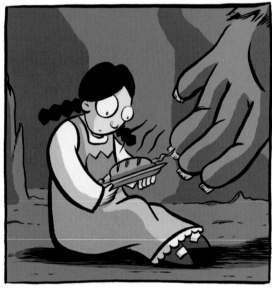

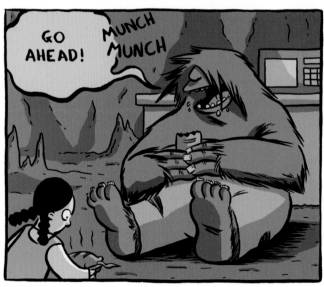

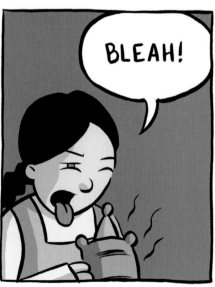

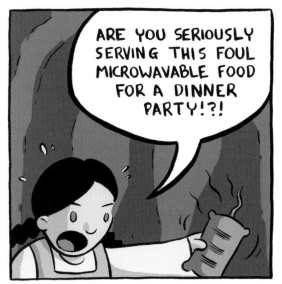

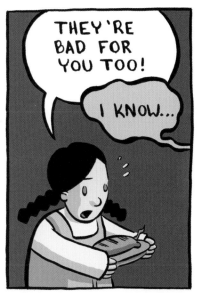

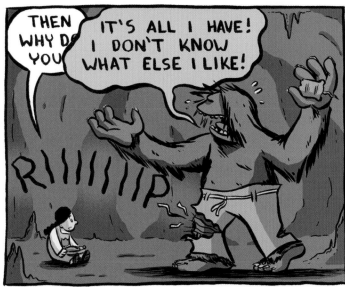

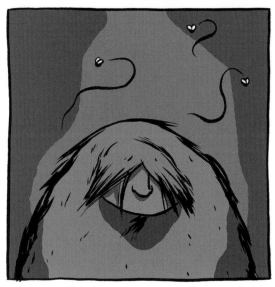

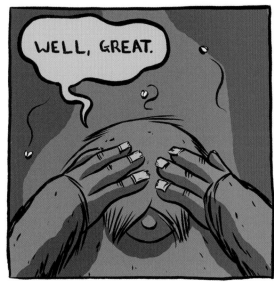

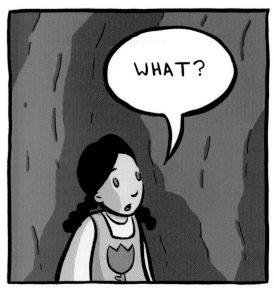

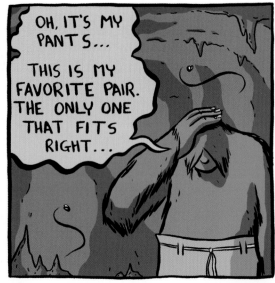

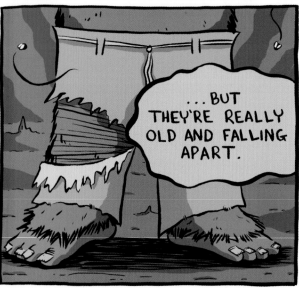

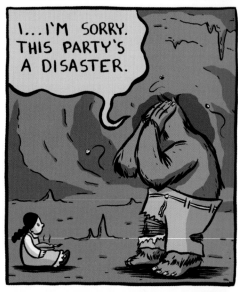

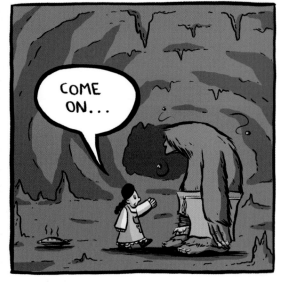

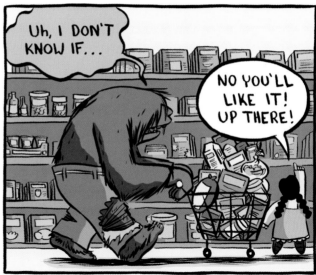

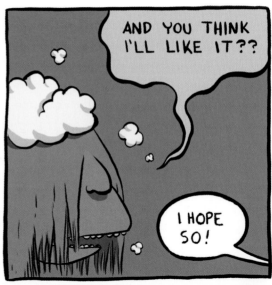

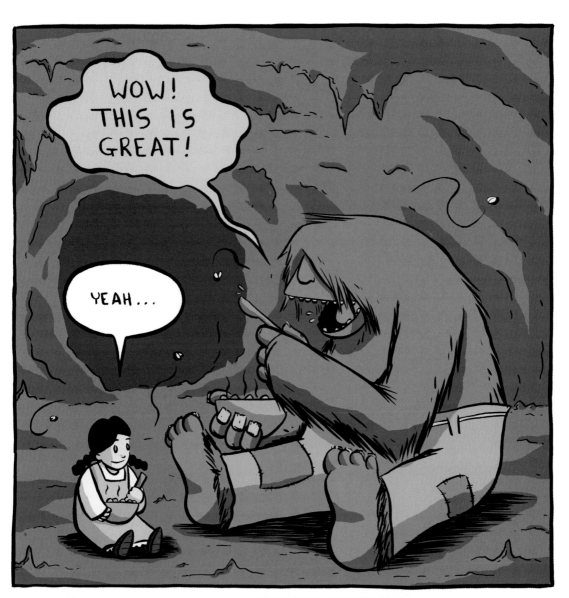

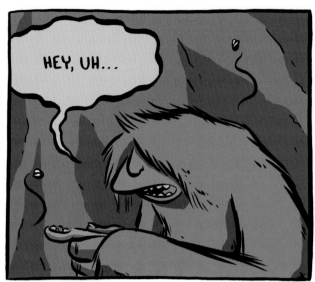

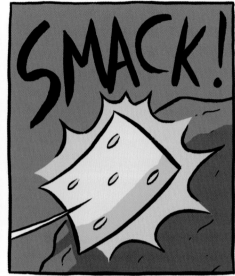

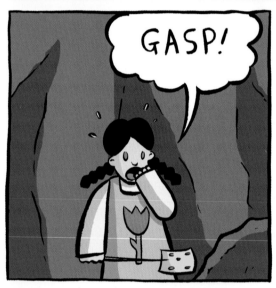

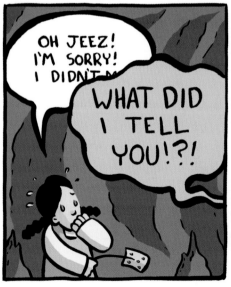

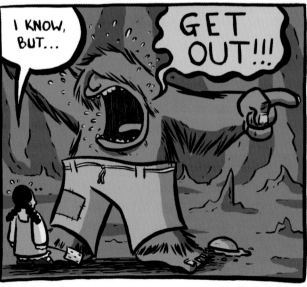

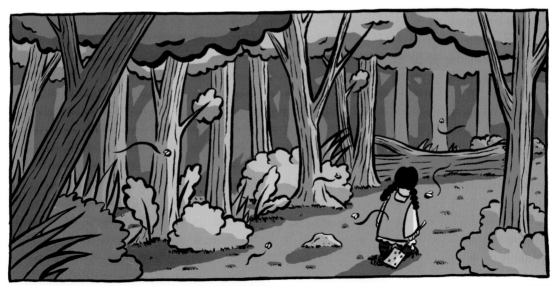

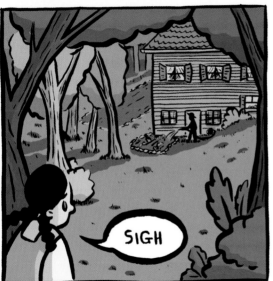

SIGH

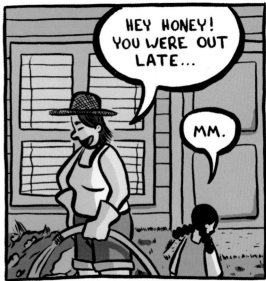

HEY HONEY! YOU WERE OUT LATE...

MM.

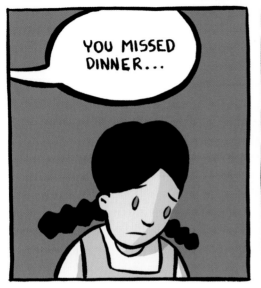

YOU MISSED DINNER...

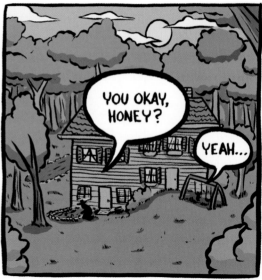

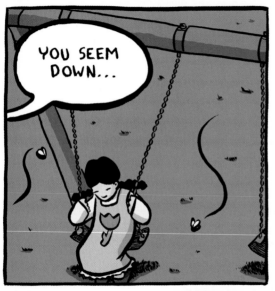

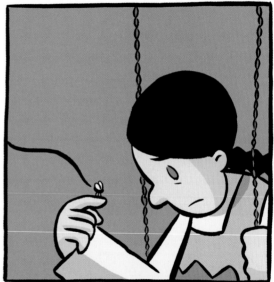

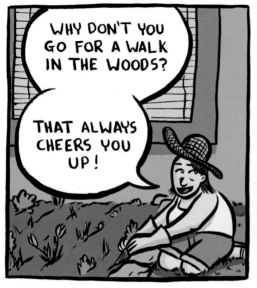

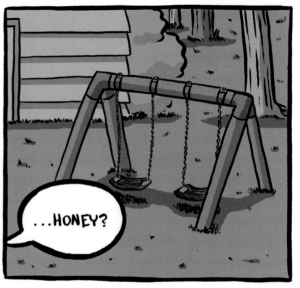

150

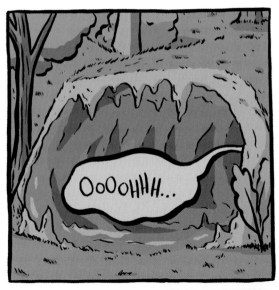

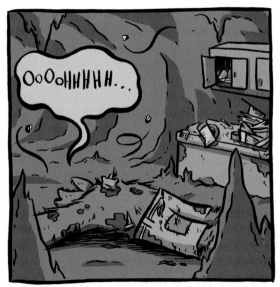

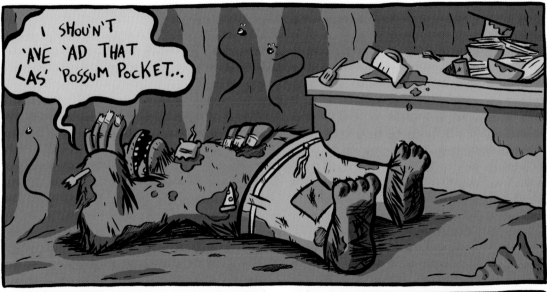

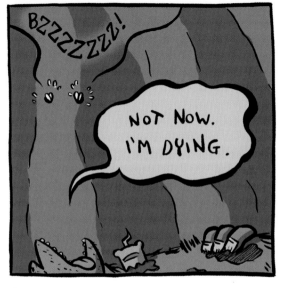

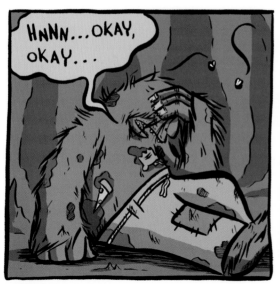

HNNN...OKAY, OKAY...

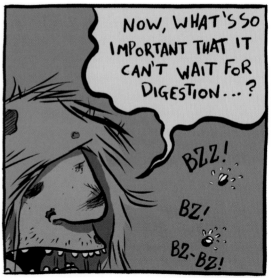

NOW, WHAT'S SO IMPORTANT THAT IT CAN'T WAIT FOR DIGESTION...?

BZZ!

BZ!

BZ-BZ!

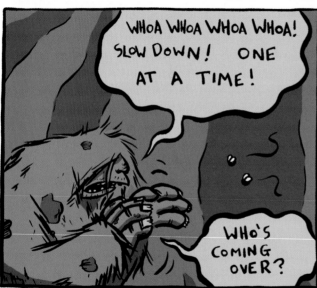

WHOA WHOA WHOA WHOA! SLOW DOWN! ONE AT A TIME!

WHO'S COMING OVER?

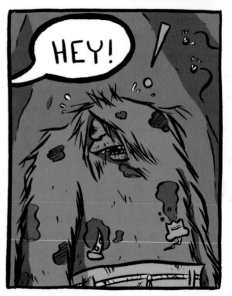

HEY!

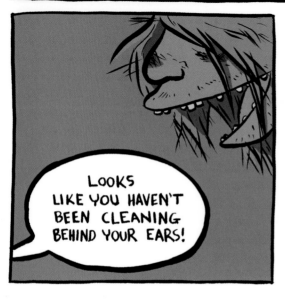

LOOKS LIKE YOU HAVEN'T BEEN CLEANING BEHIND YOUR EARS!

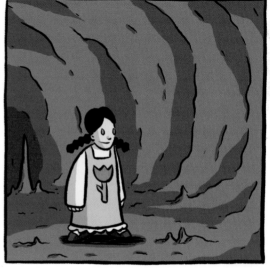

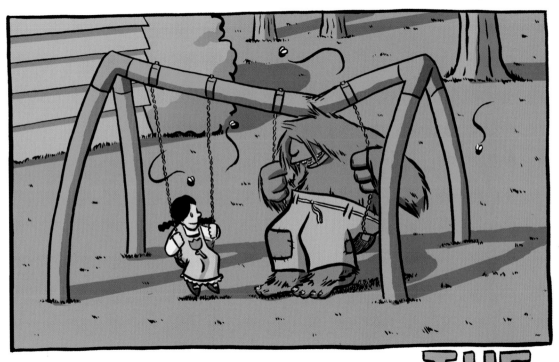

THE
END

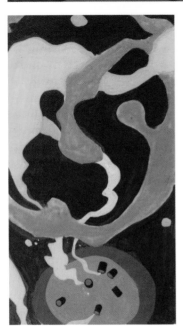

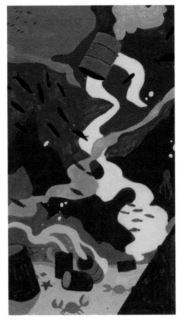

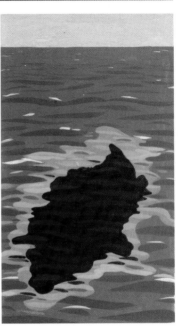

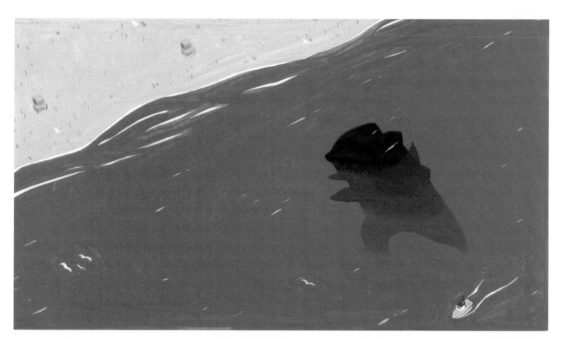

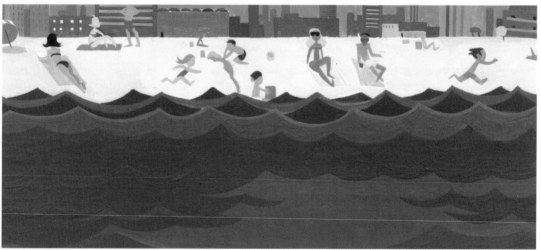

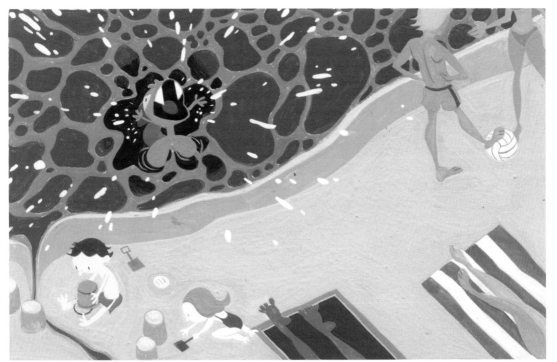

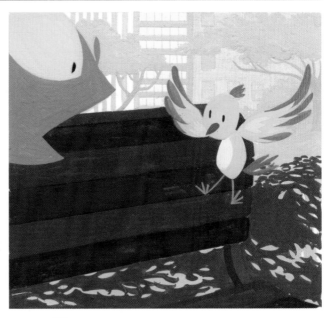

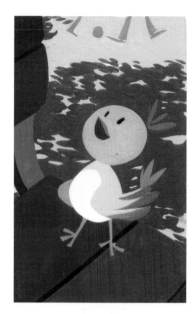

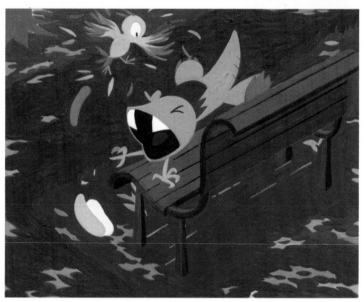
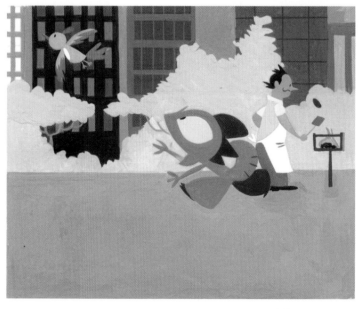
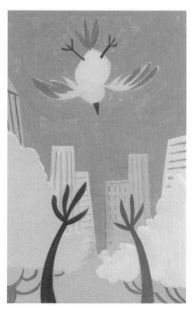

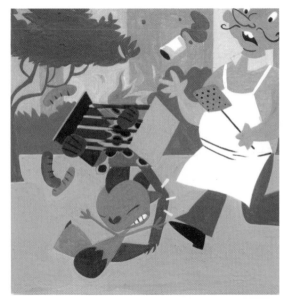

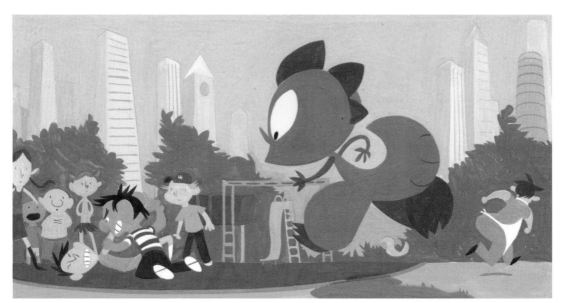

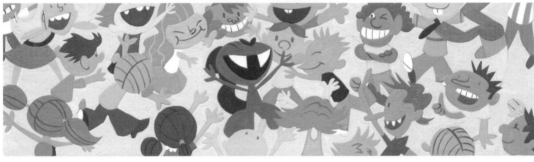

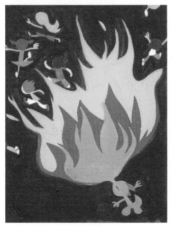

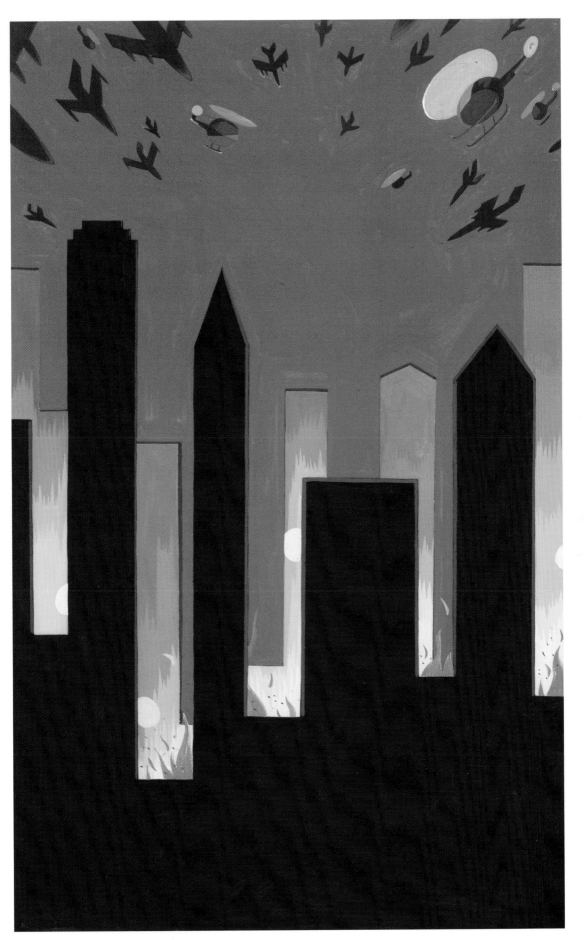

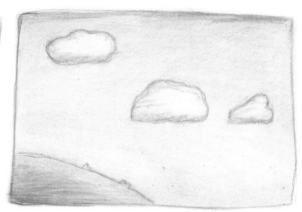

Everybody knows that clouds like to relax and bask in the sun during the day...

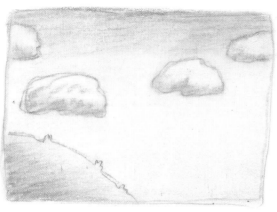

...and pretend they're just little puffs of vapor.

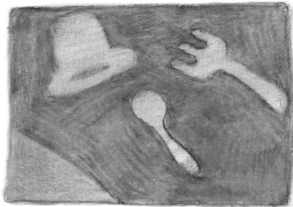

But it's a very well-kept secret that at night they playfully create wonderful images.

Of course, no humans ever see their wonderful artistry...

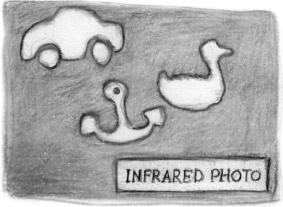

INFRARED PHOTO

...because it's dark and that's the way they like it.

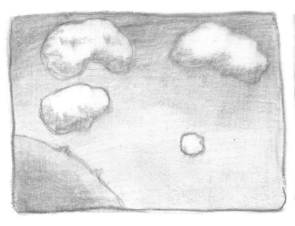

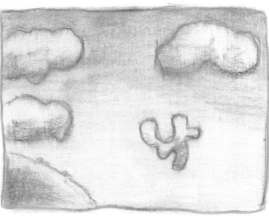

But one day, there appeared a new cloud...

...and even though he loved being a cloud, he felt different.

He didn't want to be confined by stuffy cloud rules.

He decided he wanted to play all day long.

This, of course, was strictly forbidden by the cloud code.

The elder clouds did not approve. "What kind of mayhem would result if all the clouds played all day?"

But the young cloud didn't care. He didn't want to hide his true feelings.

The elders called a council of all the cloud leaders. The cumulus was there...

...the stratus came...

...the nimbus arrived...

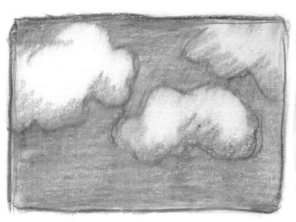

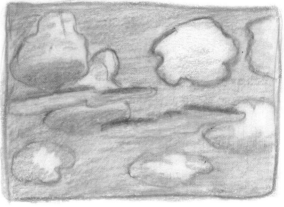

...and, of course, the cirrus was there.

"This will not do," said the cumulus. "Clouds were not meant to show off."

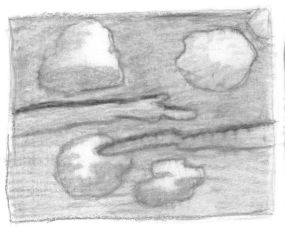

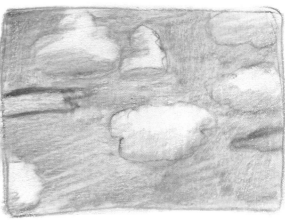

The stratus agreed, "He's not light and fluffy like us. He's weird!"

The nimbus chimed in, "We're supposed to provide rain and shade for the people, and that's it!"

"Yes," agreed the cirrus. "This rebel cloud must be stopped."

The cloud code being very important, they decided this young cloud must be taught a lesson.

And they had to hurry, because the wild cloud was drawing a crowd.

The nimbus immediately went into action.

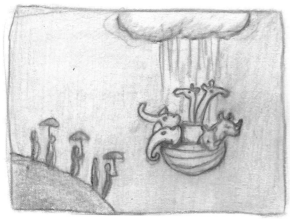

But the spunky cloud morphed into a fantastic re-creation of Noah's Ark.

The growing crowd was amused.

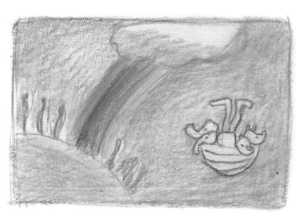

The cirrus took over. "I'll distract the audience."

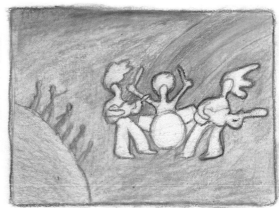

The resourceful cloud displayed an almost perfect image of a rock concert and light show.

The audience turned into a mosh pit of excitement.

The stratus moved in. "Enough of this playing around. I'll scatter this upstart to oblivion."

But the ever-imaginative cloud displayed a credible likeness of the cyclone scene from *The Wizard of Oz*.

The growing crowd thundered their pleasure.

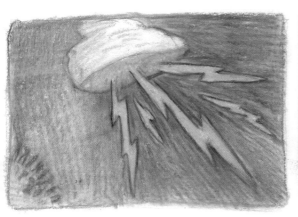

The cumulus had enough of this amateur cloud. "I'll disintegrate this upstart."

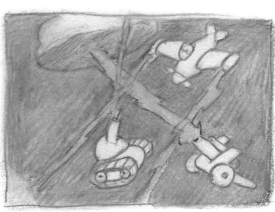

The plucky cloud produced the most amazing depiction of General Patton's famed attack at the Battle of the Bulge.

The cloud council, although amazed at his artistry, believed that rules are rules and...

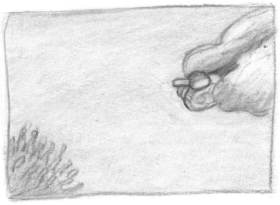

...they dragged the cloud far away from the cheering crowd.

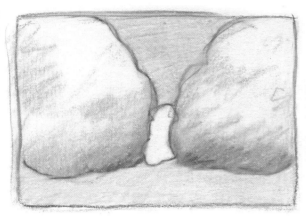

Where the two biggest cumulus clouds...

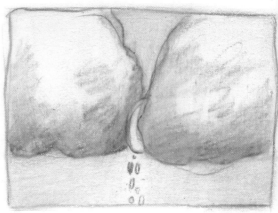

...squeezed the life out of him.

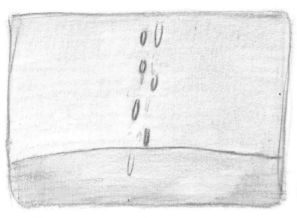

This was not something they enjoyed.
...well, maybe a little.

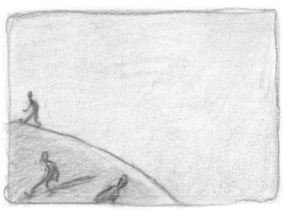

The people drifted away now that the sky
was empty and boring.

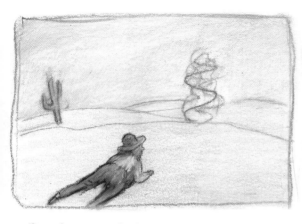

But if you ever find yourself in a certain part
of the desert, and think you see a mirage...

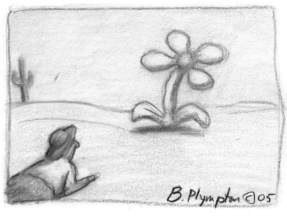

...it just might be the vapor of that
little rebel cloud.

Earl **D.**

by
Yoko Tanaka

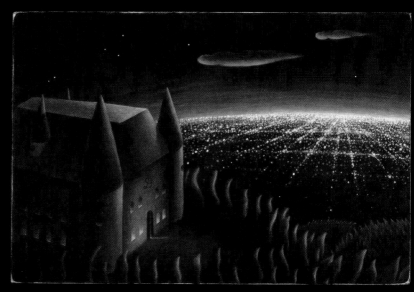

Earl D. left Europe 5 years ago and moved to a castle
on a hill in Los Angeles.

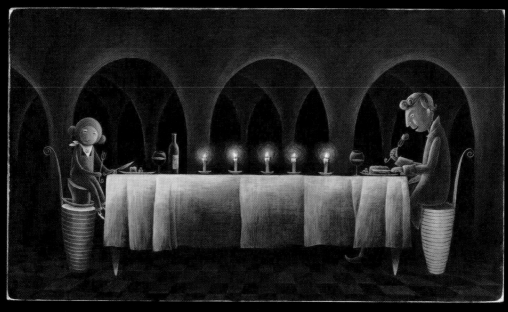

I'm his assistant, Gnocchi.
Tonight, we are going to the city to do our duty.
Because he is······

The Espresso Police !!

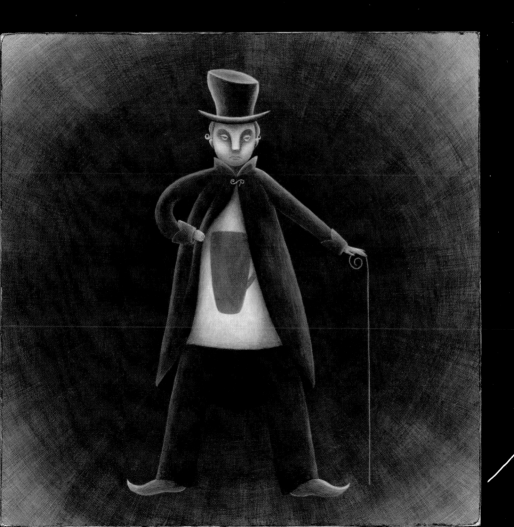

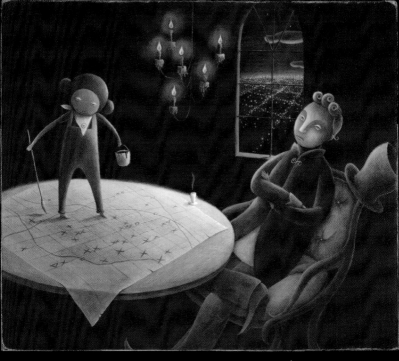

We visit all the coffee shops in Town
to check the Taste of their espresso.

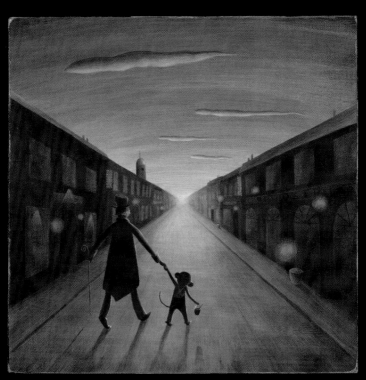

Tonight, we are visiting "Cafe Angelo".

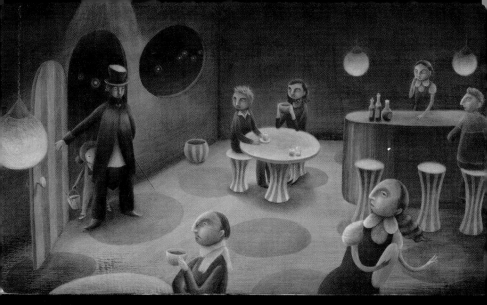

He enters the cafe

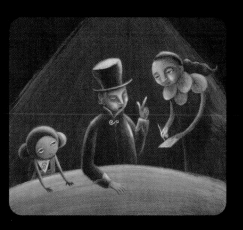

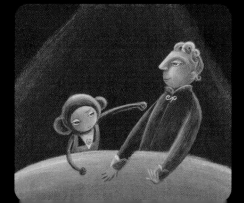

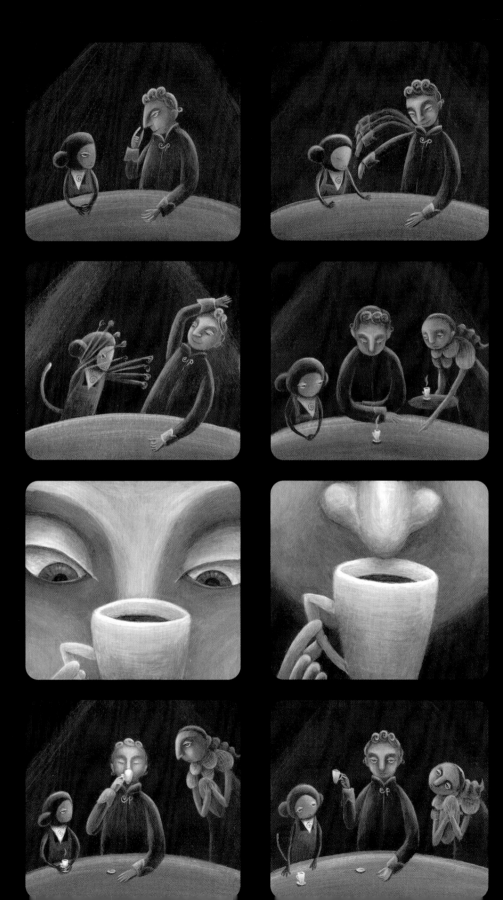

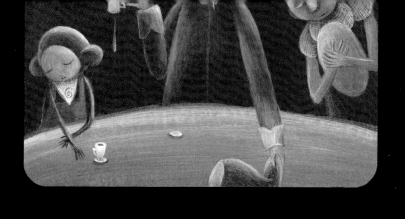

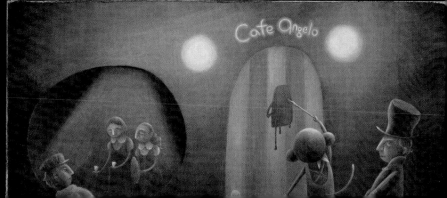

Cafe Angelo

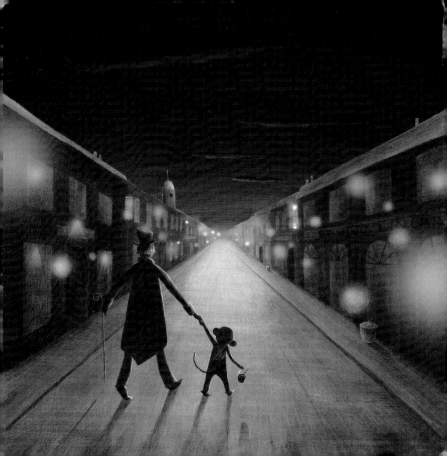

For
Daniel

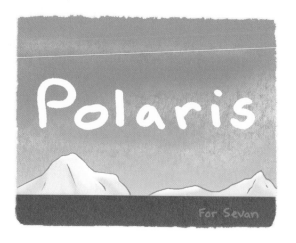

Polaris

For Sevan

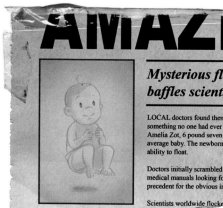

AMAZI

Mysterious floating baffles scientists fr

LOCAL doctors found themselves scra
something no one had ever seen in mo
Amelia Zot, 6 pound seven ounces was
average baby. The newborn had the unc
ability to float.

Doctors initially scrambled to fetch th
medical manuals looking for any possib
precedent for the obvious infrirmament.

Scientists worldwide flocked to the loca
investi

By Azad Injejikian

If not for the fact that she floated half a foot off the ground, Amelia Zot was an ordinary child.

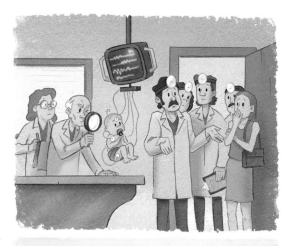

Eggheads from far and wide exhausted every avenue of scientific noodling trying to uncover what made her so unique, but were unsuccessful.

Amelia's mother worried greatly for her. Not because she was different, but because she understood all too well the world her daughter was born into.

By the time her first day of school arrived, her mother had done the best she could to prepare her for the slings and arrows she would face...

...but on that day, Amelia's head swam not with her mother's warnings, but with visions of playing with the other children.

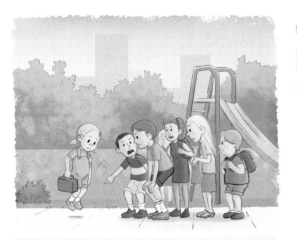

When her classmates circled around to greet her, they immediately recognized she was different from them.

Embarrassed and envious, they demanded that Amelia walk as they did.

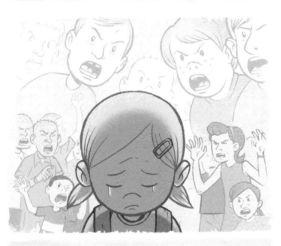

When she explained that she could not, they all (even the ugly freckled boy) teased and taunted her until she fled the grounds in tears.

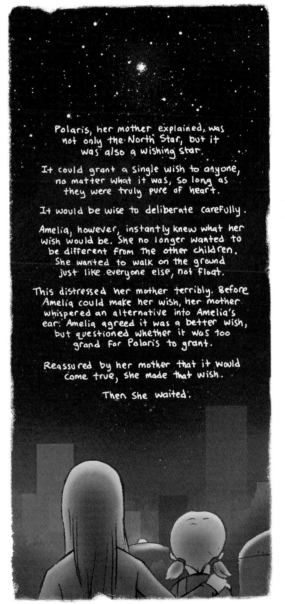

Polaris, her mother explained, was not only the North Star, but it was also a wishing star.

It could grant a single wish to anyone, no matter what it was, so long as they were truly pure of heart.

It would be wise to deliberate carefully.

Amelia, however, instantly knew what her wish would be. She no longer wanted to be different from the other children. She wanted to walk on the ground just like everyone else, not float.

This distressed her mother terribly. Before Amelia could make her wish, her mother whispered an alternative into Amelia's ear. Amelia agreed it was a better wish, but questioned whether it was too grand for Polaris to grant.

Reassured by her mother that it would come true, she made that wish.

Then she waited.

That night, Amelia's mother tried her best to console her. When all else failed, she directed her attention to the brightest object in the sky.

Exactly one year to the day, Amelia arrived home from school to find her mother excitedly pointing to the picture box.

Upon seeing the first image on the screen, Amelia understood just how truly great Polaris was.

Mankind had created a contraption that made it possible for people to fly. Now EVERYONE, not just Amelia, could float! No longer would she be different from the other children.

Her wish had been granted, just as her mother had promised.

It was the most wonderful day of her life.

the FLY BOY

v 1.062 beta

That night, Amelia dreamt she was a seagull, flying in a flock.

Overnight, the world had taken to the sky. Everyone and everything from cars to pets streaked the firmament with long trails of white.

Even Tommy the Tankboy had replaced his treads with a modified flying contraption. For a brief moment, Amelia felt utterly ordinary, which suited her fine.

But the ugly freckled boy made it perfectly clear to her that although everything was different, nothing had really changed.

For a month, Amelia did nothing but sulk. Her wish had been granted, yet she had never felt so alone. In her misery, she had not noticed that it had been raining the entire time.

When the water reached knee-high, Amelia's mother packed their bags and took to the streets, hoping one of the shuttles would rescue them.

After two days, all help ceased to arrive. Amelia and her mother had no choice but to take shelter in a floating dustbin hoping to ride out the storm.

It wasn't until they spotted Tommy that Amelia's mother realized it would be necessary to reach higher ground.

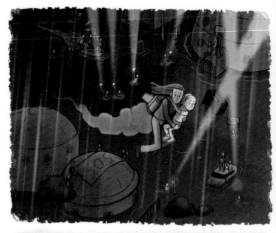

They went from rooftop to rooftop seeking sanctuary, but no one would show them kindness. One thug even plucked away their luggage with a long fishing pole.

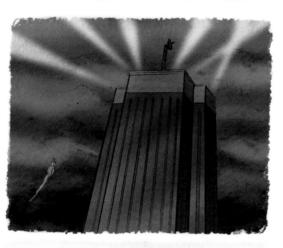

When they reached the tallest building in the landscape, they thought there would surely be room for them there.

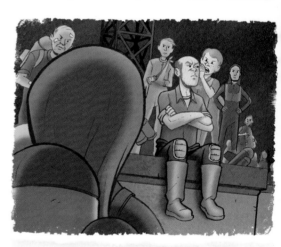

But their hopes were dashed when the ugly freckled boy whispered wicked things in his father's ear and convinced him to turn them away.

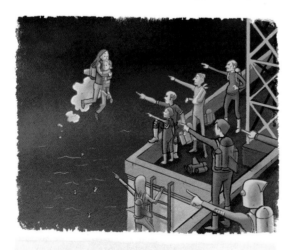

Unfairly, they were cast back out to sea.

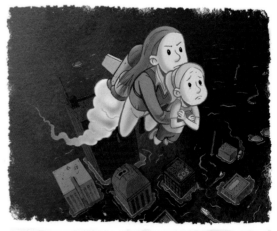

With no place left to turn, Amelia's mother did the only thing she could think of. She took Amelia as high as they could go. To Polaris if possible.

They came to a stop just above
the thick that blanketed the sky,
and could go no further.

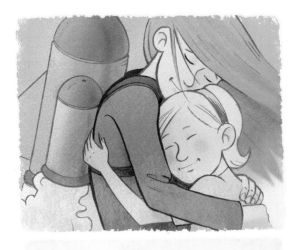

They hugged for what seemed
like an eternity.

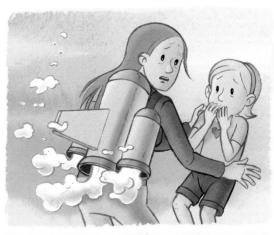

When the flying contraption coughed its
last icy breath, they held each other
tightly as they fell through the
clouds, down to the great below.

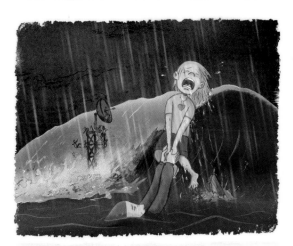

Amelia held on long after her mother had
passed away. Not even the tidal waves
that washed away the last of the
survivors could break her grip.

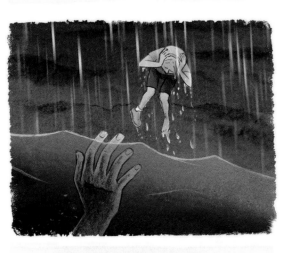

Only when her hands went numb
from the cold and fatigue did she
and her mother finally part.

And for the first time in her life,
Amelia truly WAS alone.

That night, Amelia spotted Polaris through a break in the clouds.
She knew quite well that she had spent her one and only wish,
but fervently made a second, hoping Polaris would oblige.

Then, she waited.

Gone were the snow-capped mountains and towering skyscrapers that dotted the horizon.
They had long since been replaced by the flat line of the ocean where it met the sky.
The sole blip on the surface of the watery desert was Amelia.

Every night for an entire year, she followed the North Star, hoping
that its singular direction would lead her to her heart's desire.
She counted the days with great anticipation, believing
full well that Polaris would be benevolent.

When the day finally arrived, it came as a great disappointment
to her that all Polaris offered forth was a seagull
taking shade under an arctic monolith.

It most certainly was not what
she had wished for.

Exhausted, Amelia decided to rest there.
Her cracked and sunburnt skin could at
least find refuge from the unrelenting
rays of the sun in the shade.

Soon, she lost herself in its
cool embrace and fell into
a deep sleep.

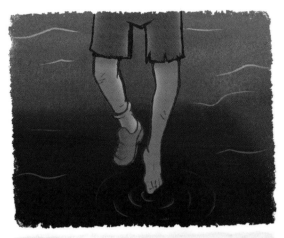

So deeply she dozed that she did
not feel the ocean when it swelled
to tickle her toes.

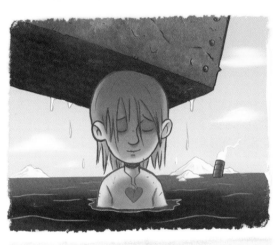

Nor did she awake when it rose to
her knees, her belly button,
and then her chin.

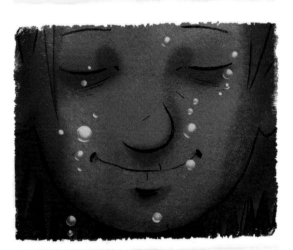

As it overtook her completely, Amelia smiled.
Polaris proved herself not only great,
but compassionate when she granted
Amelia's second wish.

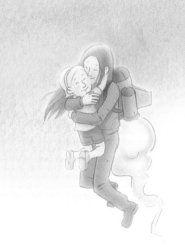

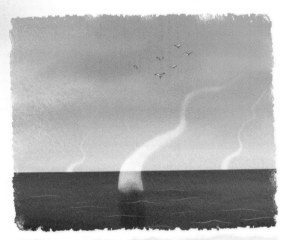

Not long afterwards, the remaining landscape
surrendered to the ocean, and rightfully,
the last traces of mankind with it.

The seagulls did just fine.

In Due Time

I've been crammed alone in trains and
classrooms for weeks. But tonight,
Kunal stopped by to see how I'm doing.
He said, "Don't be nervous."

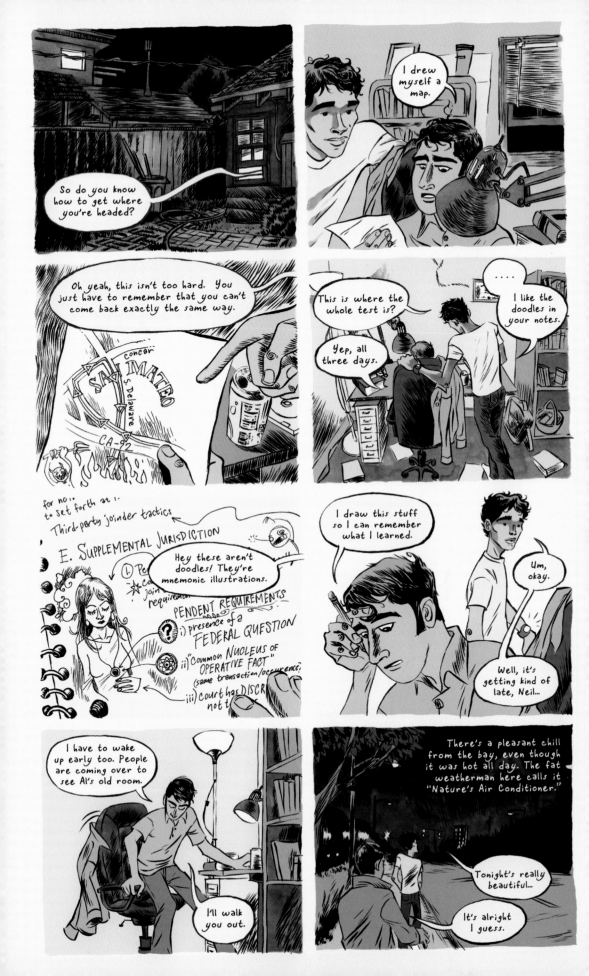

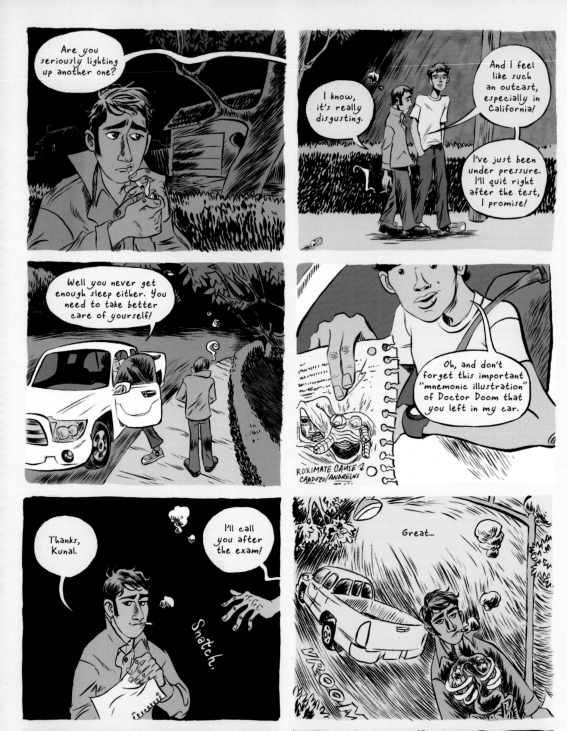

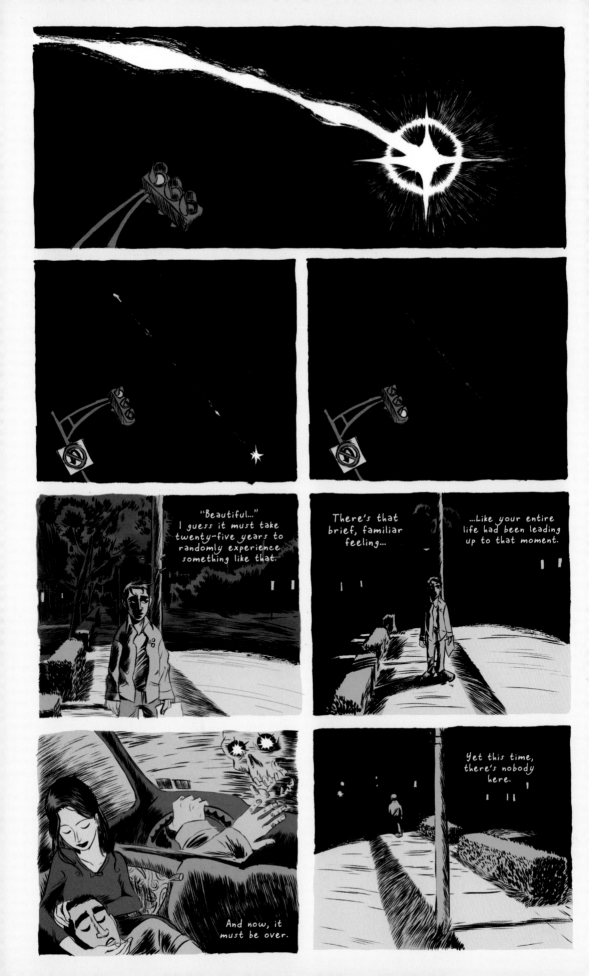

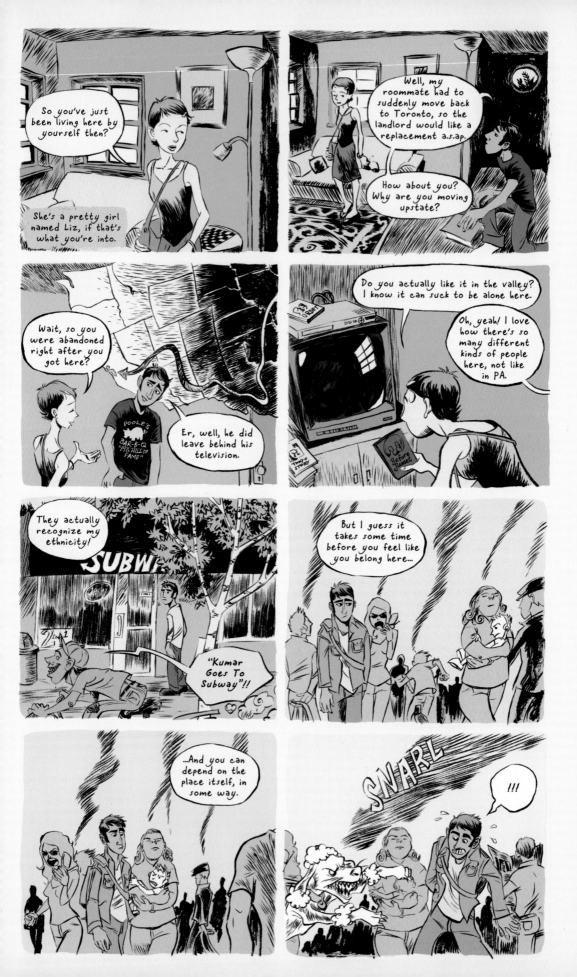

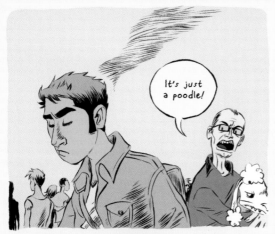

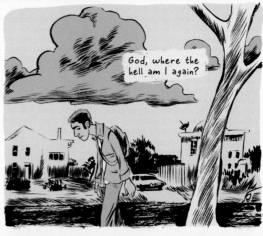

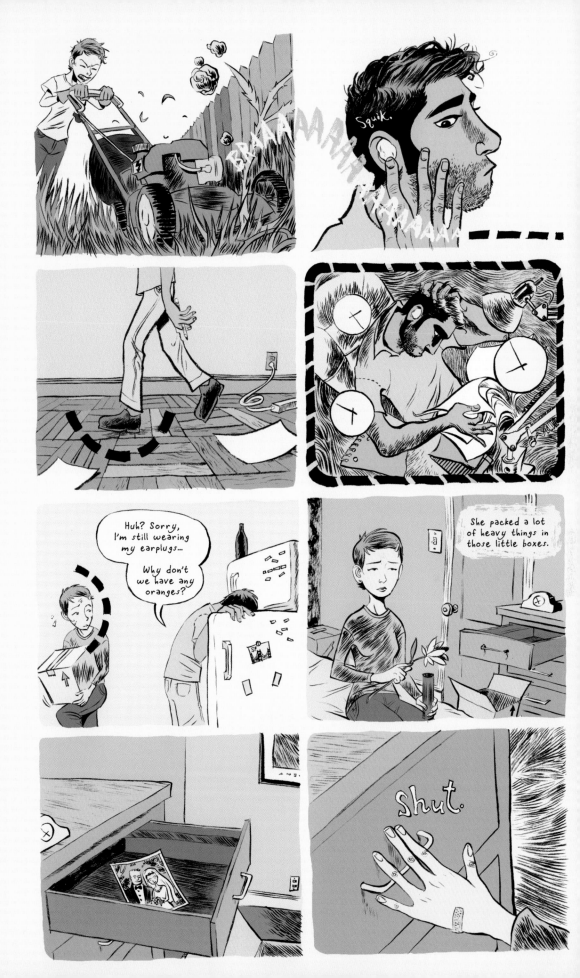

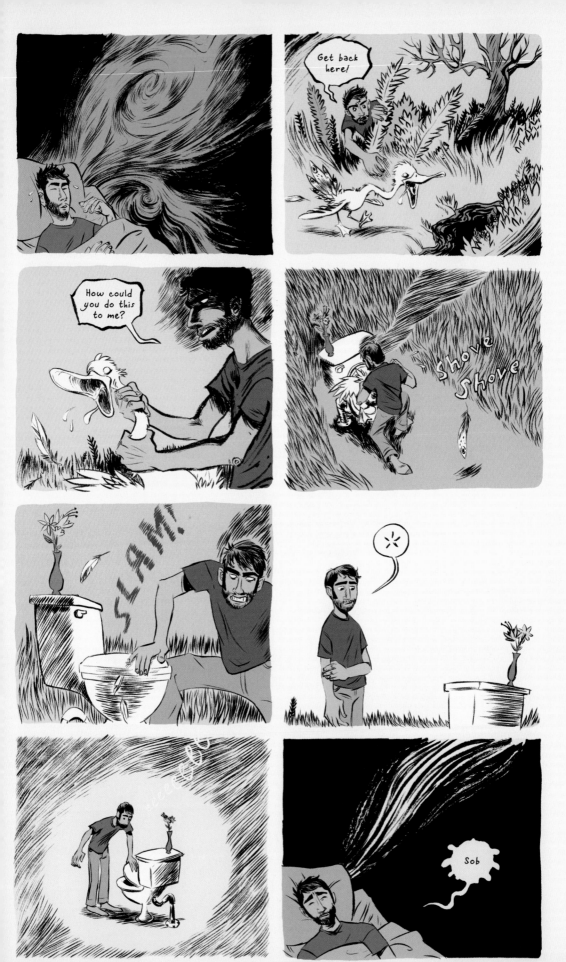

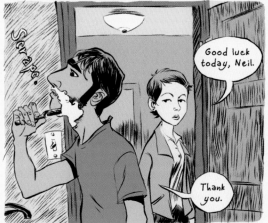

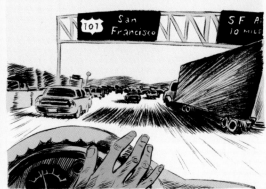

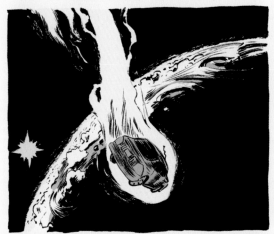

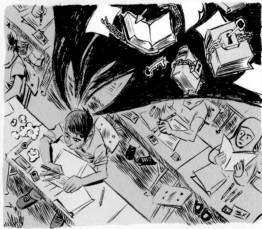

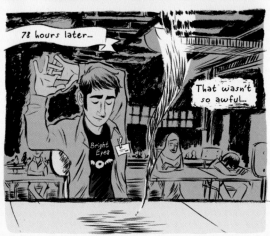

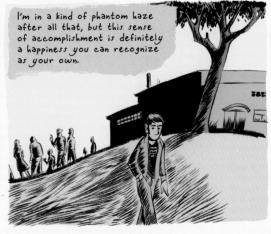

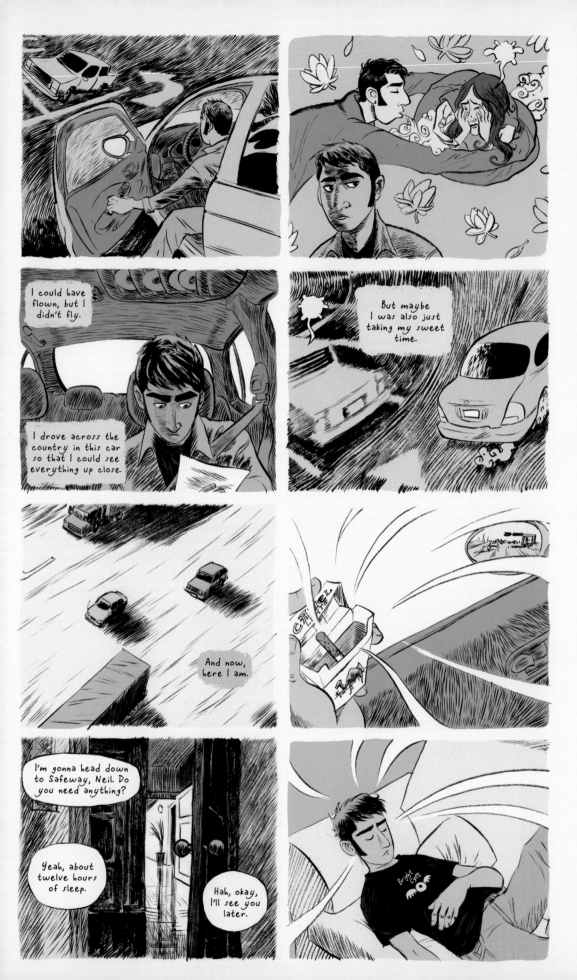

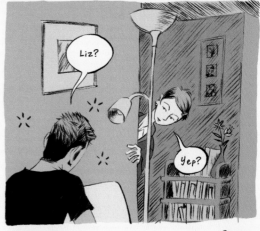

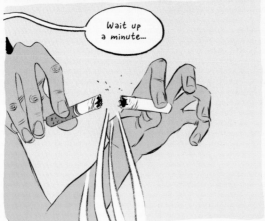

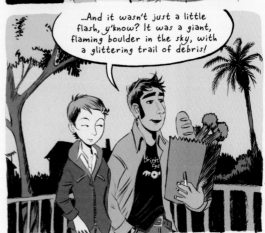

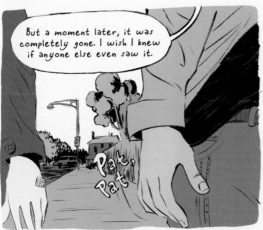

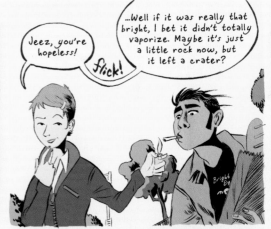

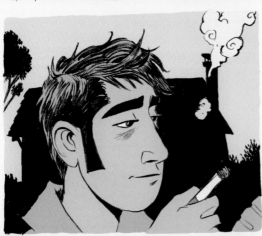

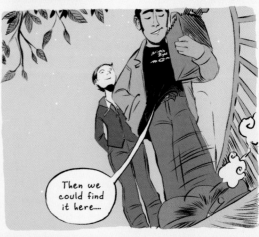

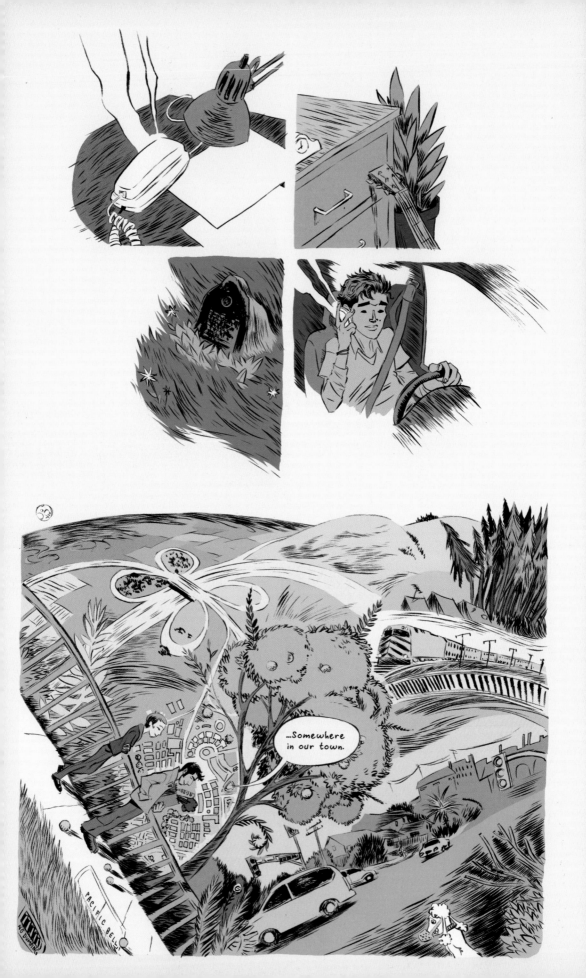

Written & Illustrated by
Neil Babra

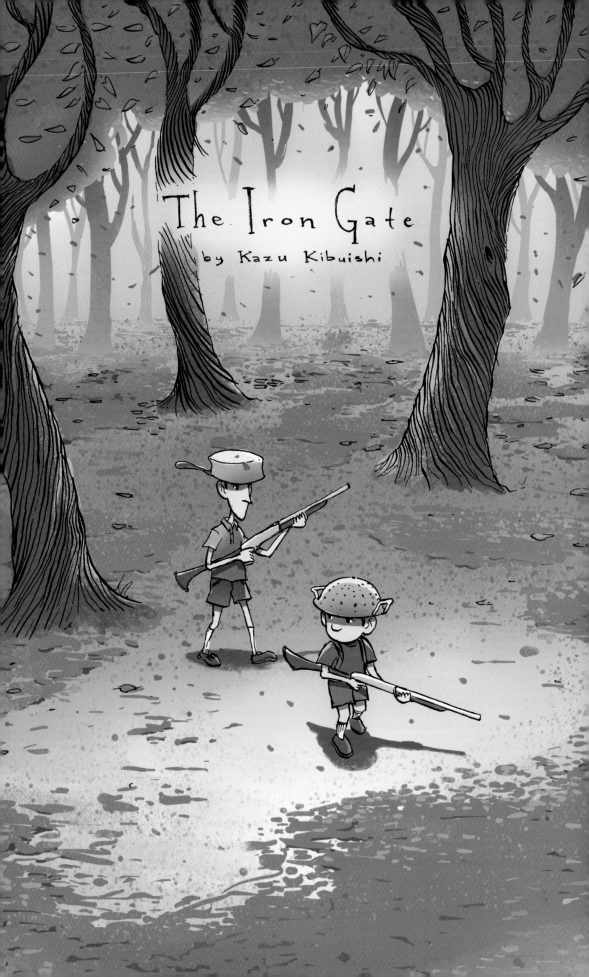

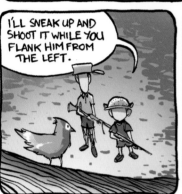

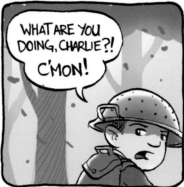

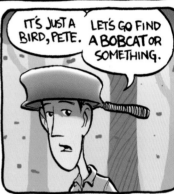

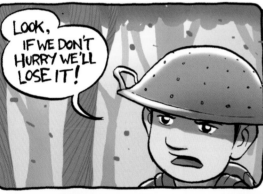

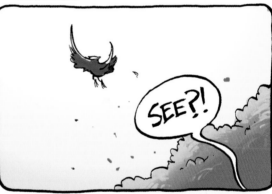

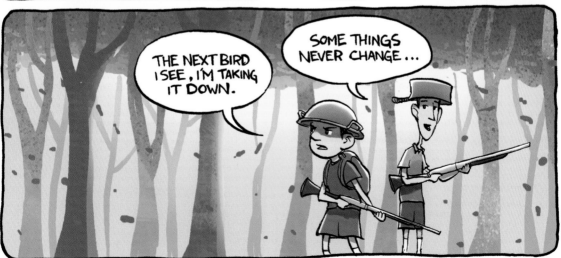

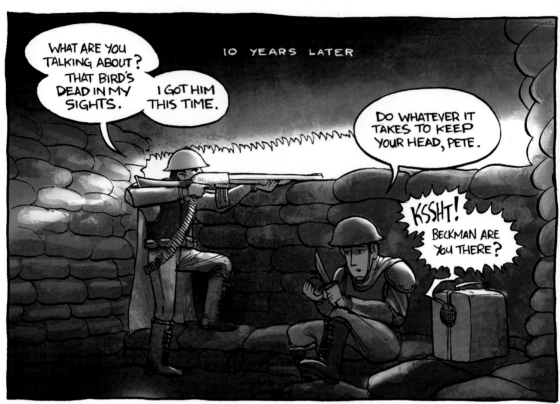

10 YEARS LATER

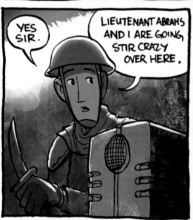

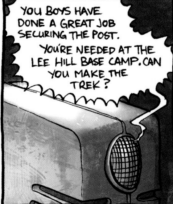

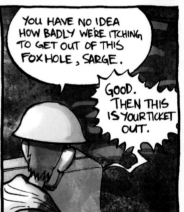

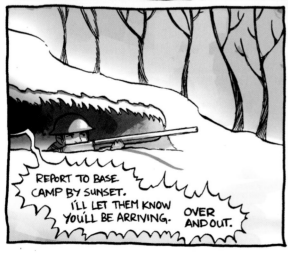

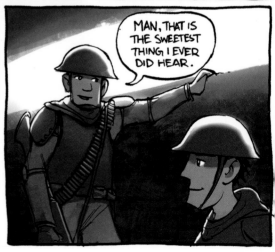

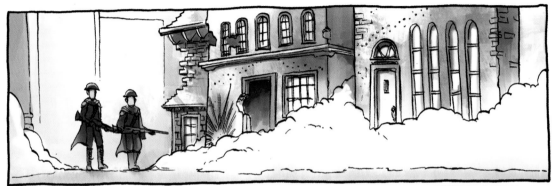

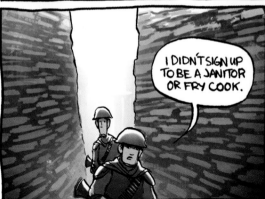

I'LL BET THEY JUST WANT US TO CLEAN MORE TOILETS WHEN WE GET THERE.

WHY IS IT WE NEVER SEE ANY OF THE ACTION?

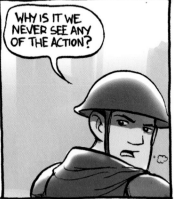

I CAME OUT HERE FOR THE ADVENTURE, MAYBE GAIN A LITTLE PERSPECTIVE.

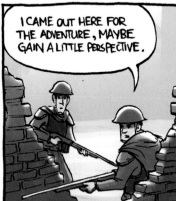

I DIDN'T SIGN UP TO BE A JANITOR OR FRY COOK.

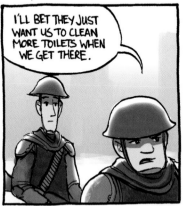

I THOUGHT COMING OUT HERE I'D ESCAPE THOSE KINDS OF MENIAL JOBS, AND DO SOME REAL WORK. FOR OUR COUNTRY.

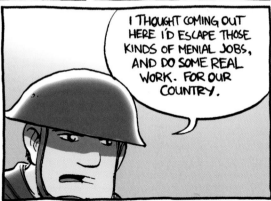

PETE, THE ONLY DIFFERENCE BETWEEN WHAT WE'RE DOING HERE AND WHAT WE DO BACK HOME IS THAT WE'RE ON THE OTHER SIDE OF THE WORLD AND WE GET SHOT AT. ASIDE FROM THAT, IT'S JUST ANOTHER JOB.

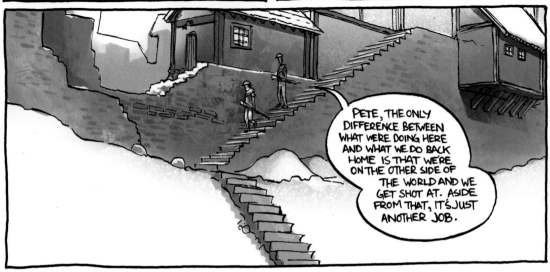

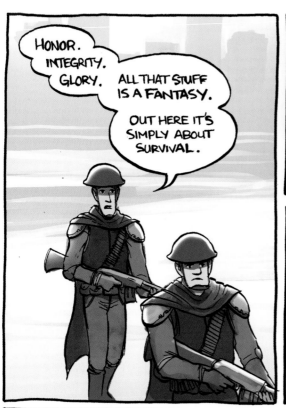

HONOR. INTEGRITY. GLORY. ALL THAT STUFF IS A FANTASY.

OUT HERE IT'S SIMPLY ABOUT SURVIVAL.

YOU'VE SEEN TOO MANY MOVIES, PETE.

NOW HOLD IT RIGHT THERE.

I DIDN'T GET THESE BADGES IN A FANTASY, CHARLIE! THIS IS REAL. IT AIN'T NO MOVIE.

HONOR IS A STATE OF MIND.

WHAT YOU CONSIDER "FANTASY" IS VERY REAL TO ME.

I DON'T KNOW ABOUT YOU, BUT I BELIEVE IN PROTECTING YOU AND ANYONE ELSE IN MY UNIT, EVEN IF I DIE TRYING.

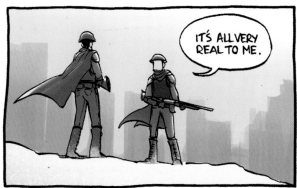

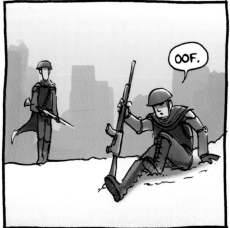
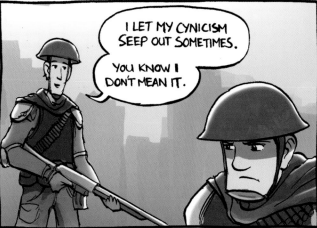

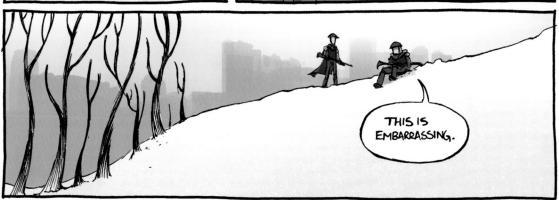

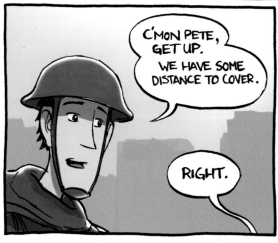
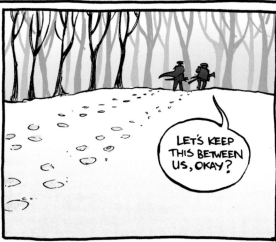

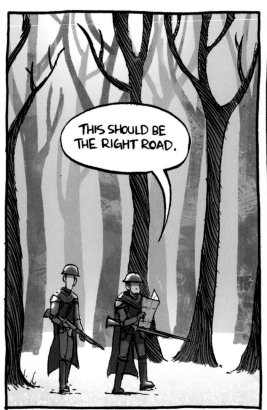

THIS SHOULD BE THE RIGHT ROAD.

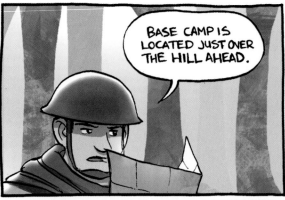

BASE CAMP IS LOCATED JUST OVER THE HILL AHEAD.

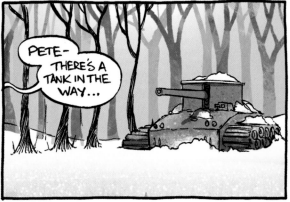

PETE— THERE'S A TANK IN THE WAY...

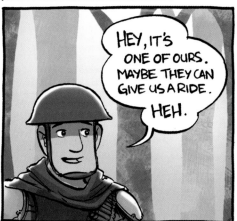

HEY, IT'S ONE OF OURS. MAYBE THEY CAN GIVE US A RIDE.

HEH.

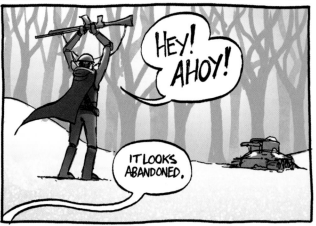

HEY! AHOY!

IT LOOKS ABANDONED.

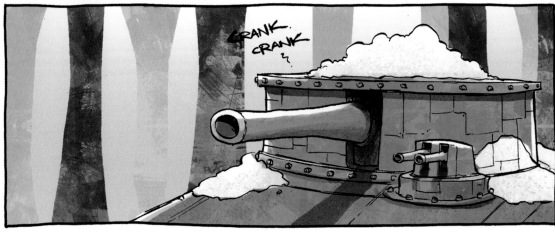

CRANK. CRANK

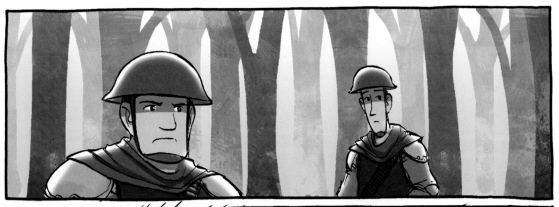

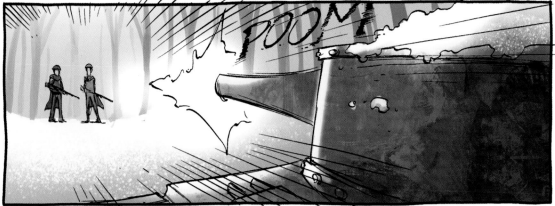

POOM!

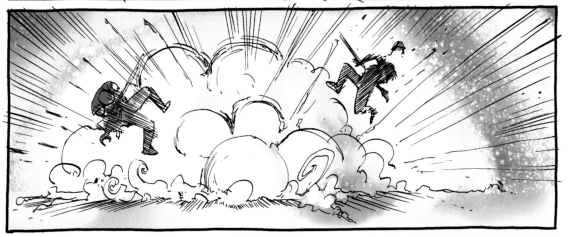

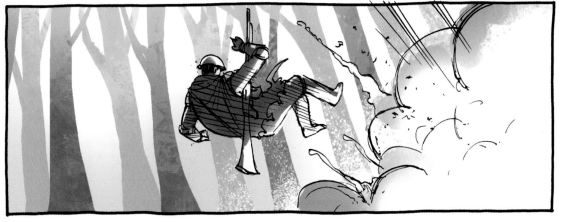

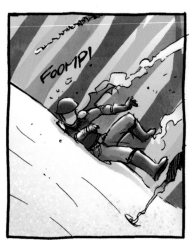

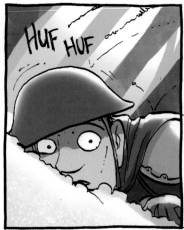

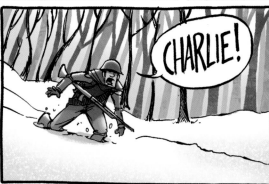

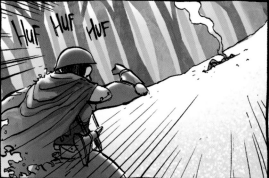

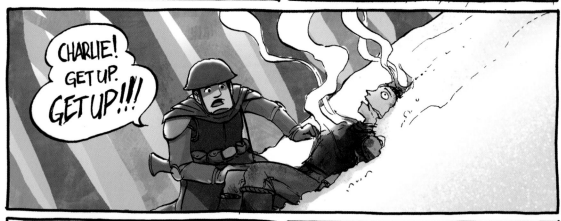

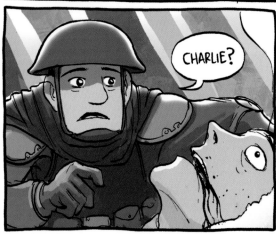

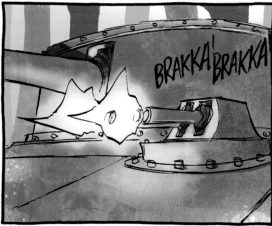

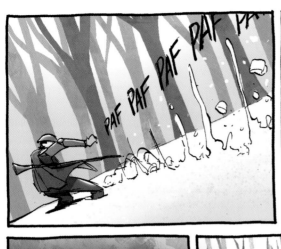
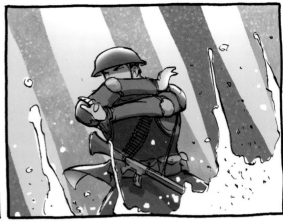

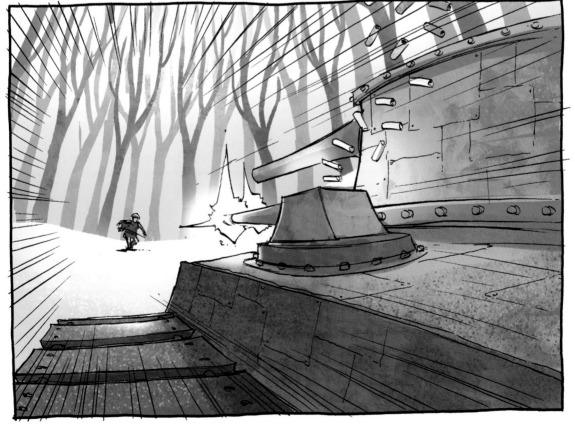

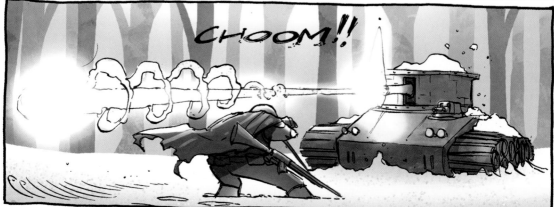

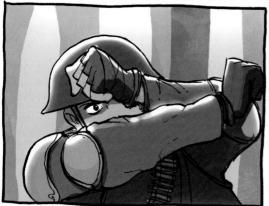

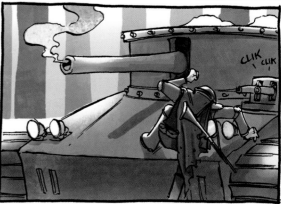

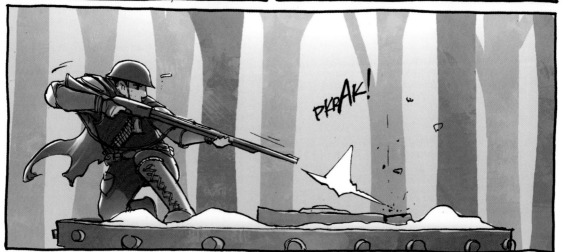

GRAAH!

KCHUNK!

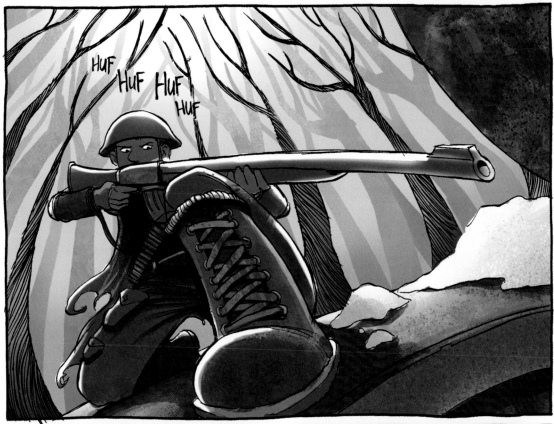

HUF HUF HUF HUF

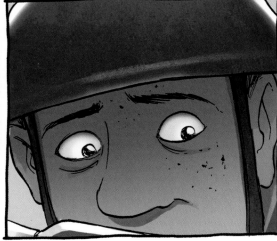

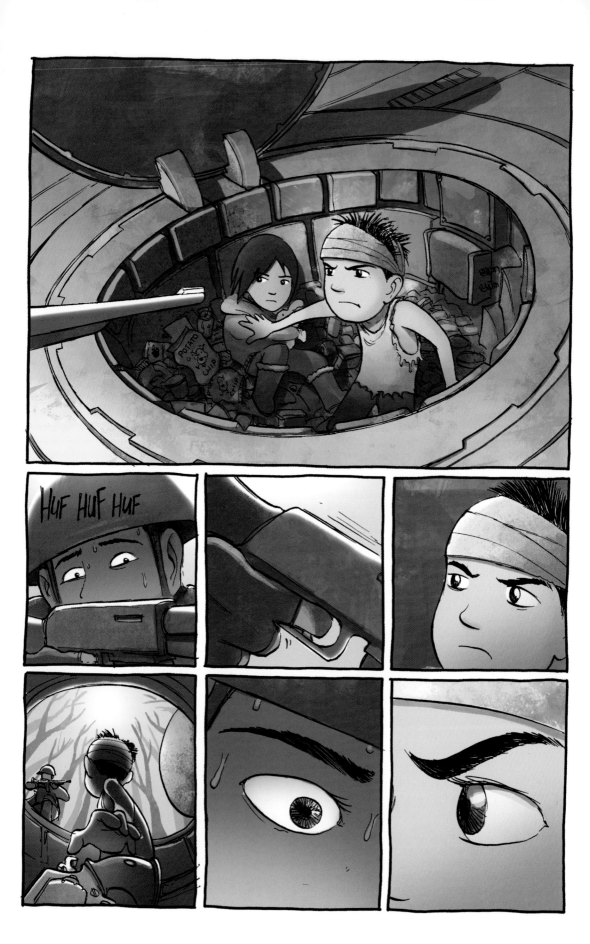

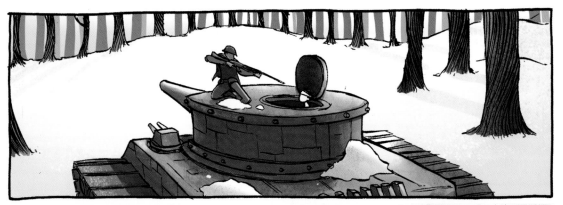

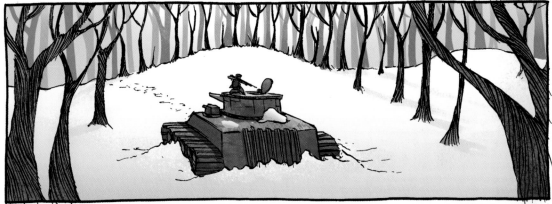

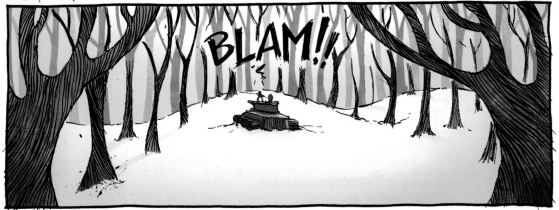

BLAM!!

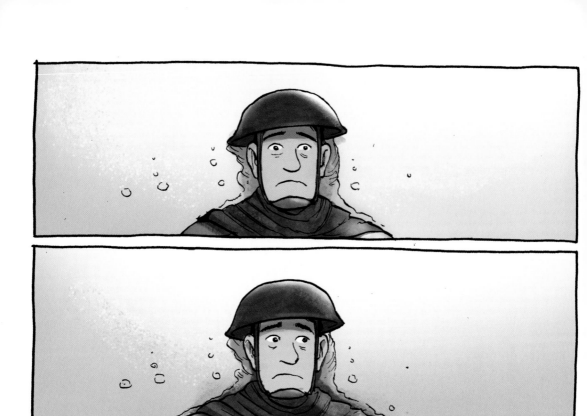

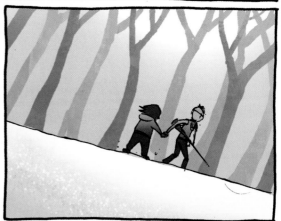

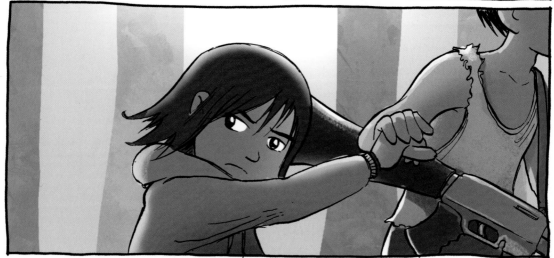

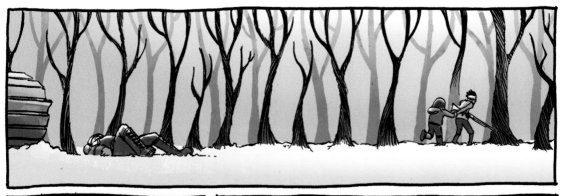

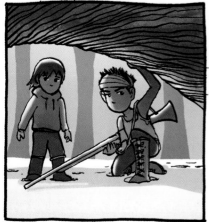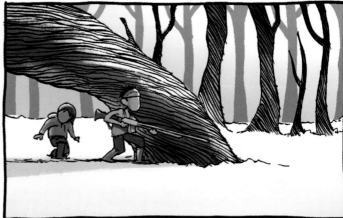

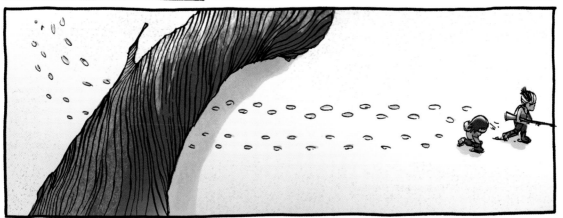

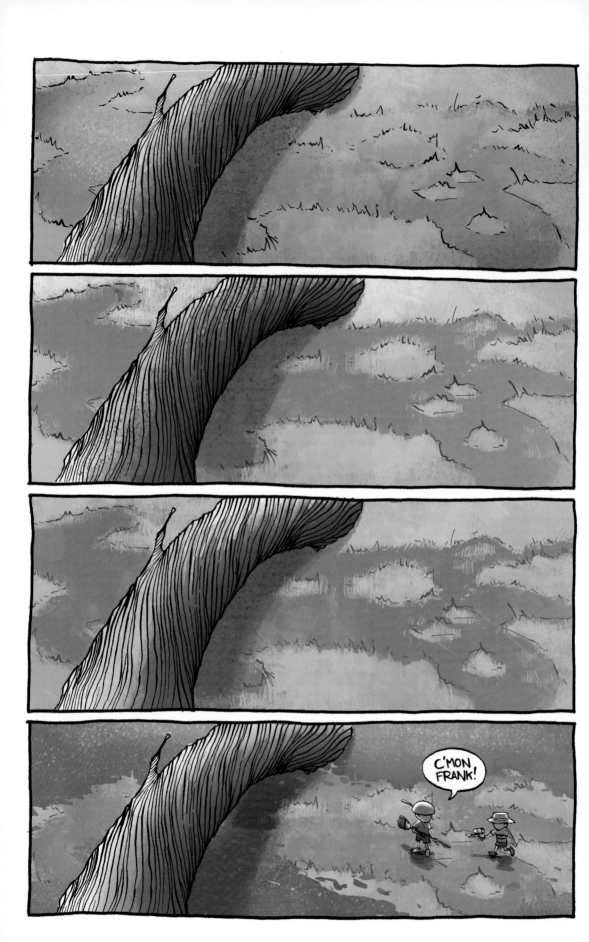

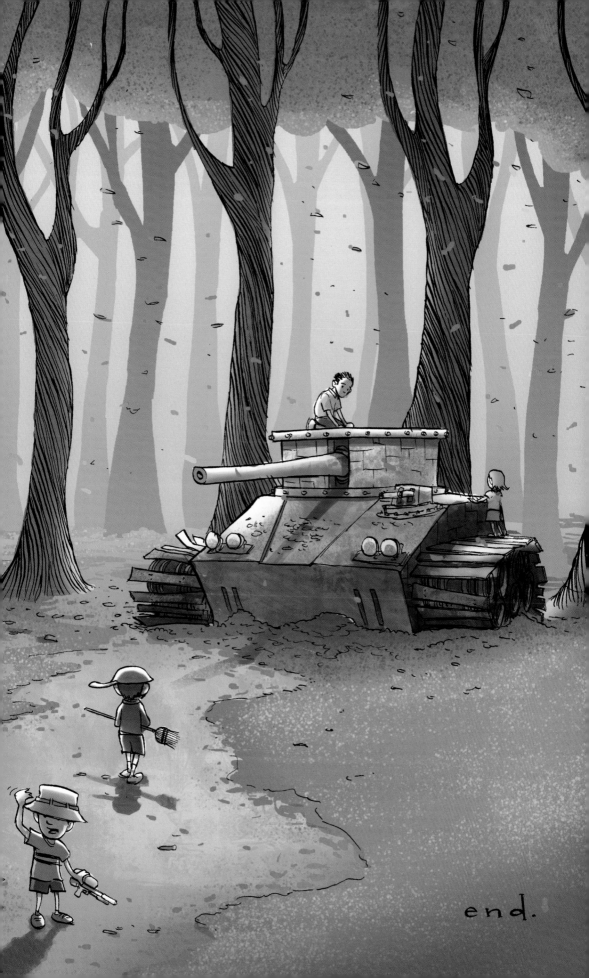

end.

Message in a Bottle

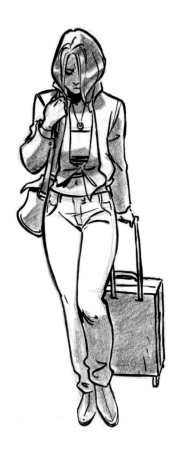

STORY AND ART

RODOLPHE GUENODEN

COLOURS
KAZU KIBUISHI

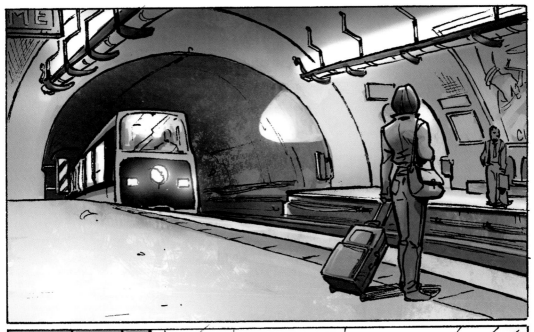

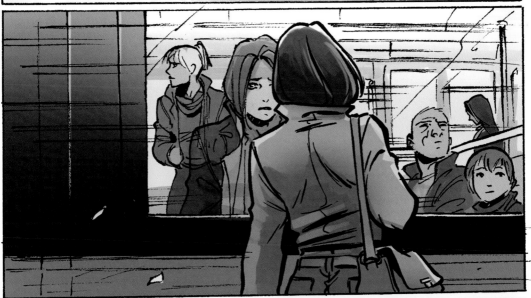

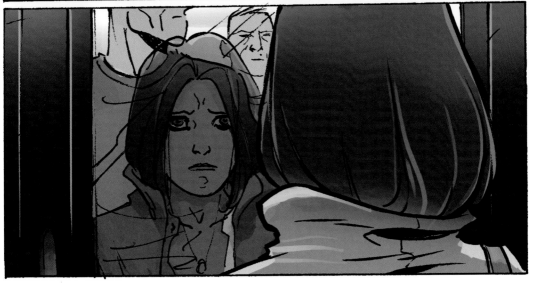

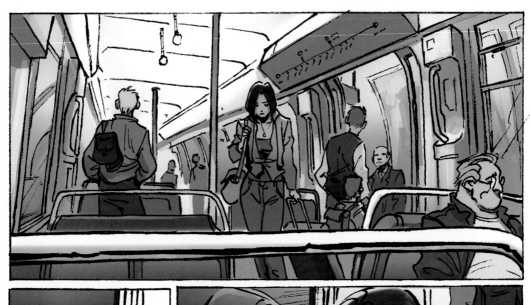

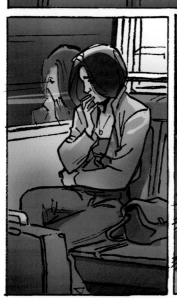

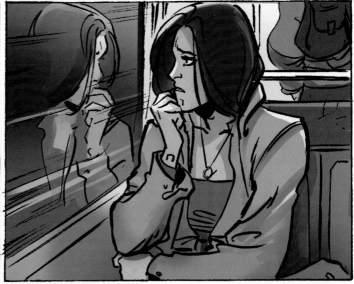

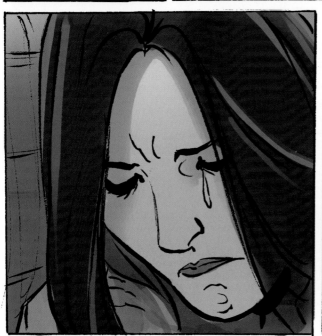

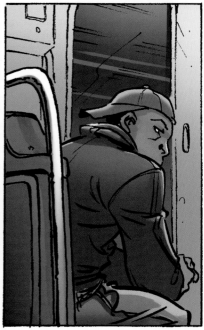

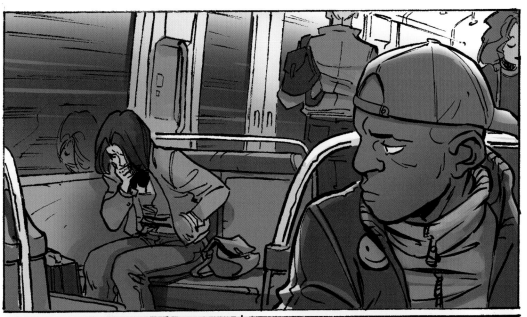

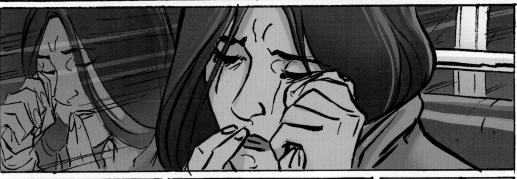

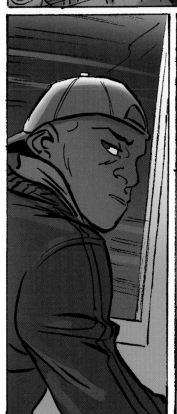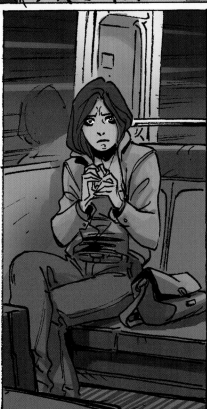

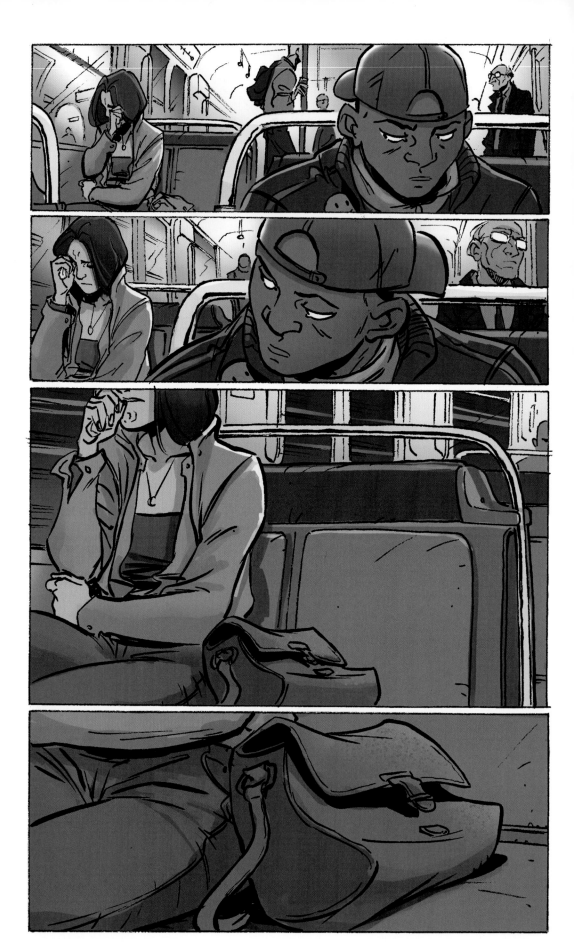

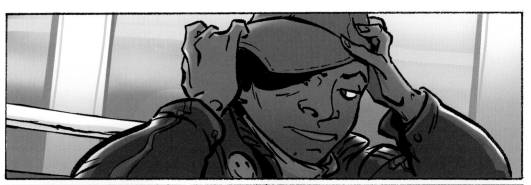

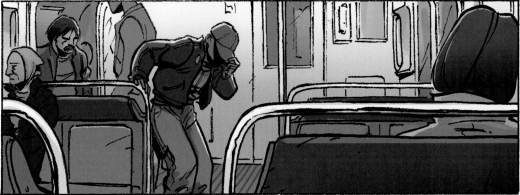

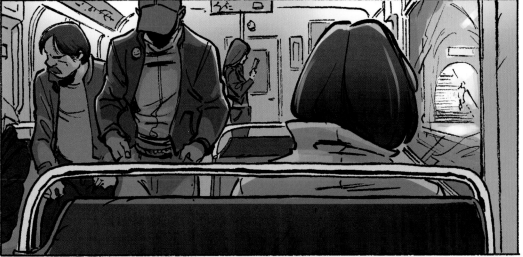

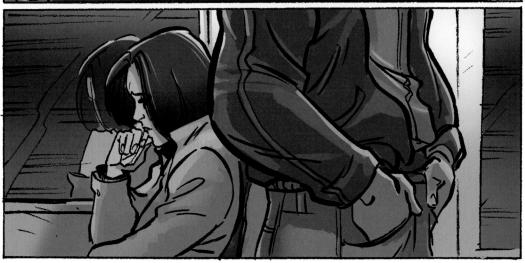

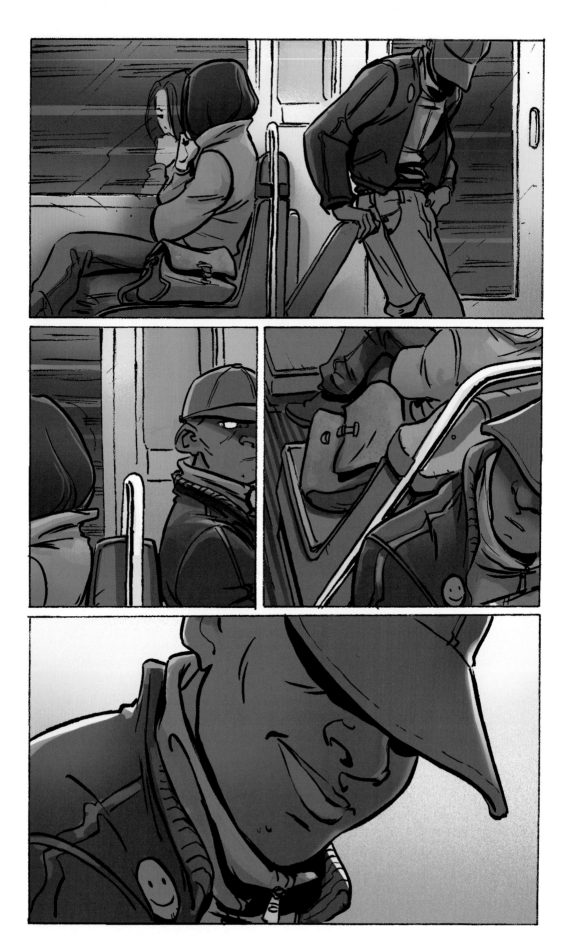

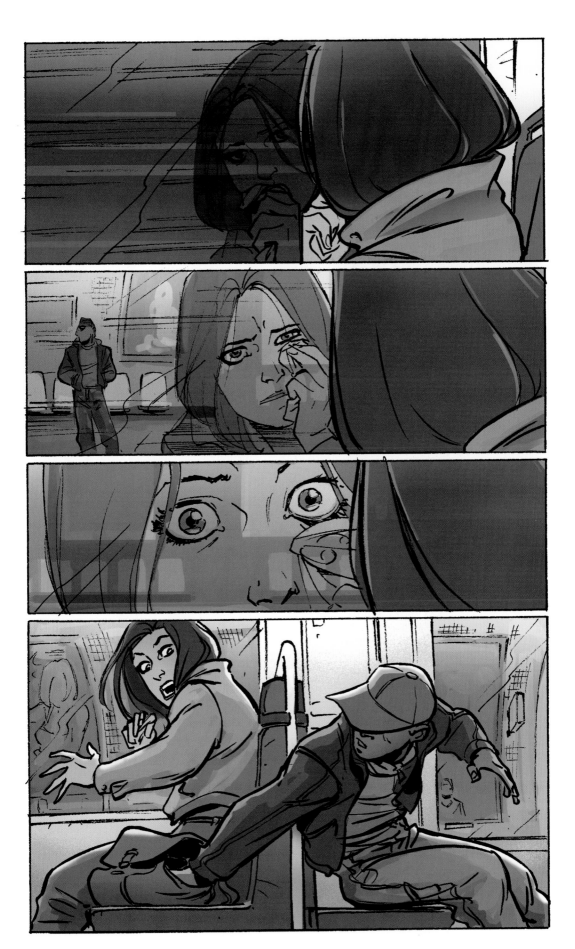

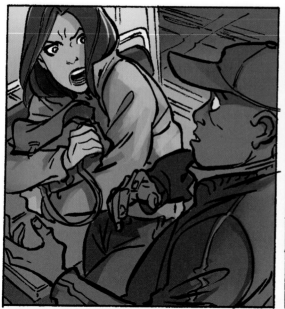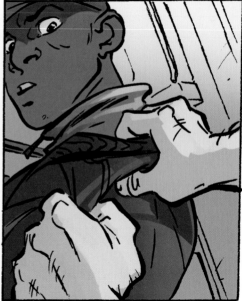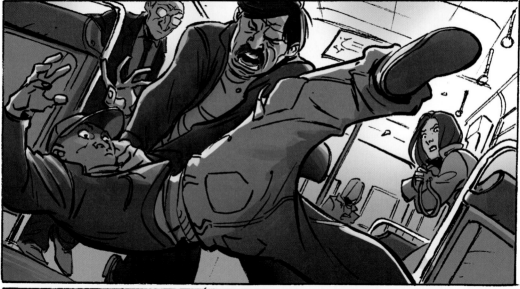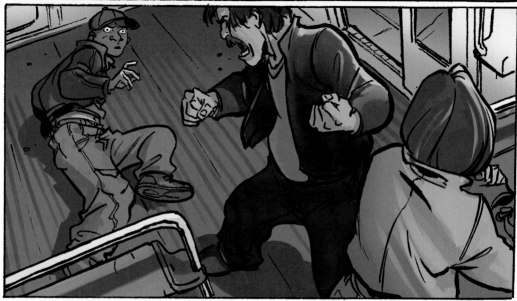

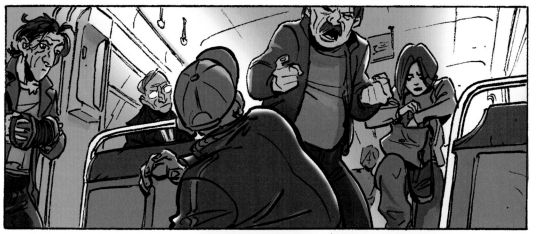

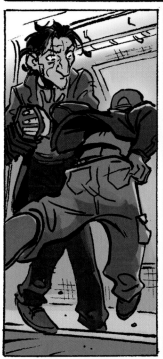

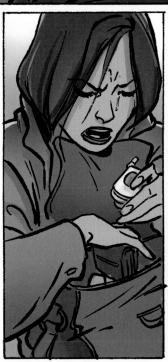

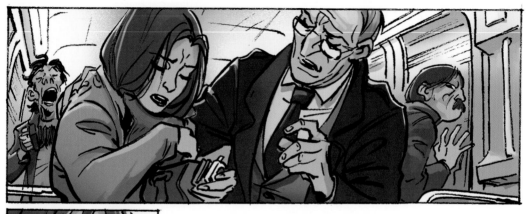

So far
So close

Story, Art and Colors
Bannister

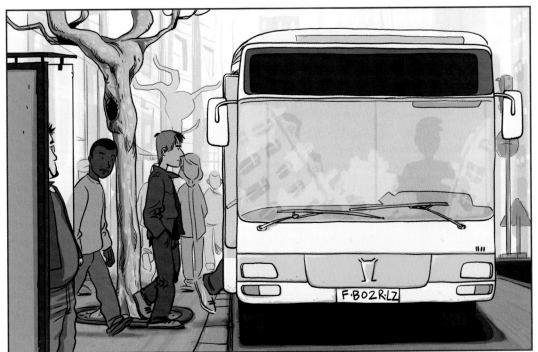

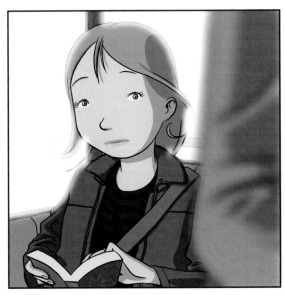
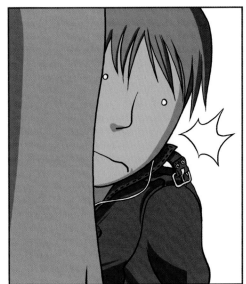

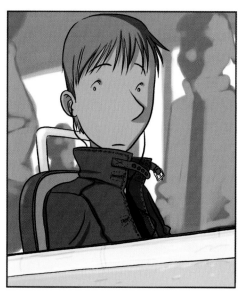
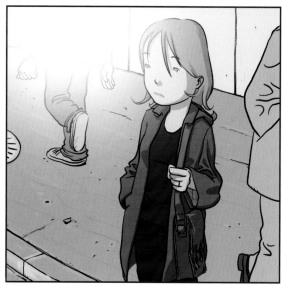

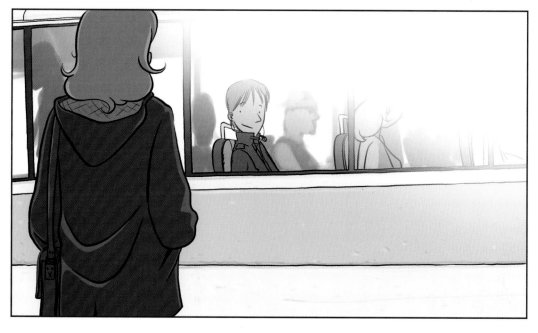

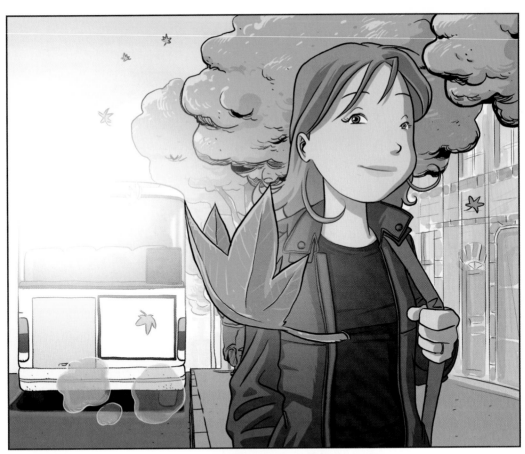

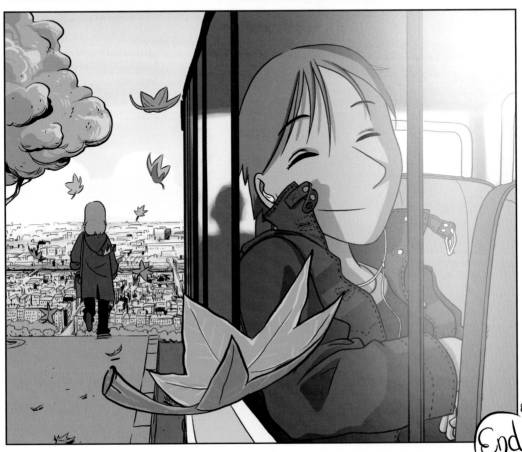

End

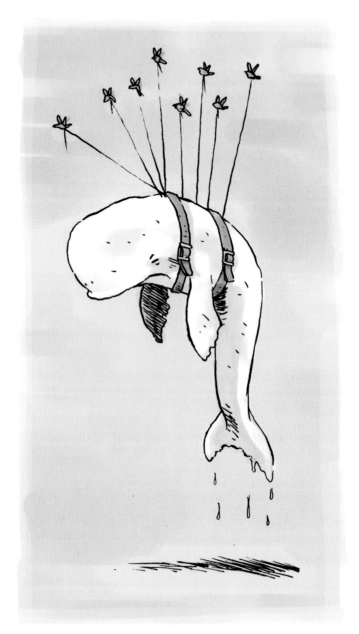

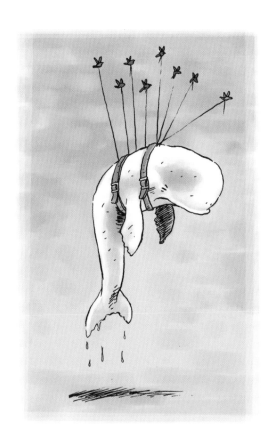

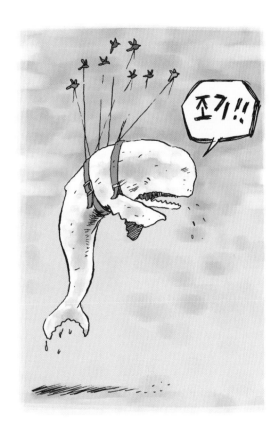

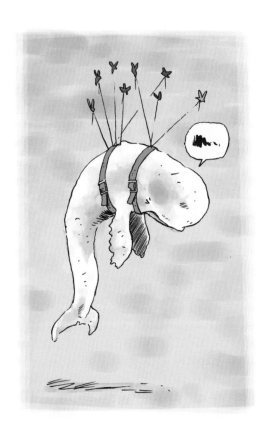

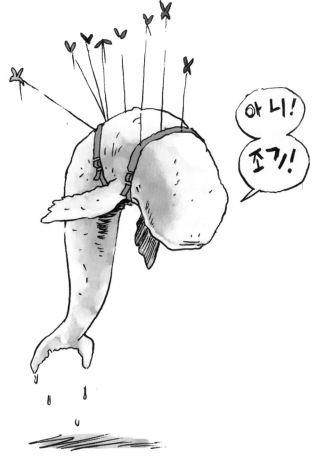

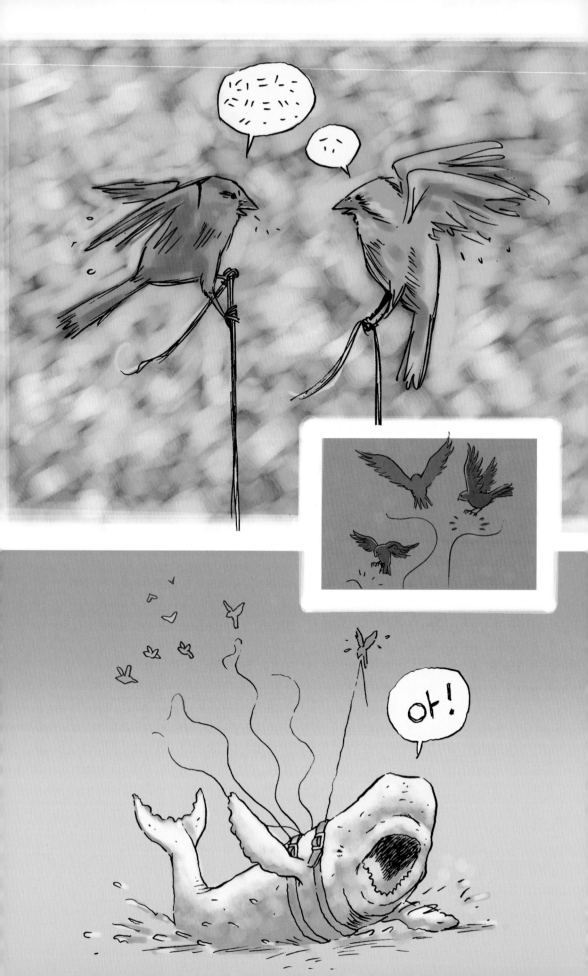

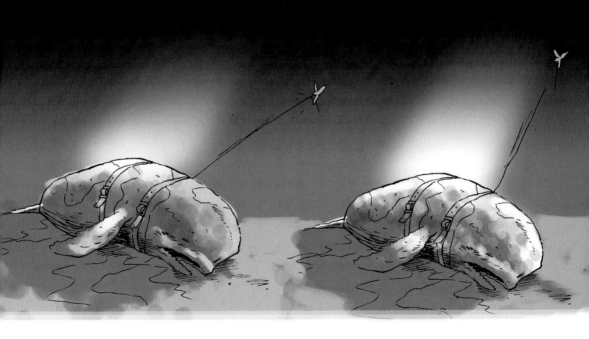

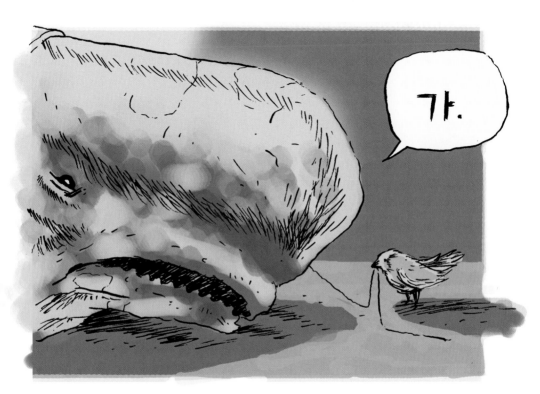

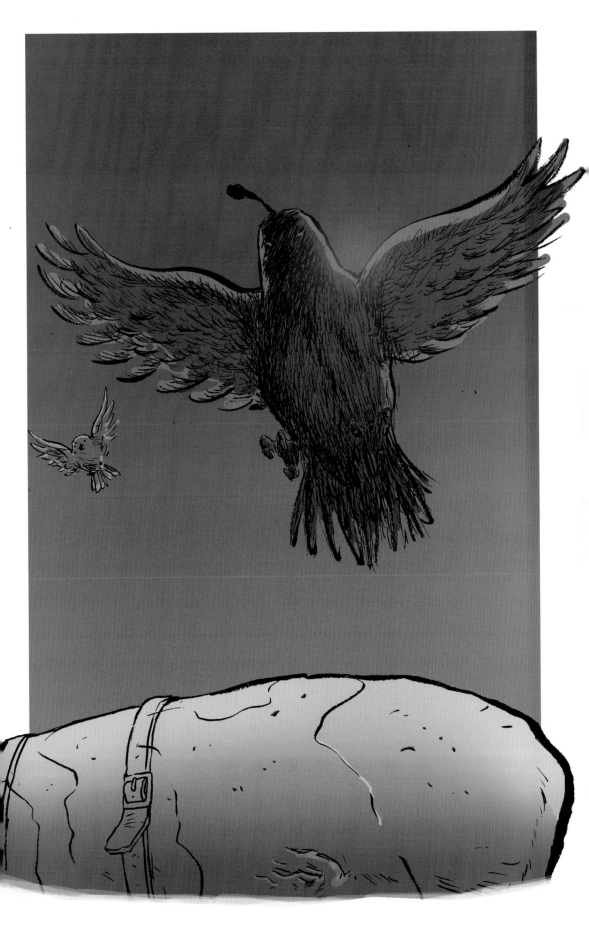

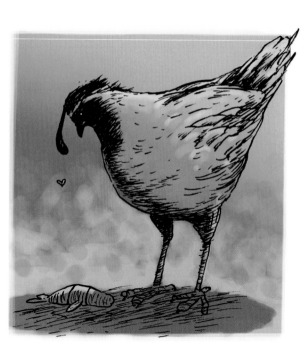
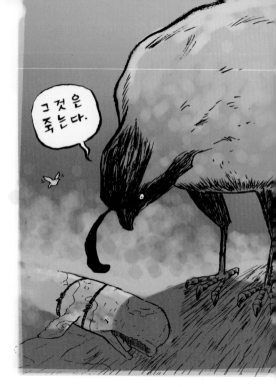
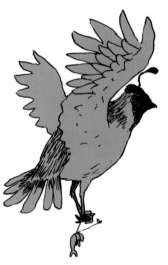

AD ASTRA

· BY CHUCKBB ·

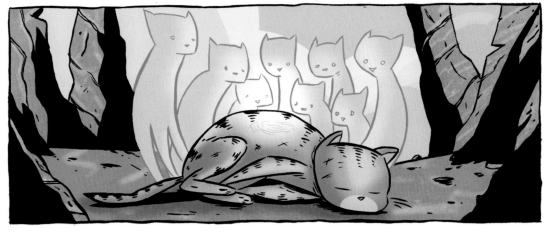

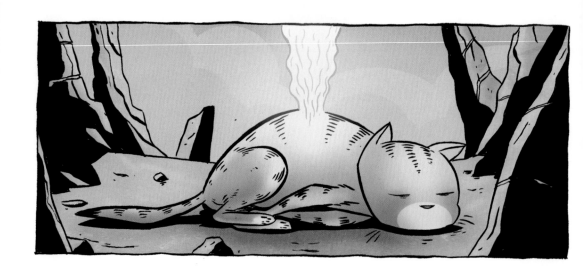

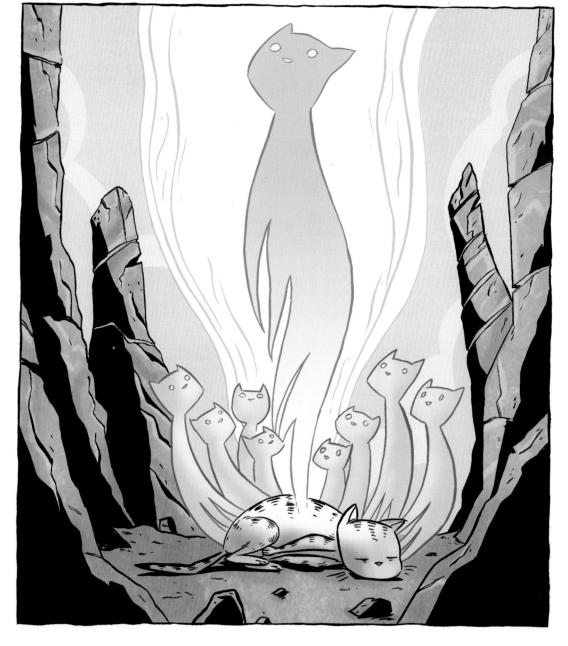

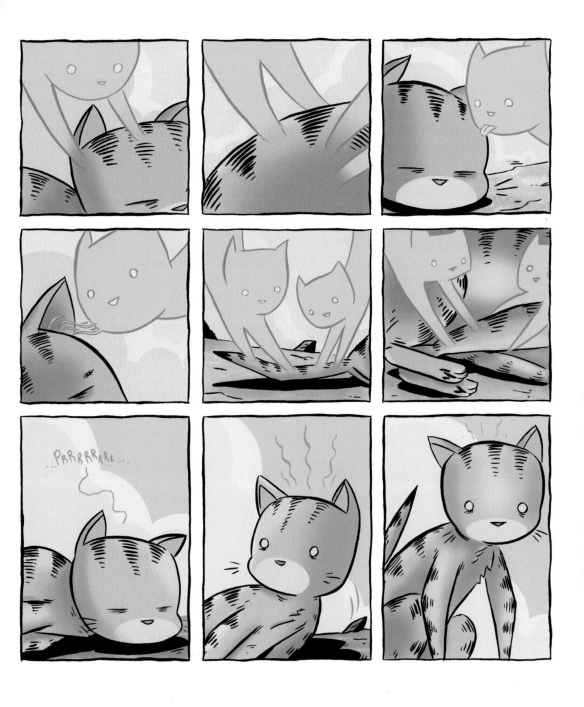

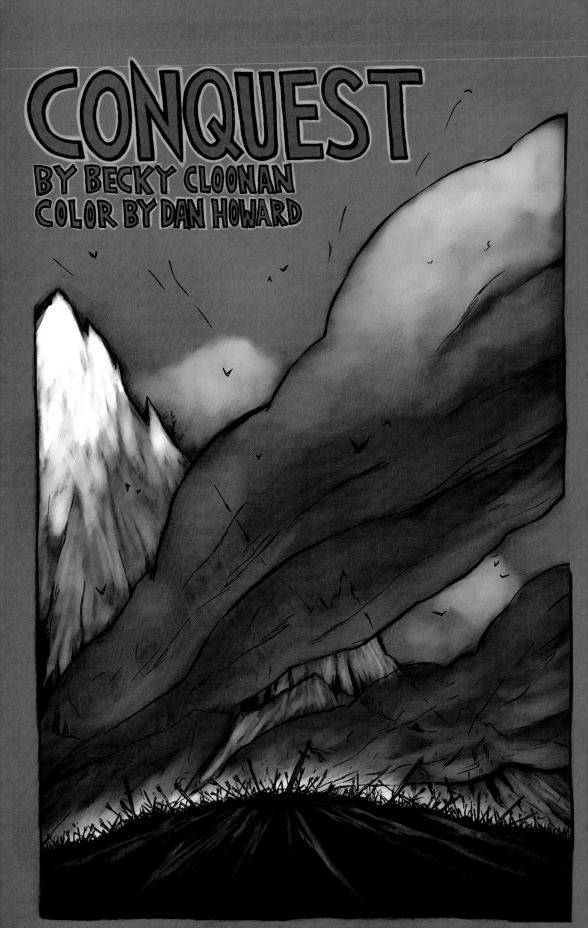

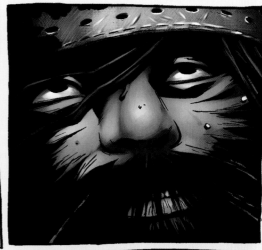
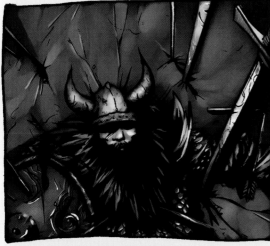
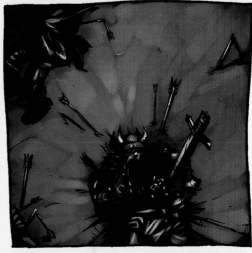

I ALWAYS HOPED IT WOULD END LIKE THIS.

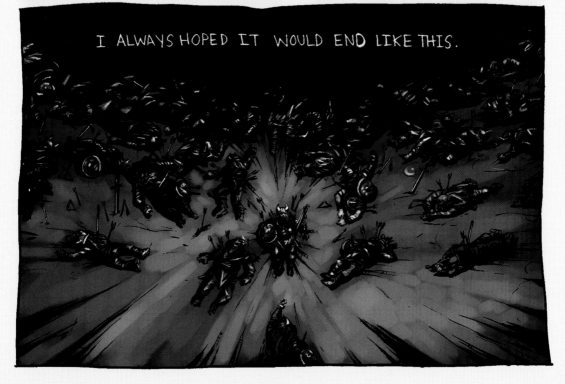

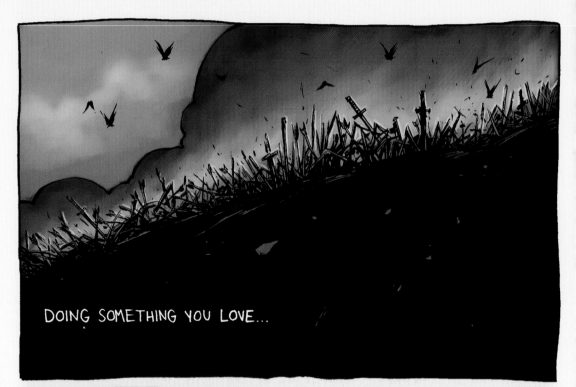

DOING SOMETHING YOU LOVE...

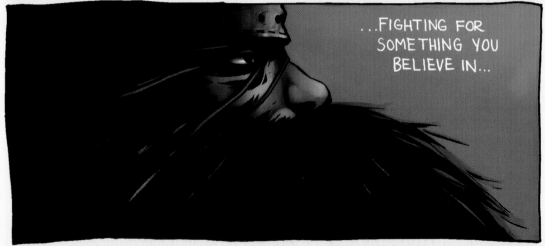

...FIGHTING FOR SOMETHING YOU BELIEVE IN...

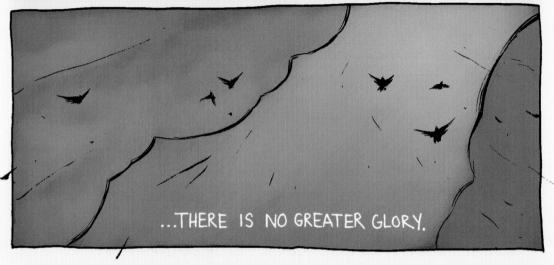

...THERE IS NO GREATER GLORY.

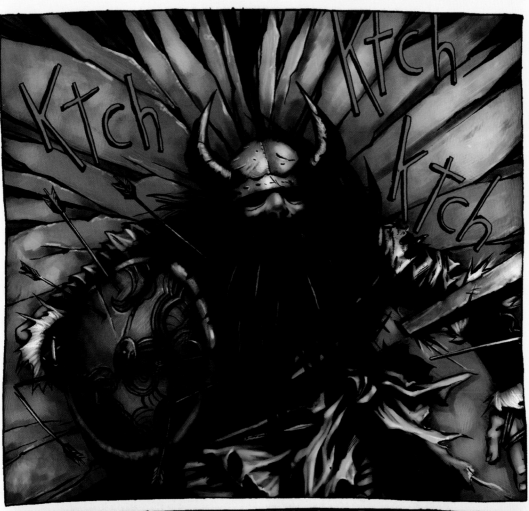

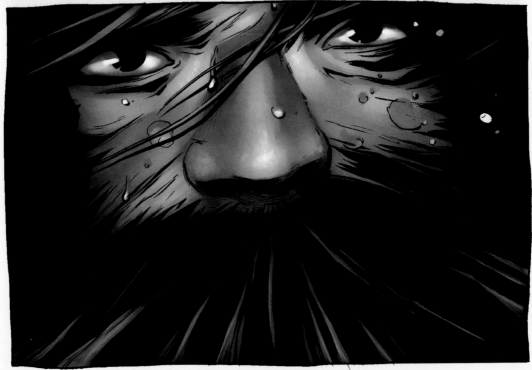

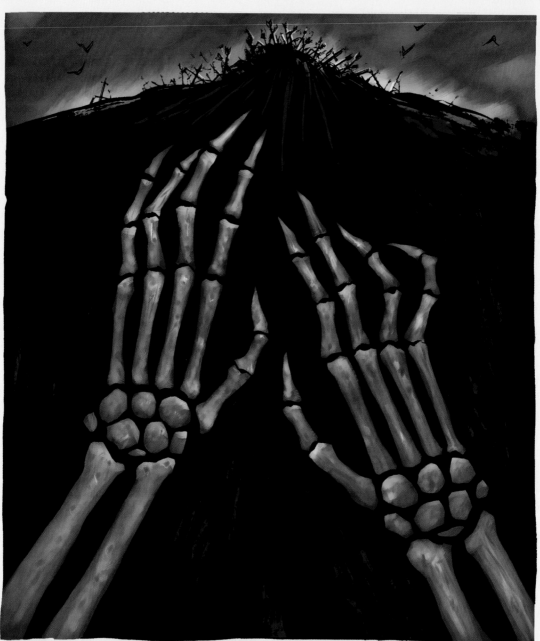

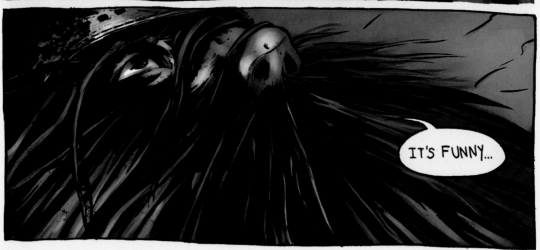

IT'S FUNNY...

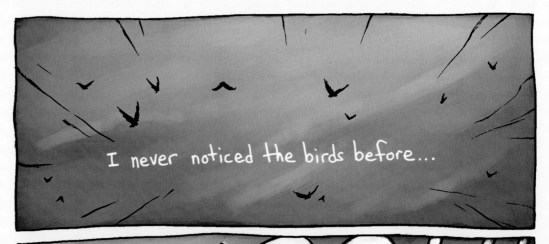

I never noticed the birds before...

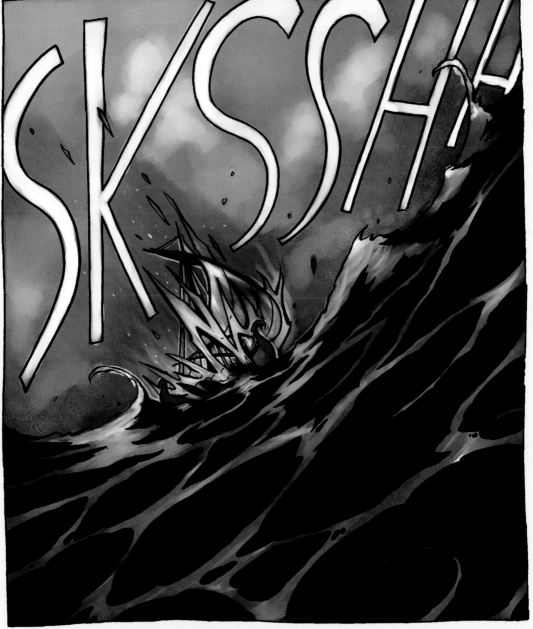

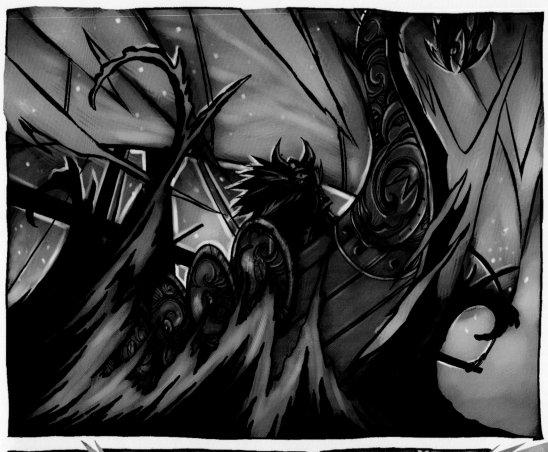

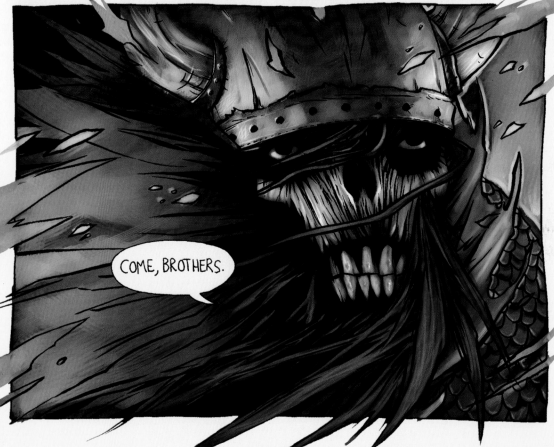

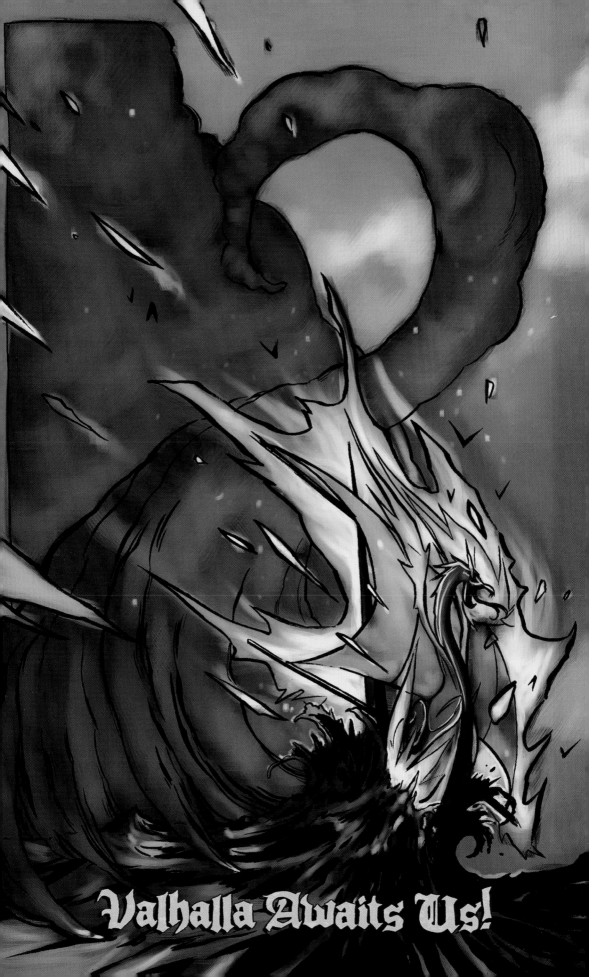

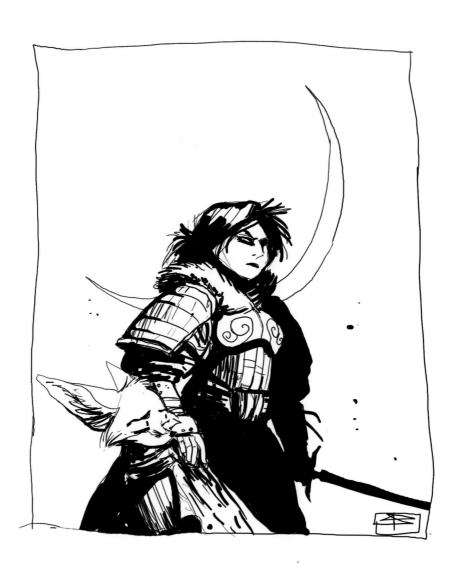

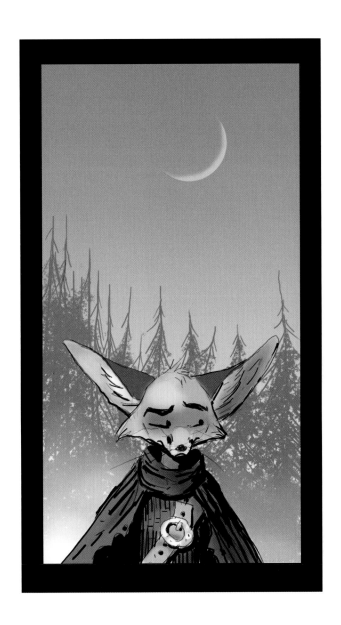

Tea

By Reagan Lodge

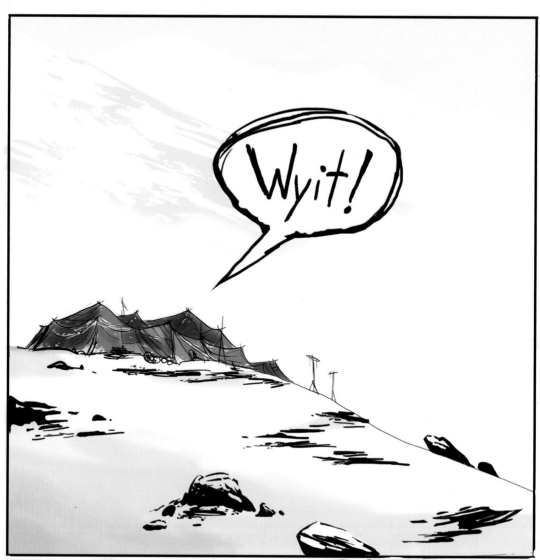

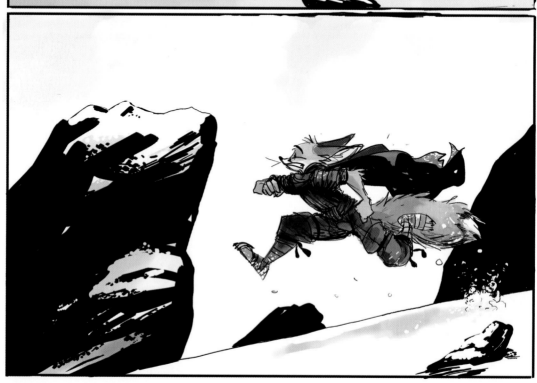

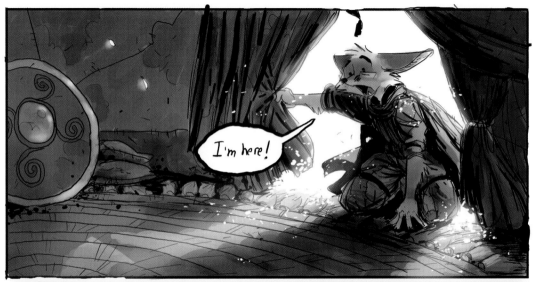

I'm here!

I have a cold.

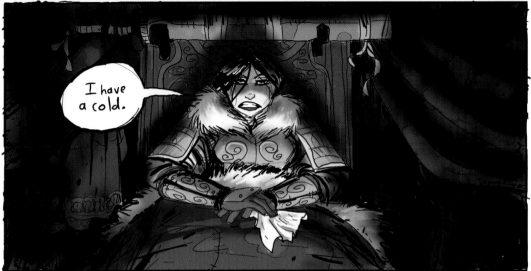

Go into the woods. Fetch some roots and brew some tea for me.

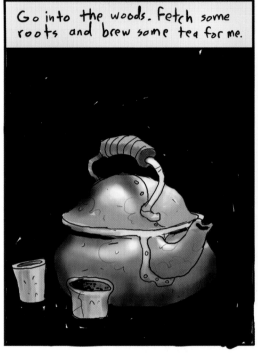

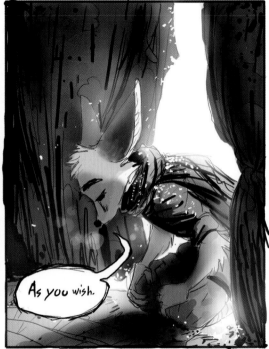

As you wish.

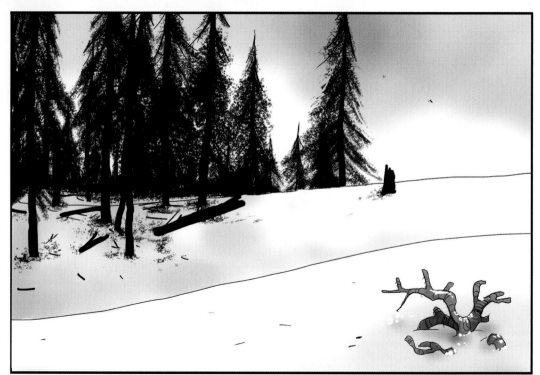

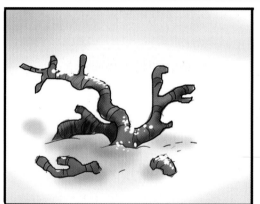

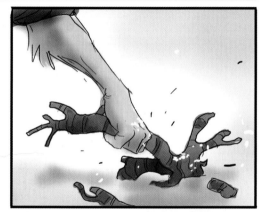

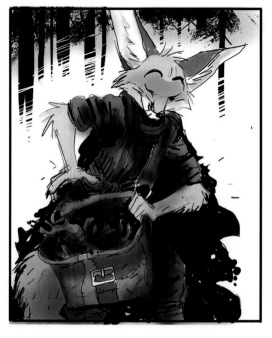

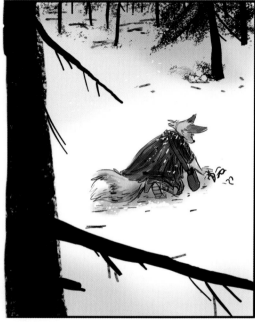

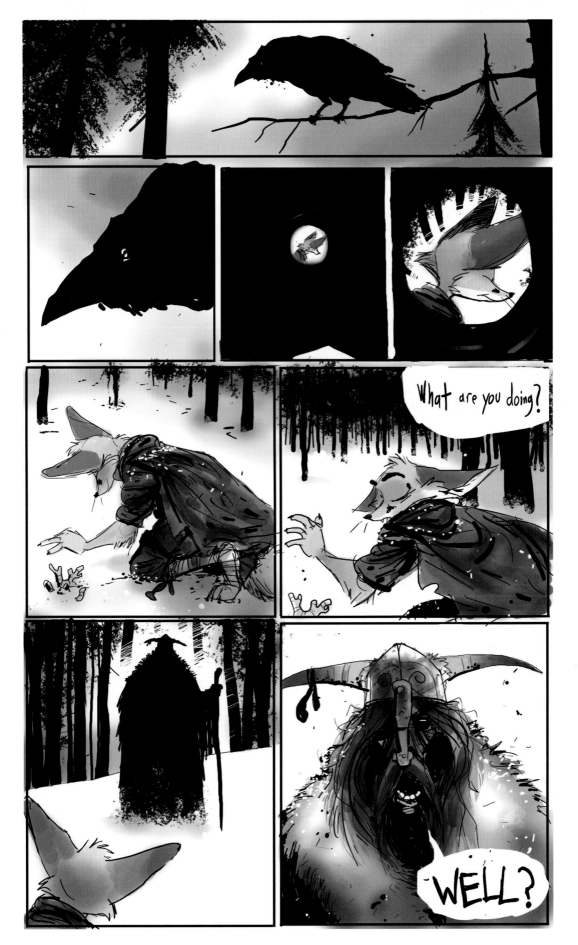

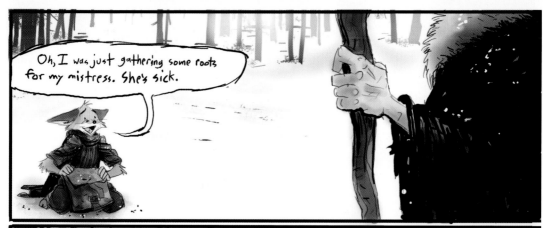

Oh, I was just gathering some roots for my mistress. She's sick.

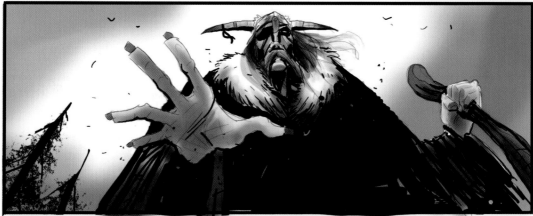

Roots?

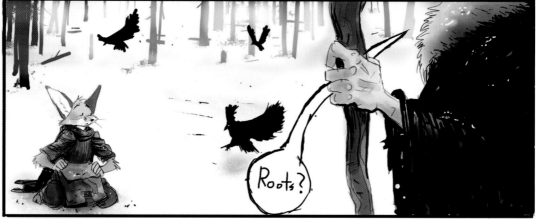

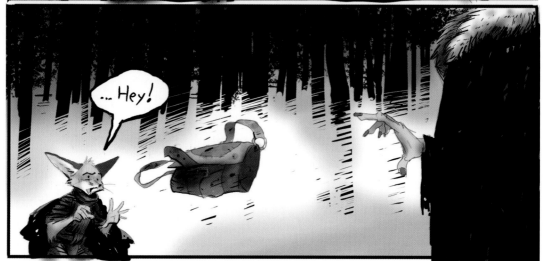

...Hey!

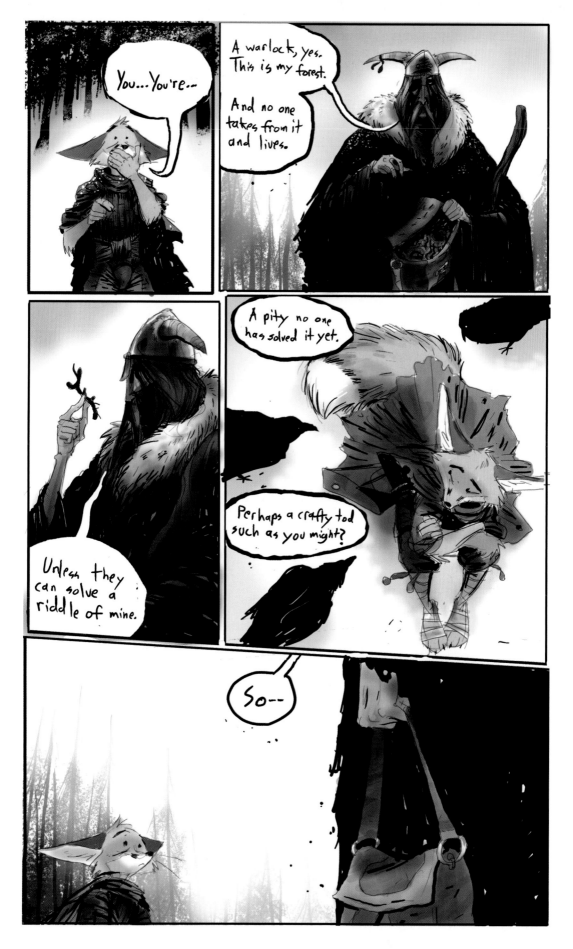

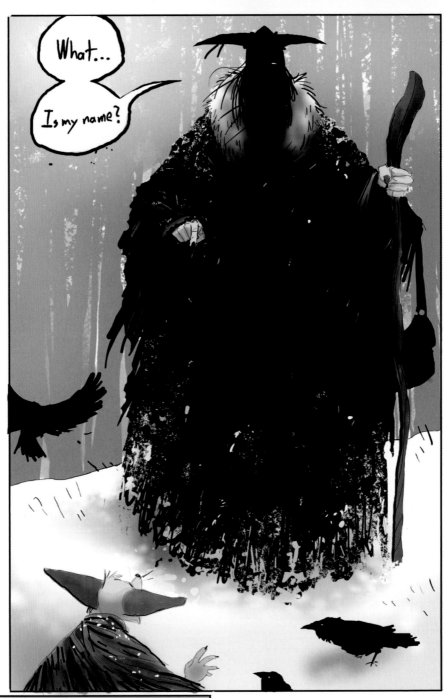

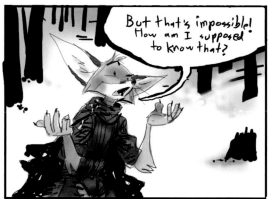

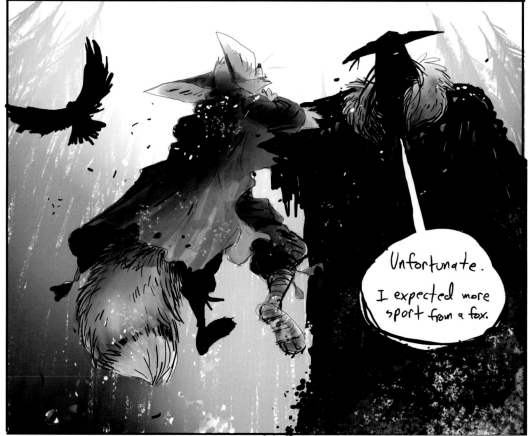

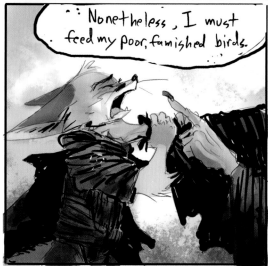

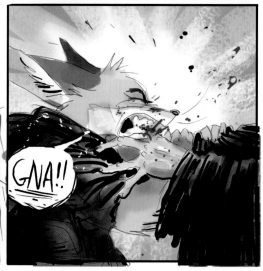

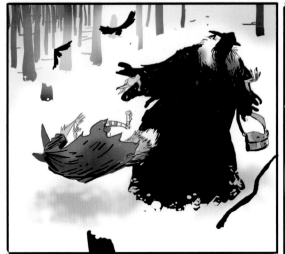

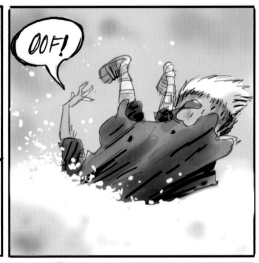

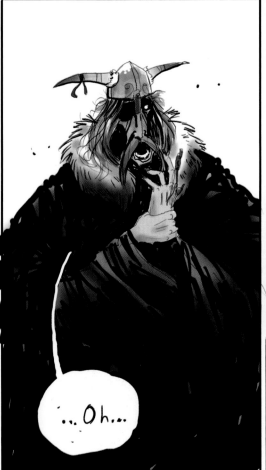

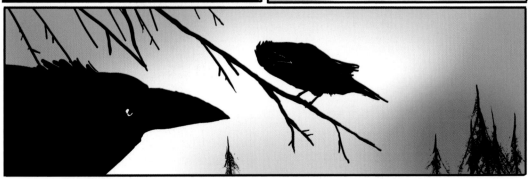

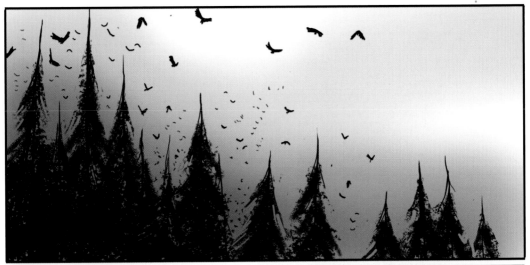

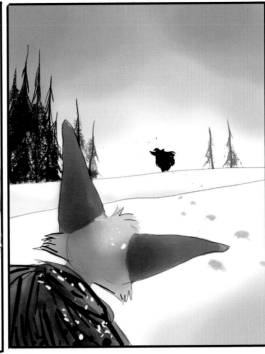

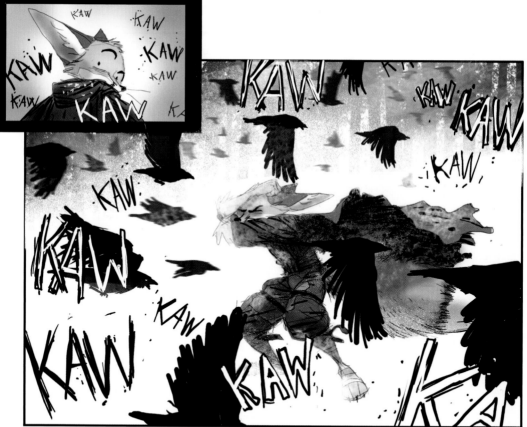

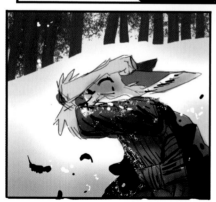

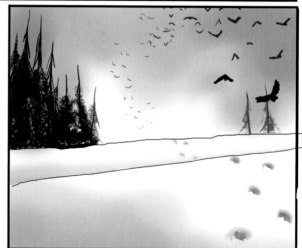

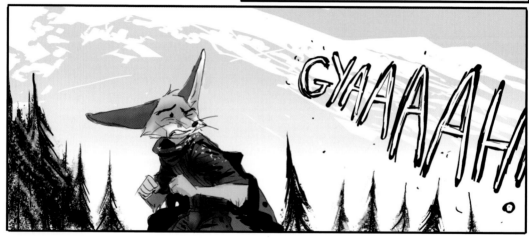

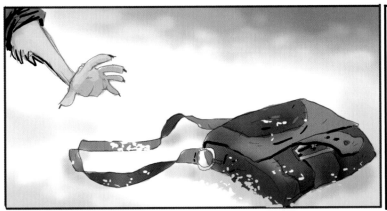
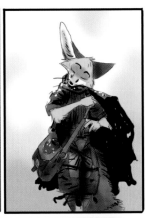
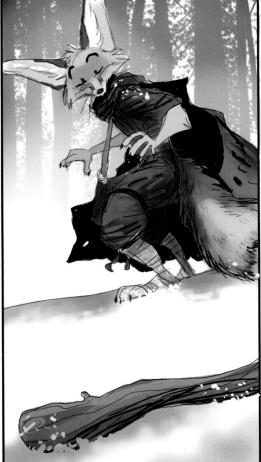
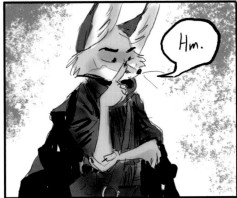

Hm.

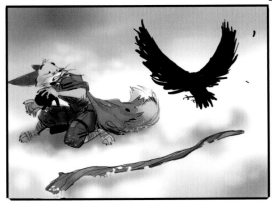

KAW!

Geez!

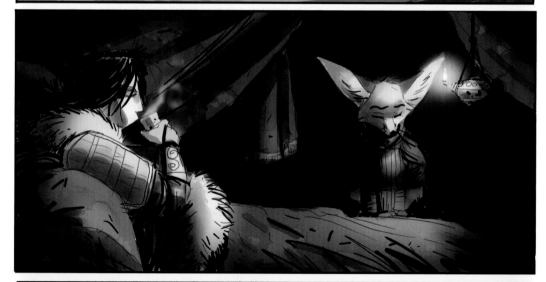

It's good.

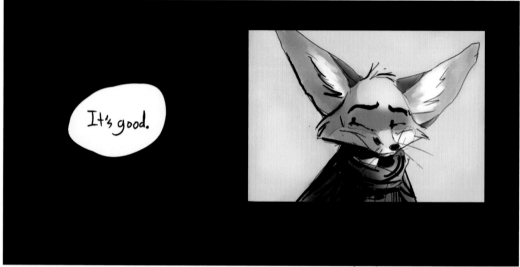

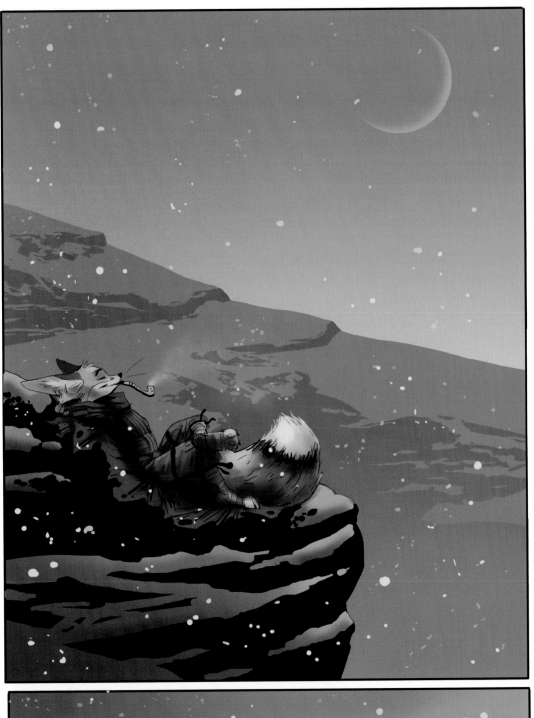

The End.

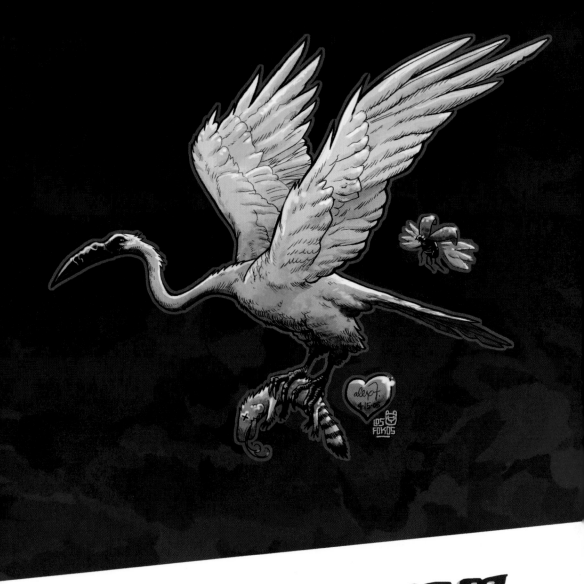

One Little Miracle for a
HUNGRY SWARM
art & story: alex fuentes

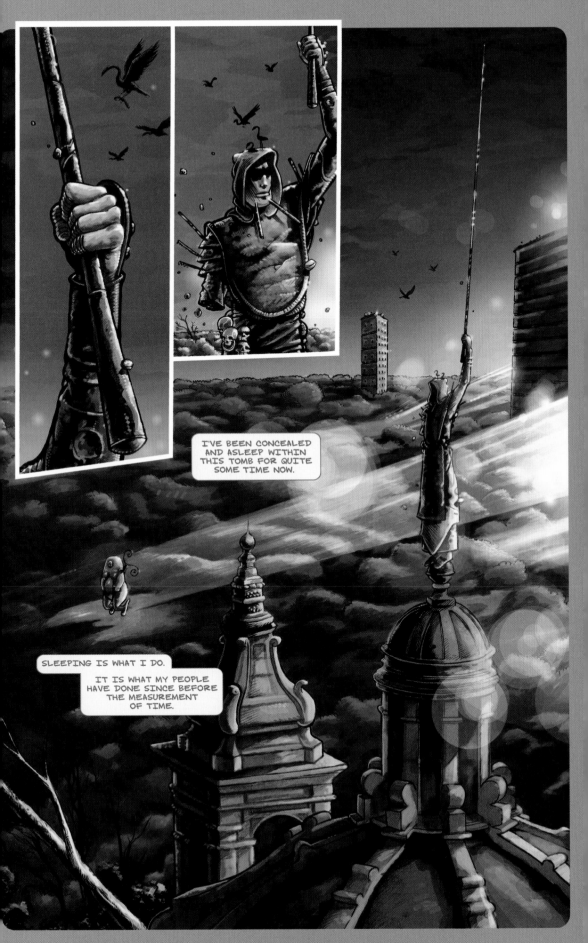

I'VE BEEN CONCEALED AND ASLEEP WITHIN THIS TOMB FOR QUITE SOME TIME NOW.

SLEEPING IS WHAT I DO.

IT IS WHAT MY PEOPLE HAVE DONE SINCE BEFORE THE MEASUREMENT OF TIME.

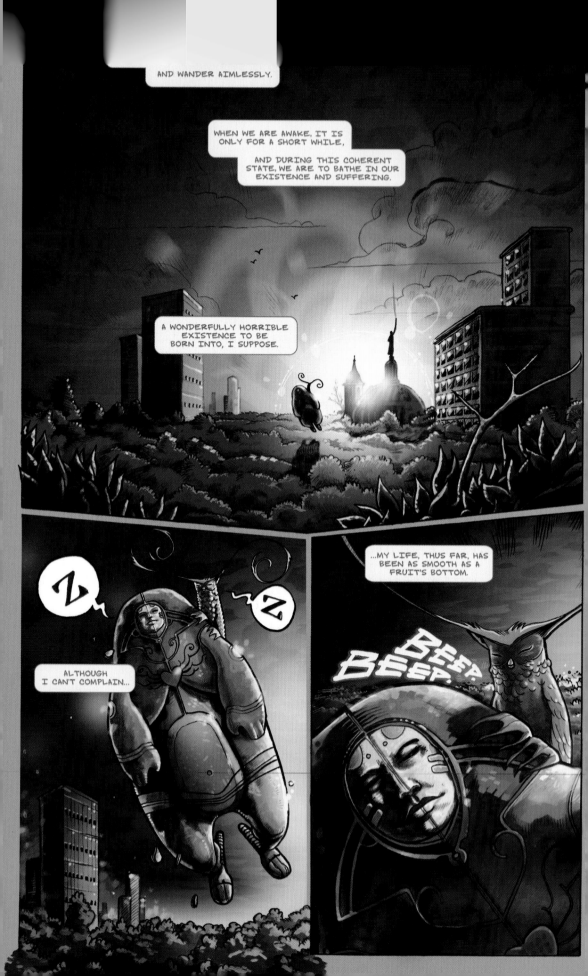

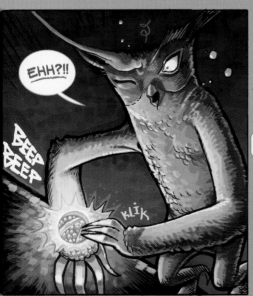

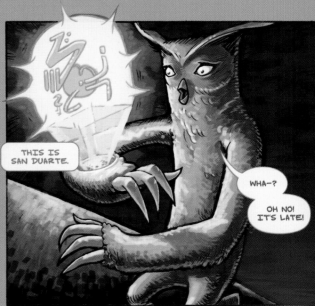

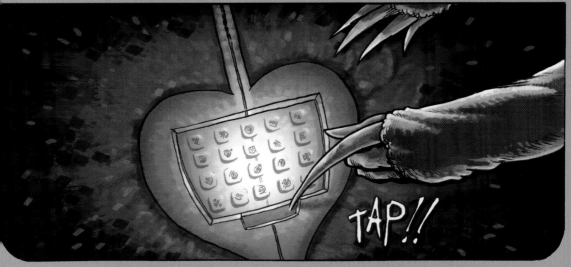

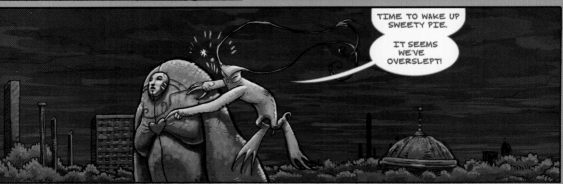

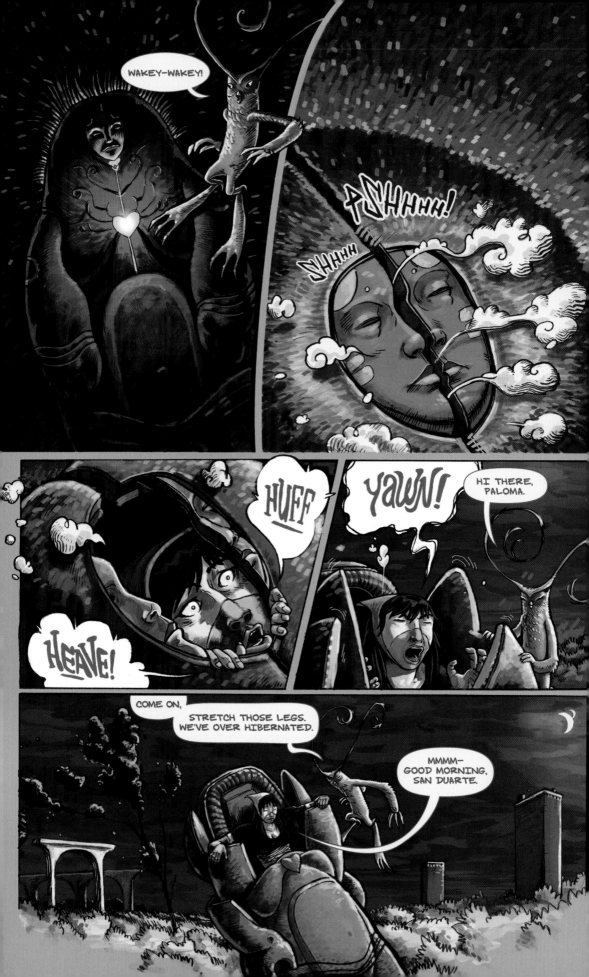

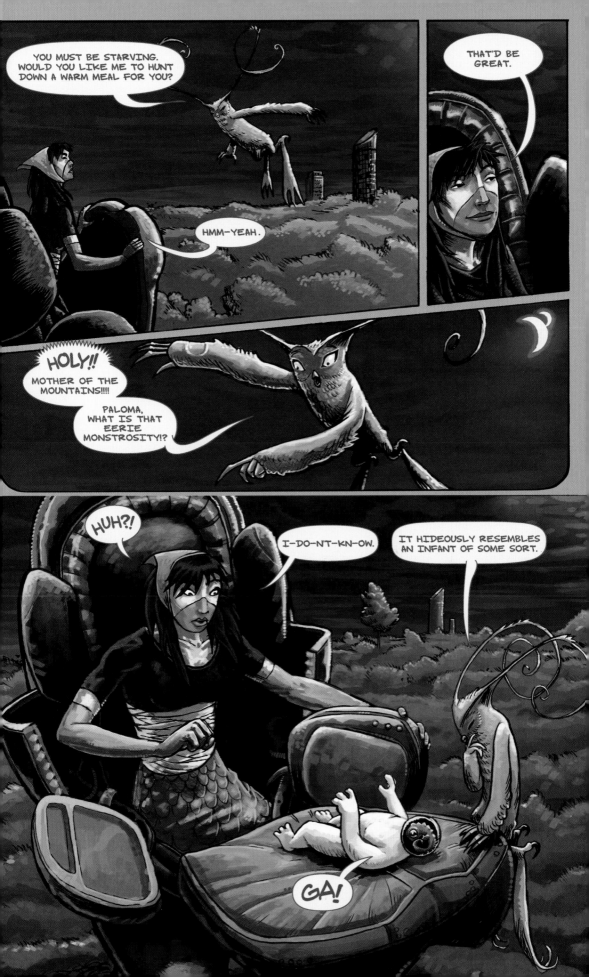

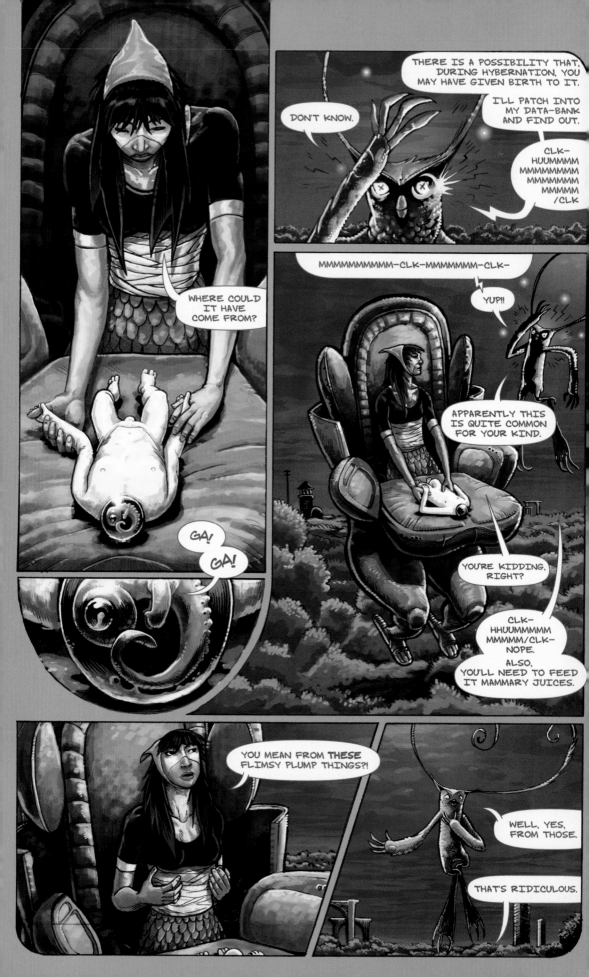

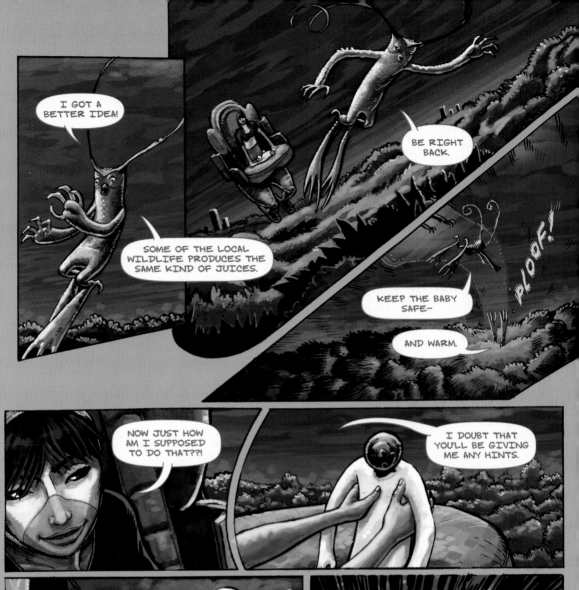

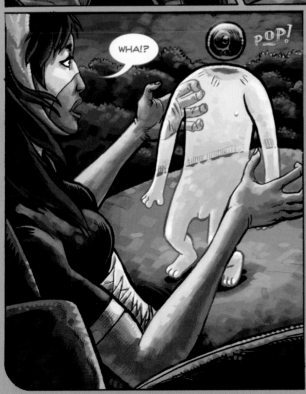

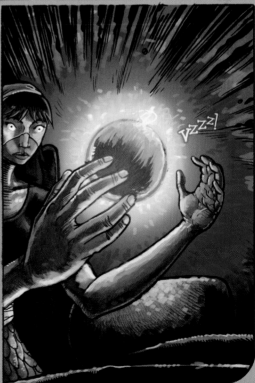

WELL, AREN'T YOU FULL OF SURPRISES.

YAWN!

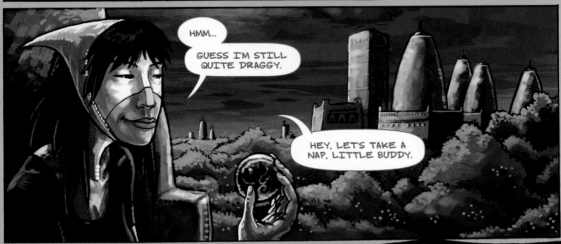

HMM... GUESS I'M STILL QUITE DRAGGY.

HEY, LET'S TAKE A NAP, LITTLE BUDDY.

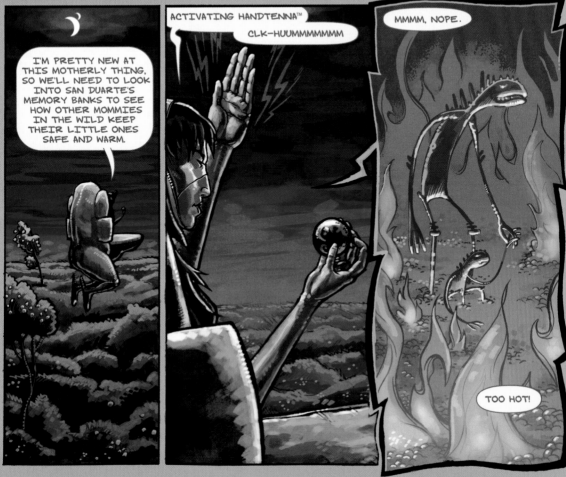

I'M PRETTY NEW AT THIS MOTHERLY THING, SO WE'LL NEED TO LOOK INTO SAN DUARTE'S MEMORY BANKS TO SEE HOW OTHER MOMMIES IN THE WILD KEEP THEIR LITTLE ONES SAFE AND WARM.

ACTIVATING HANDTENNA™

CLK-HUUMMMMMMM

MMMM, NOPE.

TOO HOT!

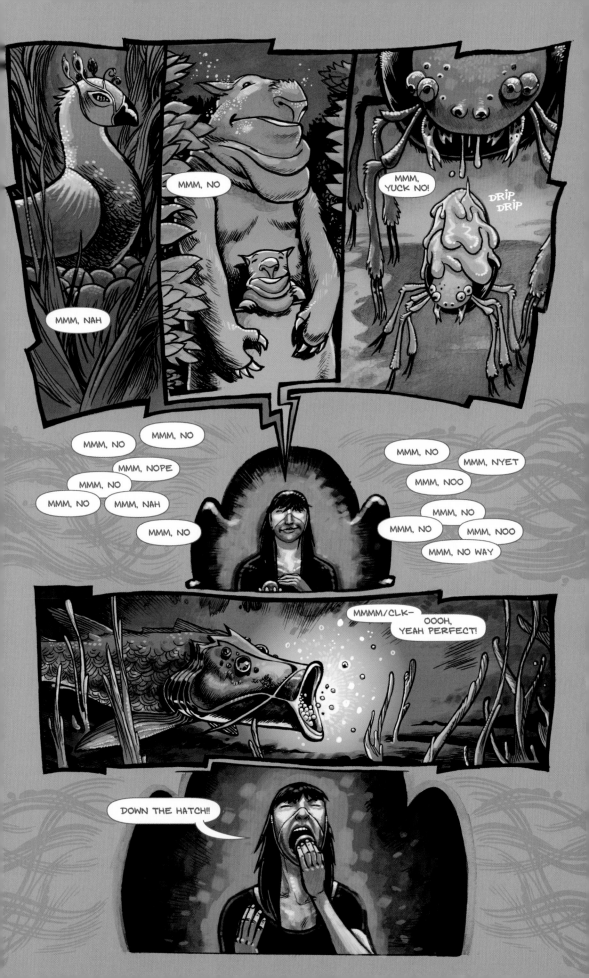

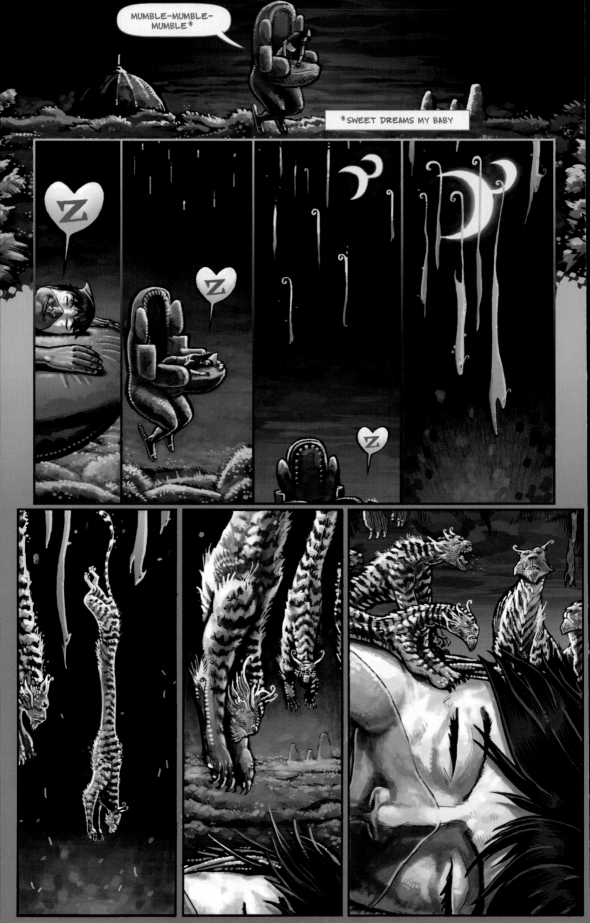

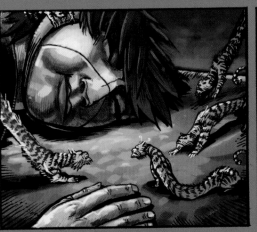
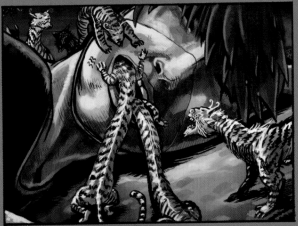

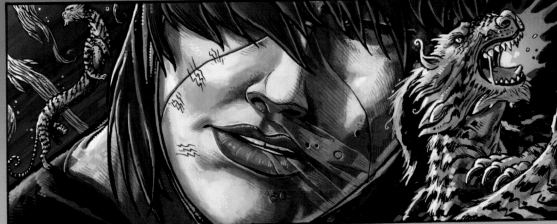

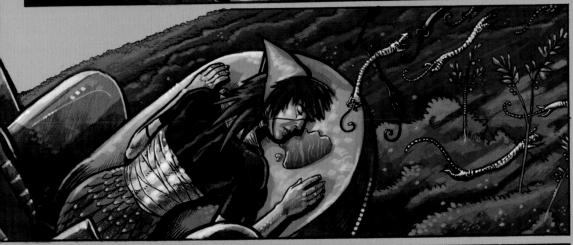

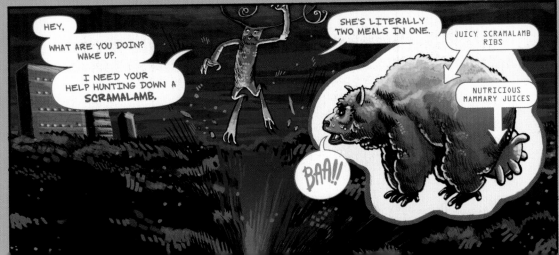

HEY,

WHAT ARE YOU DOIN? WAKE UP.

I NEED YOUR HELP HUNTING DOWN A **SCRAMALAMB.**

SHE'S LITERALLY TWO MEALS IN ONE.

JUICY SCRAMALAMB RIBS

NUTRICIOUS MAMMARY JUICES

BAA!!

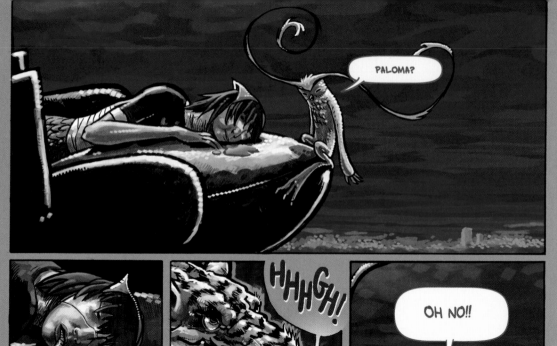

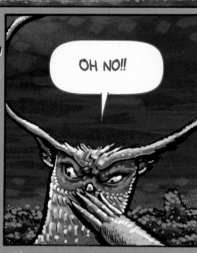

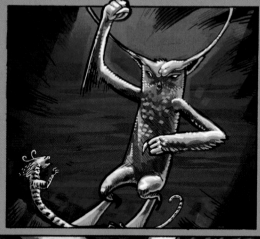

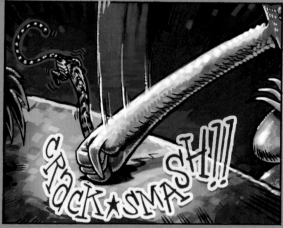

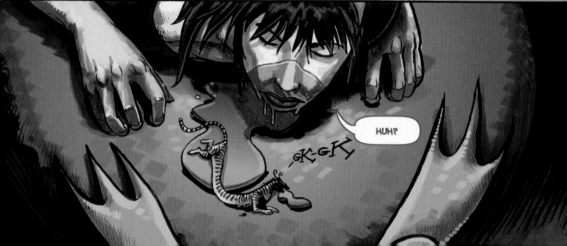

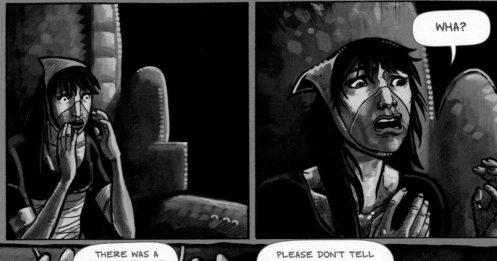

WHA?

THERE WAS A
CATERKILLAR
IN YOUR MOUTH.

PLEASE DON'T TELL
ME YOU KEPT
THE INFANT IN THERE.

OH!
NO!

I'M SORRY,
PALOMA.

CONSIDER THIS
YOUR FIRST VENTURE
INTO SUFFERING.

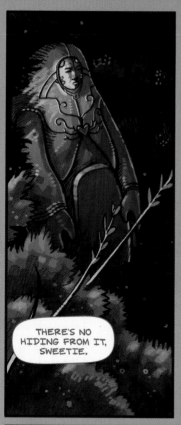

THERE'S NO HIDING FROM IT, SWEETIE.

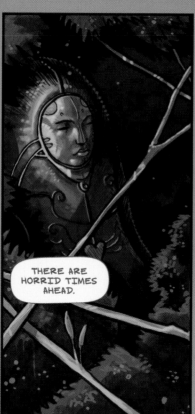

THERE ARE HORRID TIMES AHEAD.

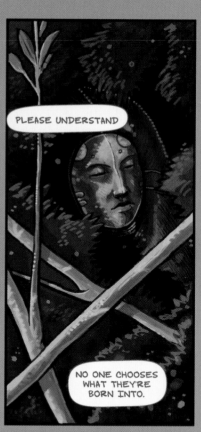

PLEASE UNDERSTAND

NO ONE CHOOSES WHAT THEY'RE BORN INTO.

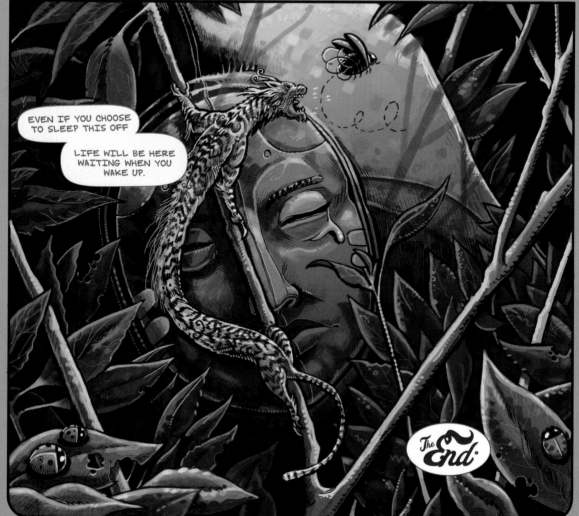

EVEN IF YOU CHOOSE TO SLEEP THIS OFF

LIFE WILL BE HERE WAITING WHEN YOU WAKE UP.

The End.

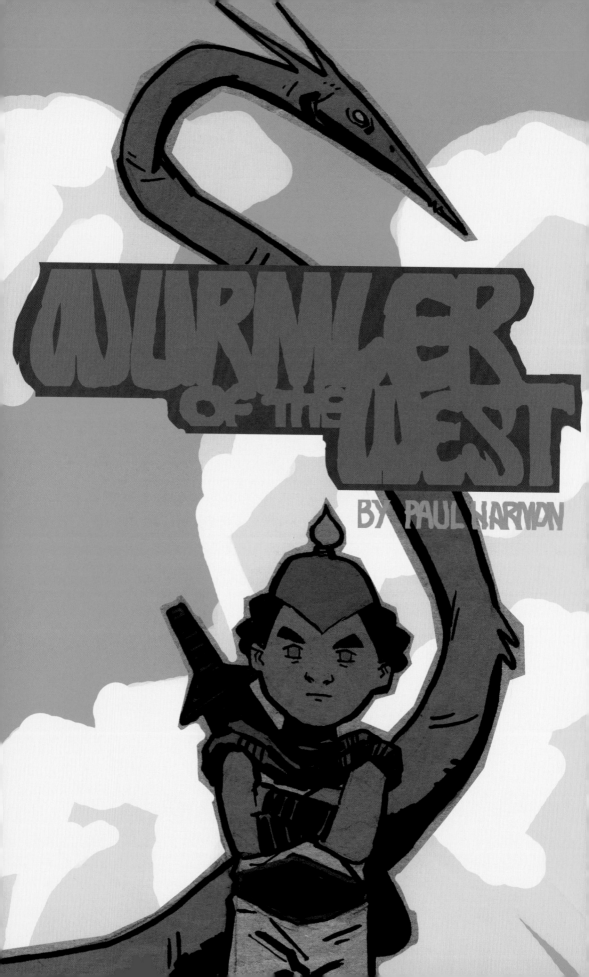

WURMLER OF THE WEST

BY PAUL HARMON

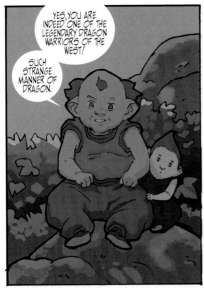

YES, YOU ARE INDEED ONE OF THE LEGENDARY DRAGON WARRIORS OF THE WEST!

SUCH STRANGE MANNER OF DRAGON.

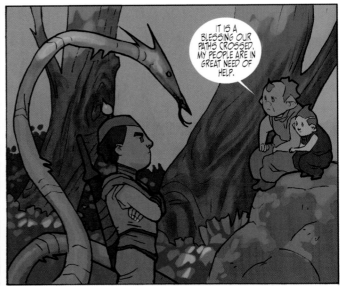

IT IS A BLESSING OUR PATHS CROSSED. MY PEOPLE ARE IN GREAT NEED OF HELP.

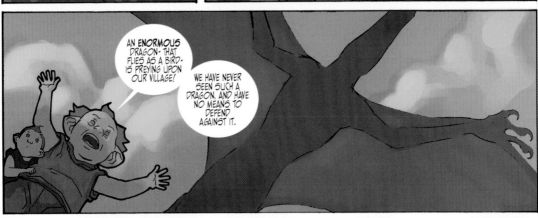

AN ENORMOUS DRAGON- THAT FLIES AS A BIRD- IS PREYING UPON OUR VILLAGE!

WE HAVE NEVER SEEN SUCH A DRAGON, AND HAVE NO MEANS TO DEFEND AGAINST IT.

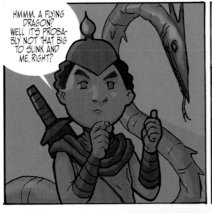

HMMM, A FLYING DRAGON? WELL IT'S PROBA-BLY NOT THAT BIG TO SLINK AND ME, RIGHT?

NO, I THINK IT'S BIG FOR EVERYONE.

WELL, NO MATTER. WE WILL DO ALL WE CAN TO STOP THIS MENACE.

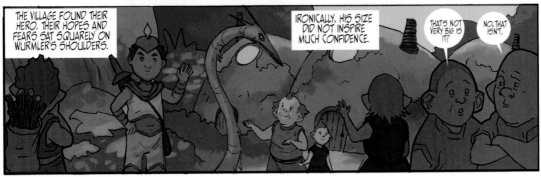

THE VILLAGE FOUND THEIR HERO. THEIR HOPES AND FEARS SAT SQUARELY ON WURMLER'S SHOULDERS.

IRONICALLY, HIS SIZE DID NOT INSPIRE MUCH CONFIDENCE.

THAT'S NOT VERY BIG IS IT?

NO, THAT ISN'T.

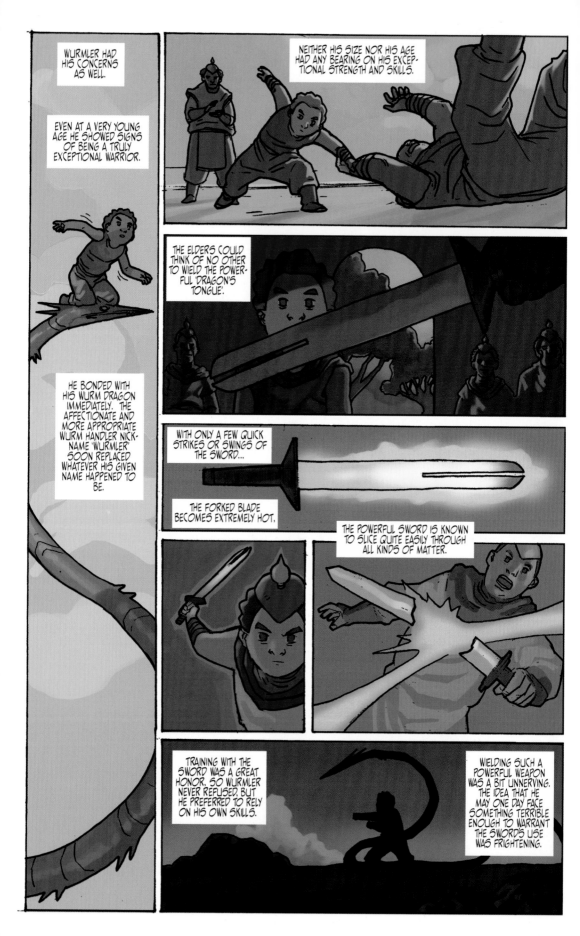

WURMLER HAD HIS CONCERNS AS WELL.

NEITHER HIS SIZE NOR HIS AGE HAD ANY BEARING ON HIS EXCEPTIONAL STRENGTH AND SKILLS.

EVEN AT A VERY YOUNG AGE HE SHOWED SIGNS OF BEING A TRULY EXCEPTIONAL WARRIOR.

THE ELDERS COULD THINK OF NO OTHER TO WIELD THE POWERFUL 'DRAGON'S TONGUE'.

HE BONDED WITH HIS WURM DRAGON IMMEDIATELY. THE AFFECTIONATE AND MORE APPROPRIATE WURM HANDLER NICKNAME 'WURMLER' SOON REPLACED WHATEVER HIS GIVEN NAME HAPPENED TO BE.

WITH ONLY A FEW QUICK STRIKES OR SWINGS OF THE SWORD...

THE FORKED BLADE BECOMES EXTREMELY HOT,

THE POWERFUL SWORD IS KNOWN TO SLICE QUITE EASILY THROUGH ALL KINDS OF MATTER.

TRAINING WITH THE SWORD WAS A GREAT HONOR. SO WURMLER NEVER REFUSED. BUT HE PREFERRED TO RELY ON HIS OWN SKILLS.

WIELDING SUCH A POWERFUL WEAPON WAS A BIT UNNERVING. THE IDEA THAT HE MAY ONE DAY FACE SOMETHING TERRIBLE ENOUGH TO WARRANT THE SWORD'S USE WAS FRIGHTENING.

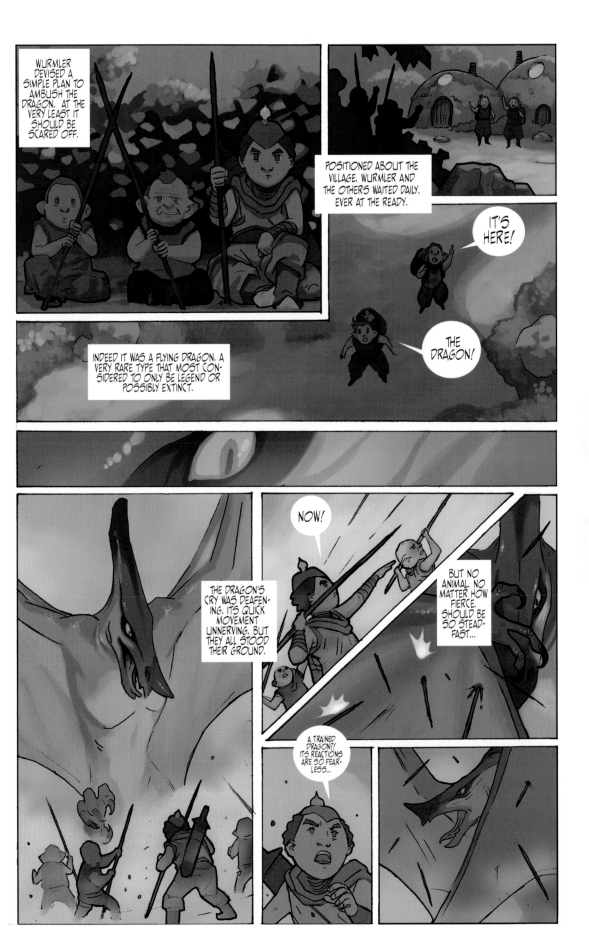

WURMLER DEVISED A SIMPLE PLAN TO AMBUSH THE DRAGON. AT THE VERY LEAST IT SHOULD BE SCARED OFF.

POSITIONED ABOUT THE VILLAGE, WURMLER AND THE OTHERS WAITED DAILY, EVER AT THE READY.

IT'S HERE!

THE DRAGON!

INDEED IT WAS A FLYING DRAGON. A VERY RARE TYPE THAT MOST CONSIDERED TO ONLY BE LEGEND OR POSSIBLY EXTINCT.

NOW!

THE DRAGON'S CRY WAS DEAFENING, ITS QUICK MOVEMENT UNNERVING. BUT THEY ALL STOOD THEIR GROUND.

BUT NO ANIMAL, NO MATTER HOW FIERCE, SHOULD BE SO STEADFAST...

A TRAINED DRAGON?! ITS REACTIONS ARE SO FEARLESS...

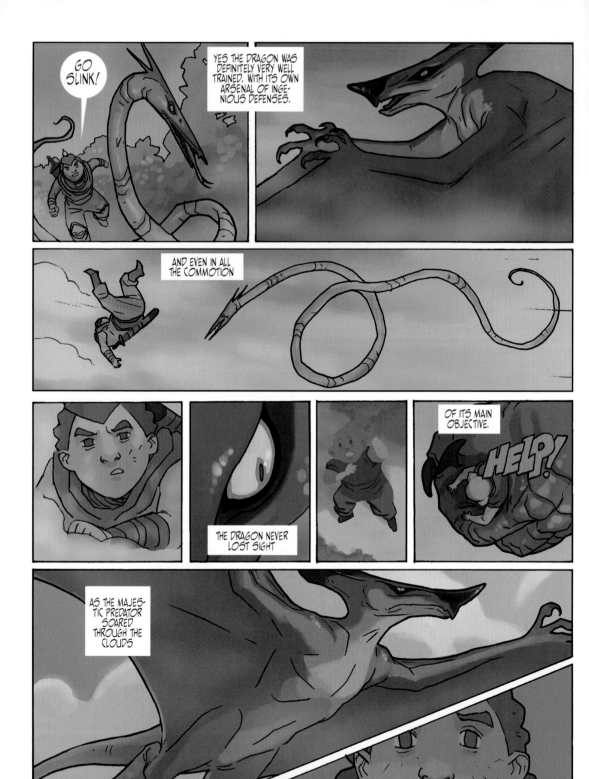

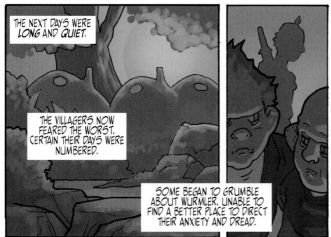

THE NEXT DAYS WERE *LONG* AND *QUIET*.

THE VILLAGERS NOW FEARED THE WORST. CERTAIN THEIR DAYS WERE NUMBERED.

SOME BEGAN TO GRUMBLE ABOUT WURMLER, UNABLE TO FIND A BETTER PLACE TO DIRECT THEIR ANXIETY AND DREAD.

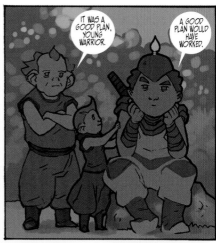

IT WAS A GOOD PLAN, YOUNG WARRIOR.

A GOOD PLAN WOULD HAVE WORKED.

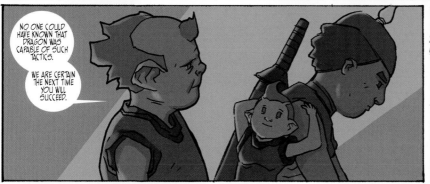

NO ONE COULD HAVE KNOWN THAT DRAGON WAS CAPABLE OF SUCH TACTICS.

WE ARE CERTAIN THE NEXT TIME YOU WILL SUCCEED.

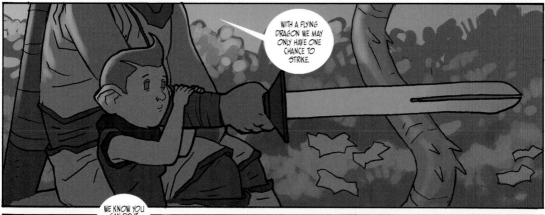

WITH A FLYING DRAGON WE MAY ONLY HAVE ONE CHANCE TO STRIKE.

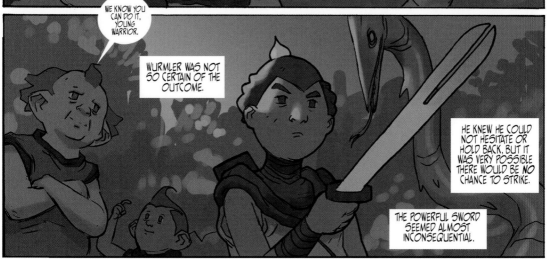

WE KNOW YOU CAN DO IT, YOUNG WARRIOR.

WURMLER WAS NOT SO CERTAIN OF THE OUTCOME.

HE KNEW HE COULD NOT HESITATE OR HOLD BACK, BUT IT WAS VERY POSSIBLE THERE WOULD BE *NO* CHANCE TO STRIKE.

THE POWERFUL SWORD SEEMED ALMOST INCONSEQUENTIAL.

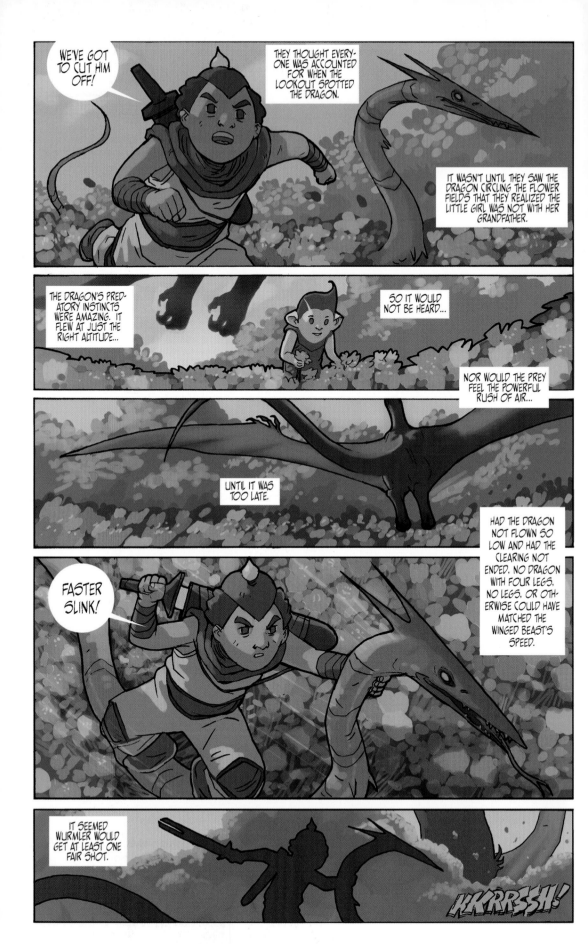

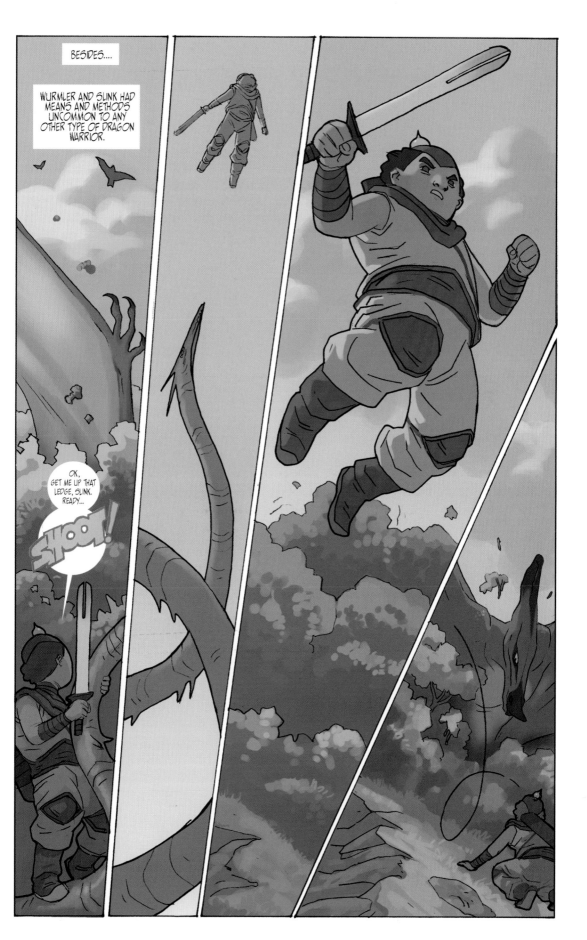

BESIDES....

WURMLER AND SLINK HAD MEANS AND METHODS UNCOMMON TO ANY OTHER TYPE OF DRAGON WARRIOR.

OK, GET ME UP THAT LEDGE, SLINK. READY...

SHOOT!

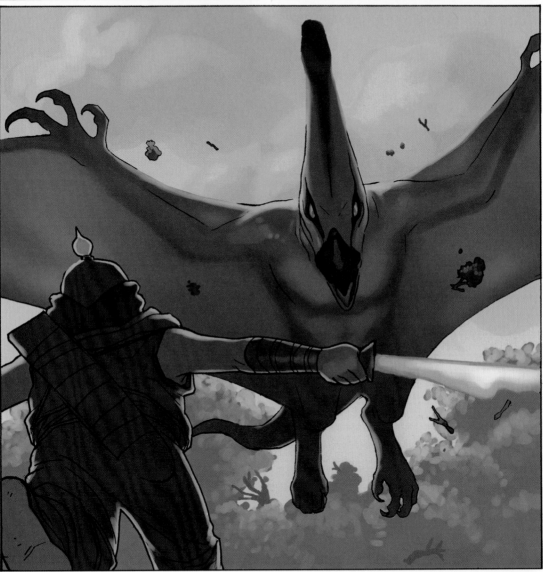

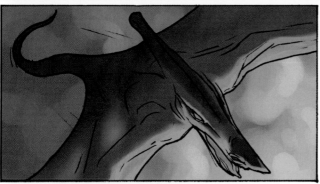

NO!
I HIT HIM!

NO!

WURMLER FELT A SUDDEN SICK-
ENING PAIN IN HIS STOMACH...
ALL OF HIS TRAINING
AMOUNTED TO NOTHING.

HE COULD NOT SAVE HER.

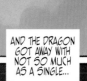

AND THE DRAGON
GOT AWAY WITH
NOT SO MUCH
AS A SINGLE...

SCRATCH?

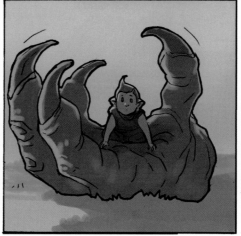

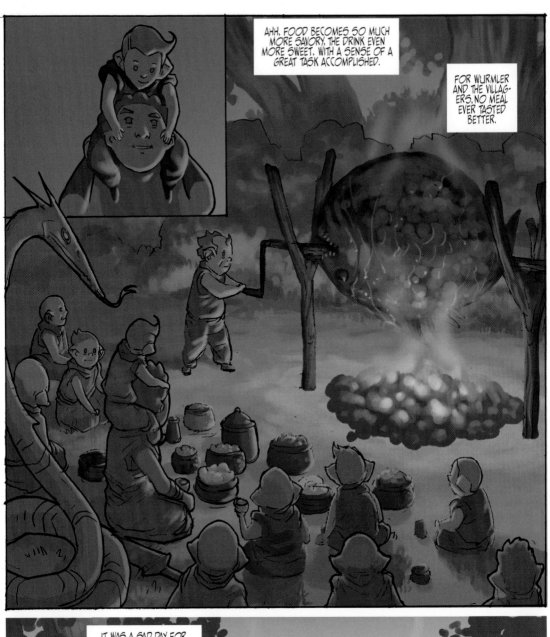

AHH, FOOD BECOMES SO MUCH MORE SAVORY, THE DRINK EVEN MORE SWEET, WITH A SENSE OF A GREAT TASK ACCOMPLISHED.

FOR WURMLER AND THE VILLAGERS, NO MEAL EVER TASTED BETTER.

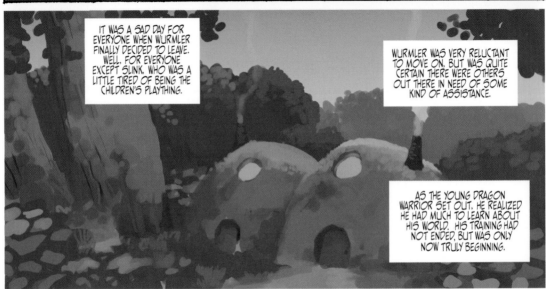

IT WAS A SAD DAY FOR EVERYONE WHEN WURMLER FINALLY DECIDED TO LEAVE. WELL, FOR EVERYONE EXCEPT SLINK, WHO WAS A LITTLE TIRED OF BEING THE CHILDREN'S PLAYTHING.

WURMLER WAS VERY RELUCTANT TO MOVE ON, BUT WAS QUITE CERTAIN THERE WERE OTHERS OUT THERE IN NEED OF SOME KIND OF ASSISTANCE.

AS THE YOUNG DRAGON WARRIOR SET OUT, HE REALIZED HE HAD MUCH TO LEARN ABOUT HIS WORLD. HIS TRAINING HAD NOT ENDED, BUT WAS ONLY NOW TRULY BEGINNING.

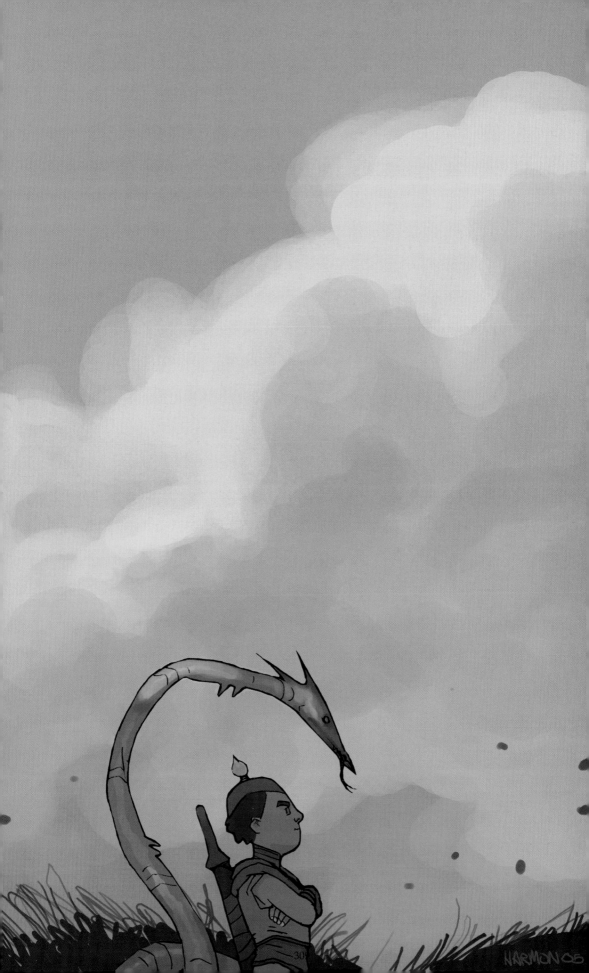

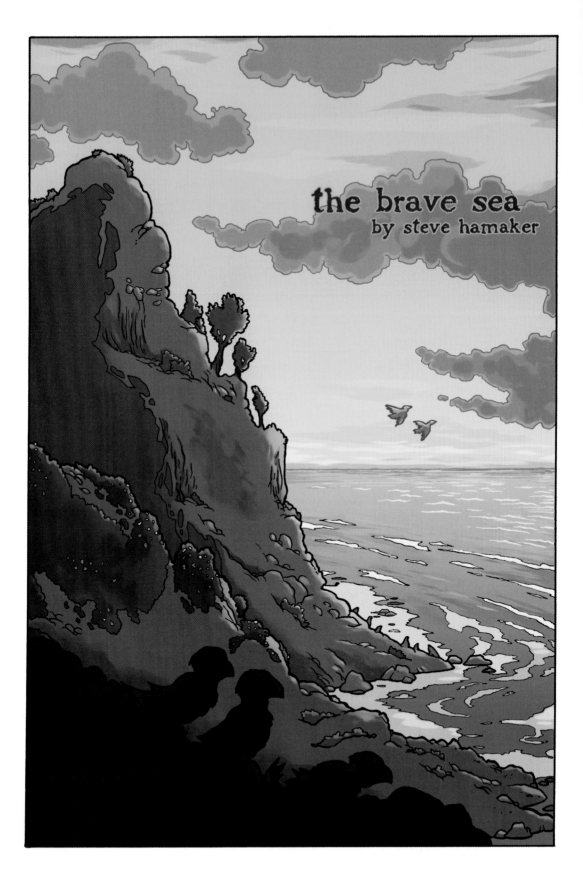

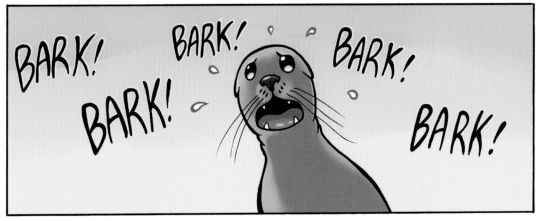
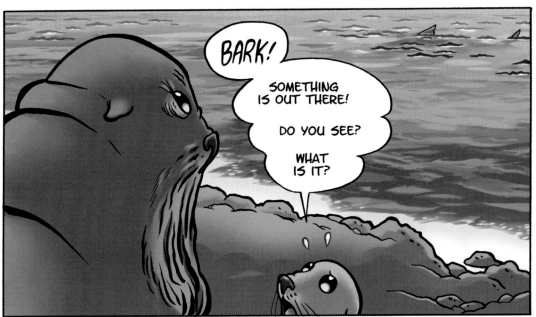

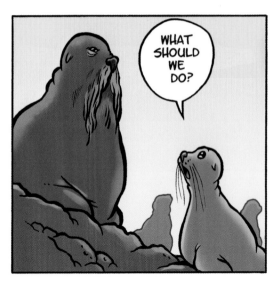

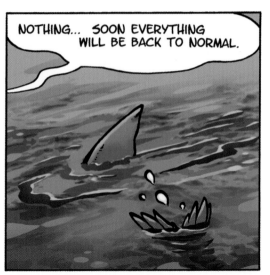

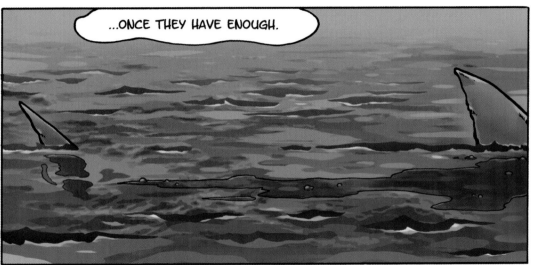

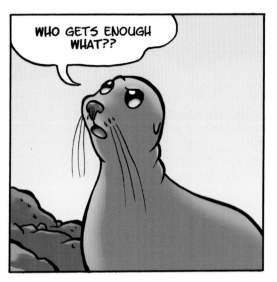

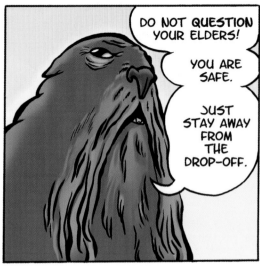

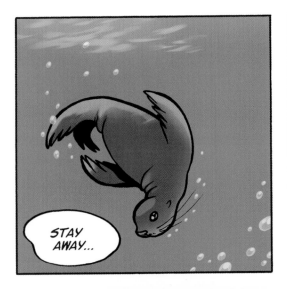

NO!

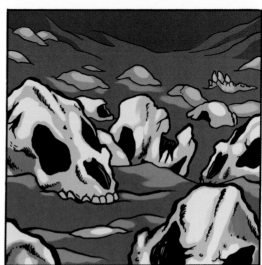

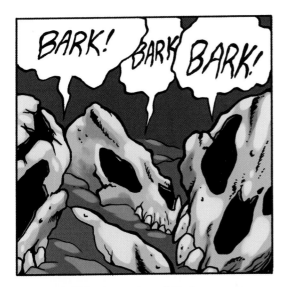

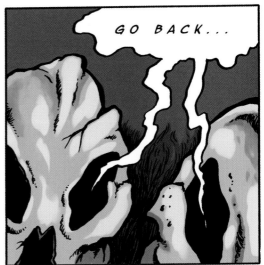

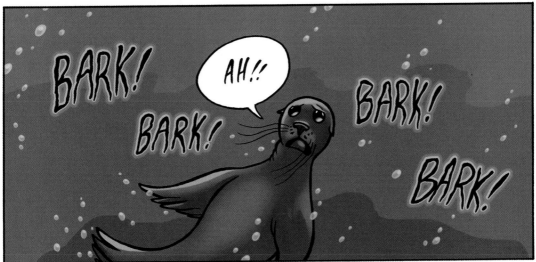

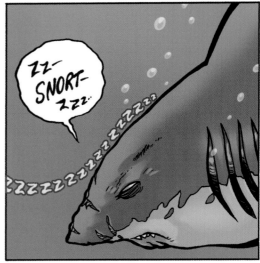

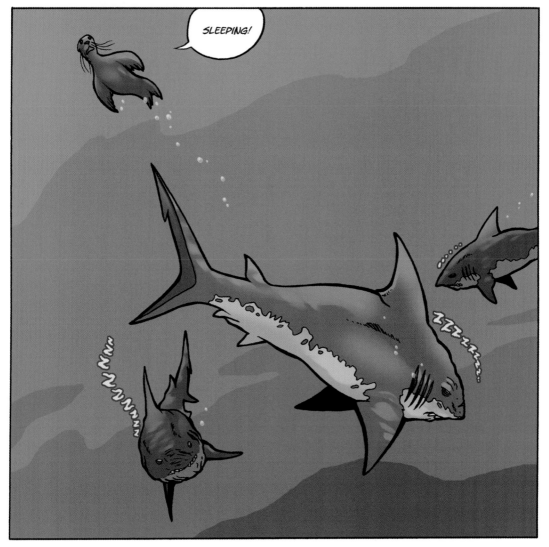

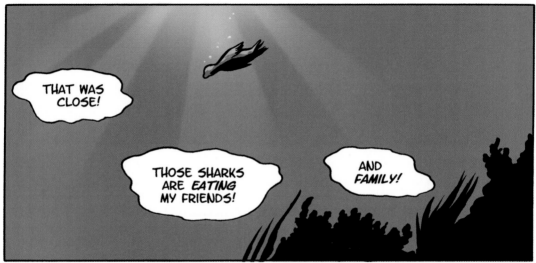

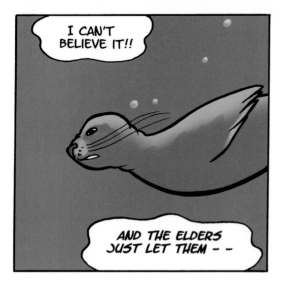

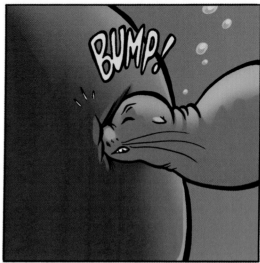

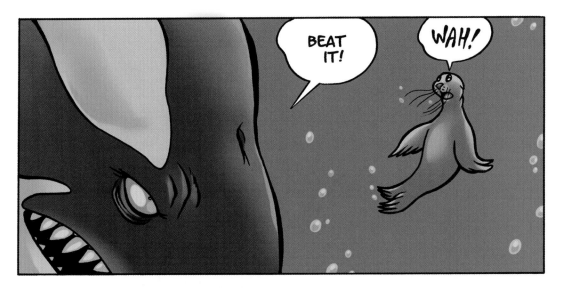

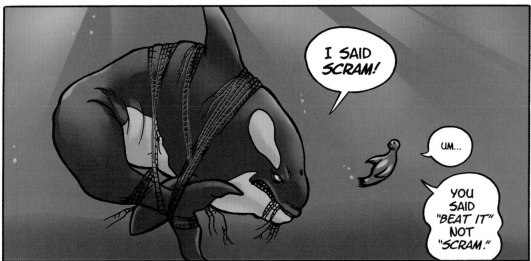

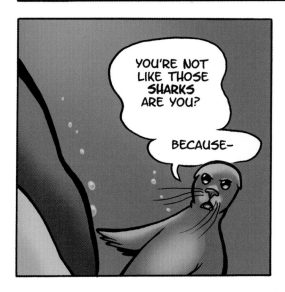

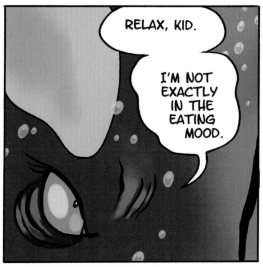

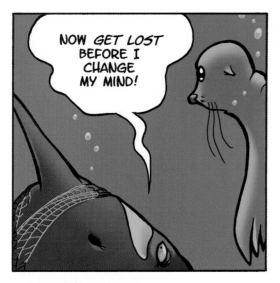

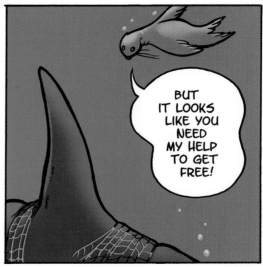

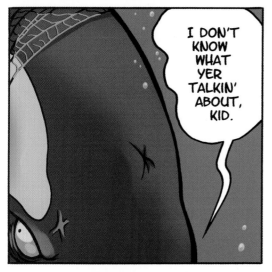

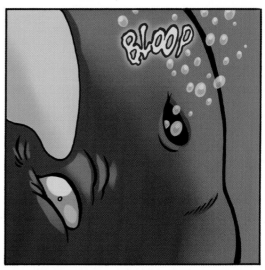

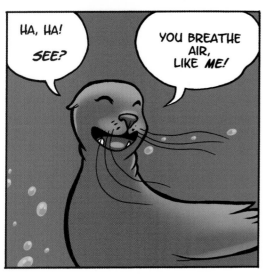

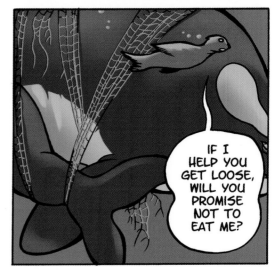

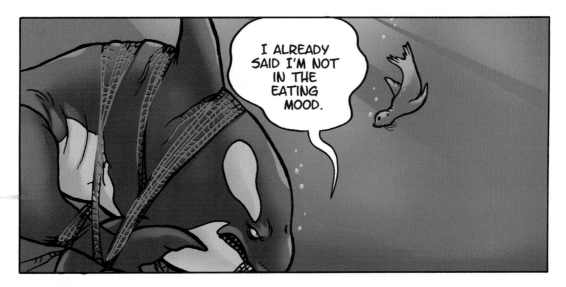

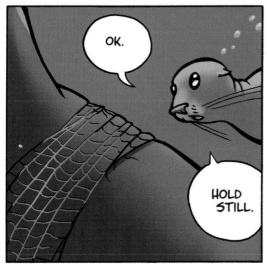

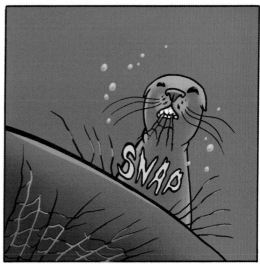

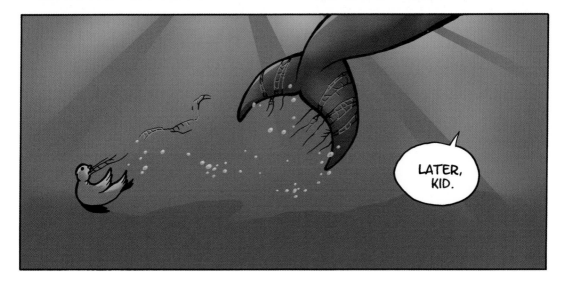

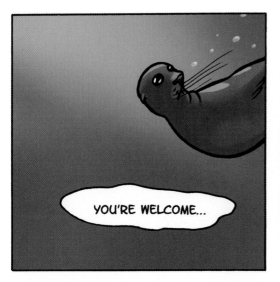

YOU'RE WELCOME...

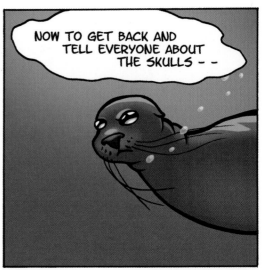

NOW TO GET BACK AND TELL EVERYONE ABOUT THE SKULLS - -

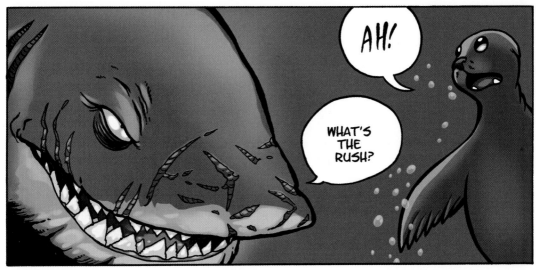

AH!

WHAT'S THE RUSH?

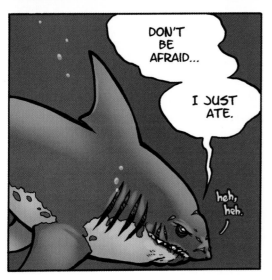

DON'T BE AFRAID...

I JUST ATE.

heh, heh.

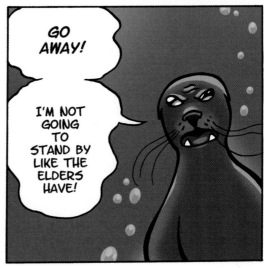

GO AWAY!

I'M NOT GOING TO STAND BY LIKE THE ELDERS HAVE!

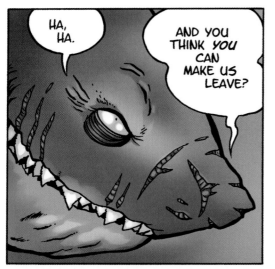

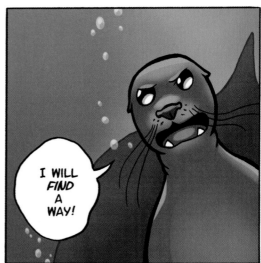

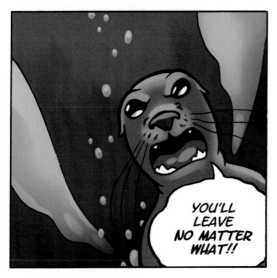

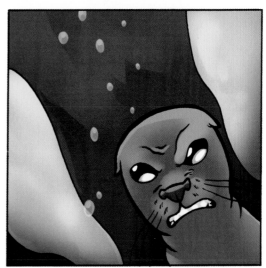

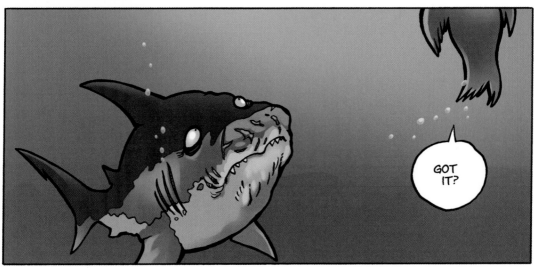

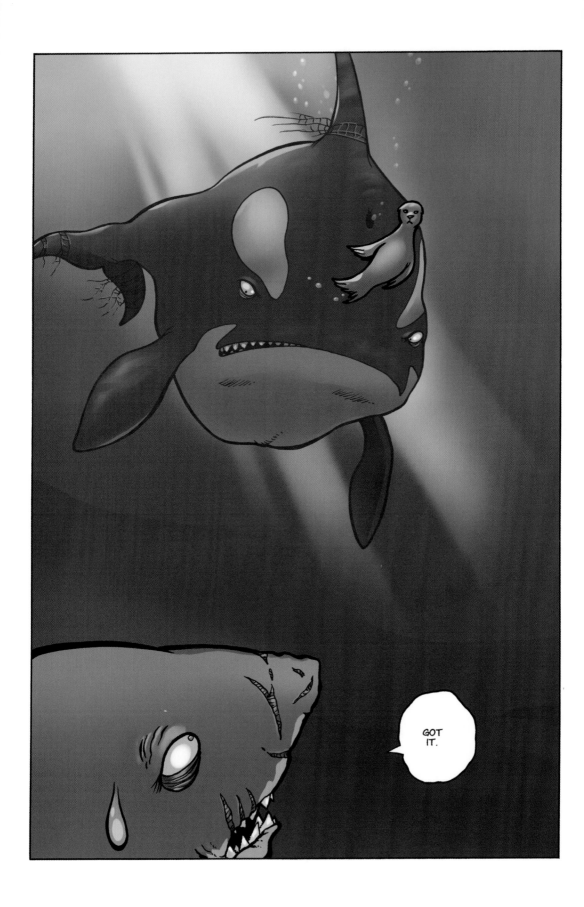

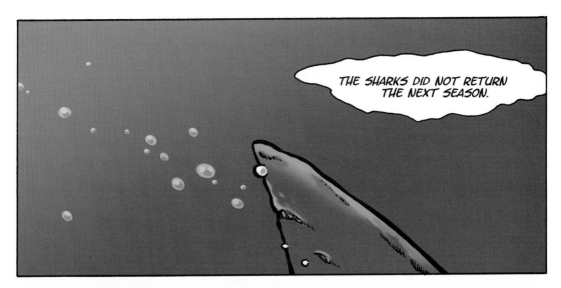

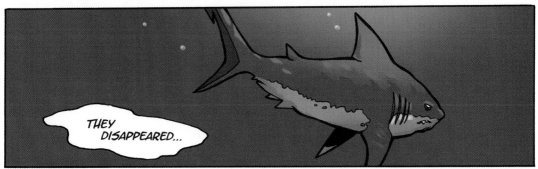

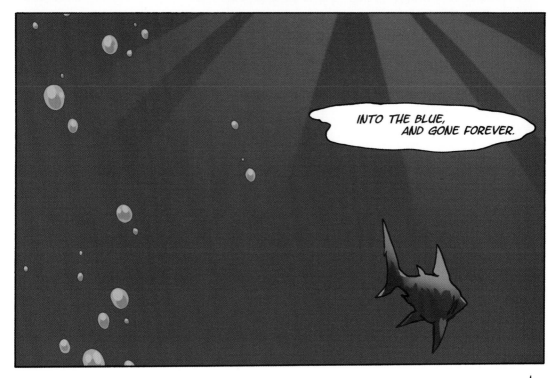

end.

The Great Bunny Migration

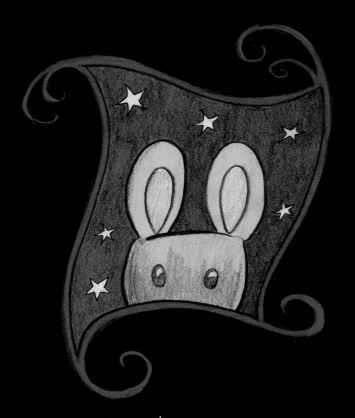

by dave roman

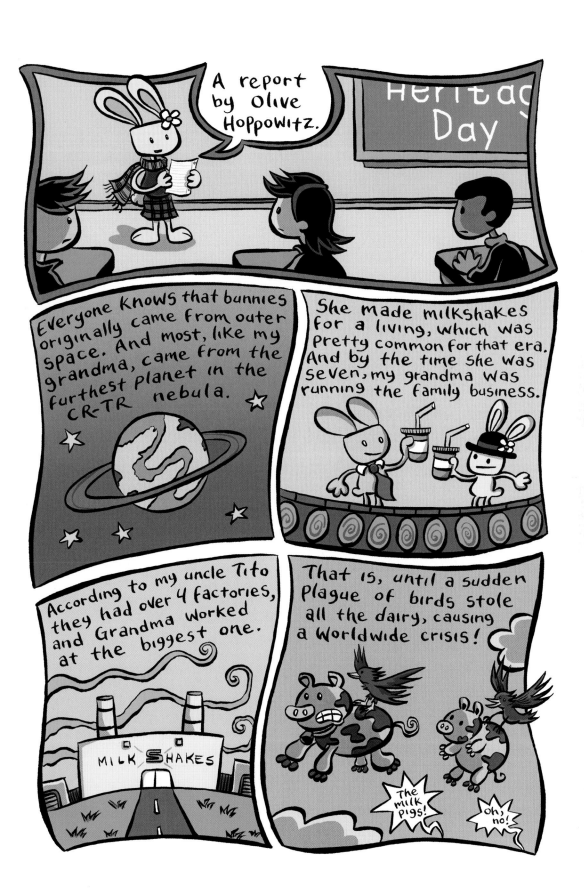

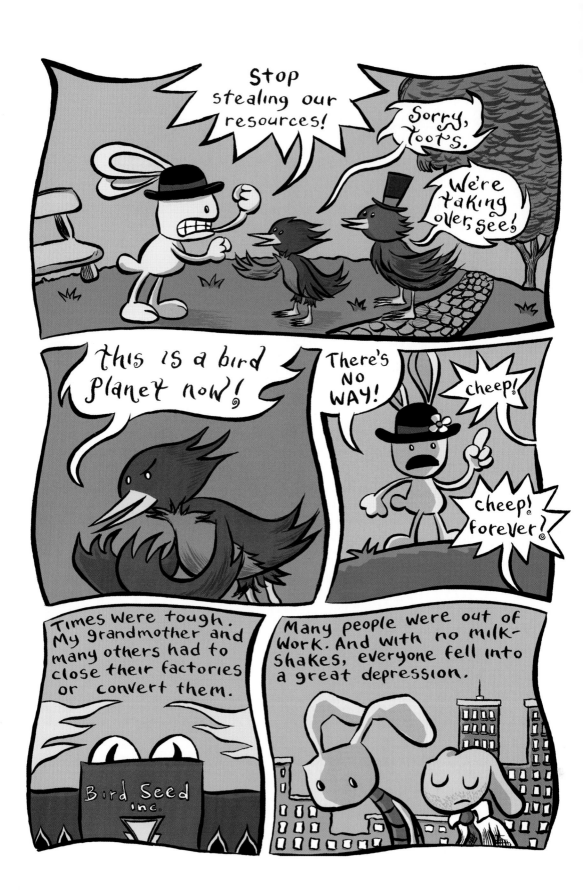

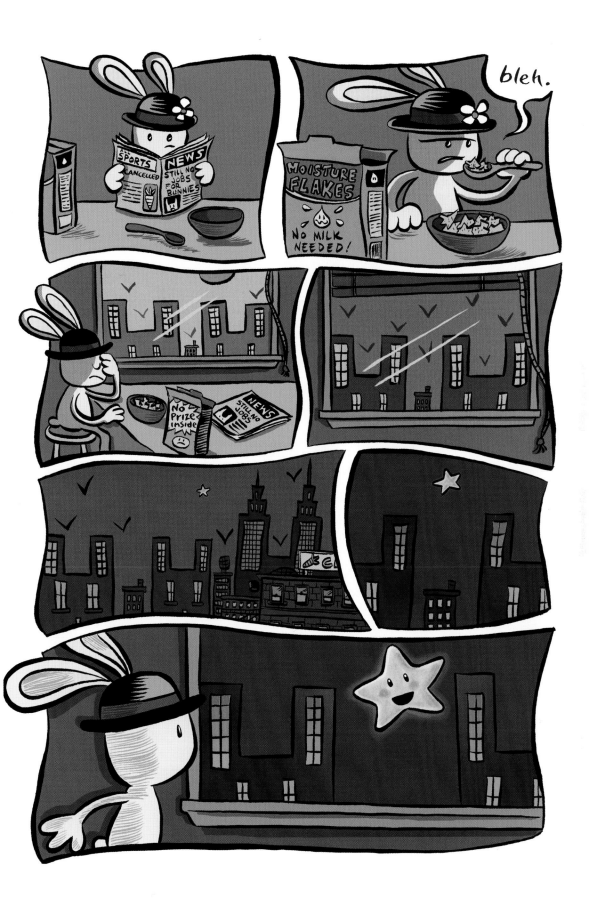

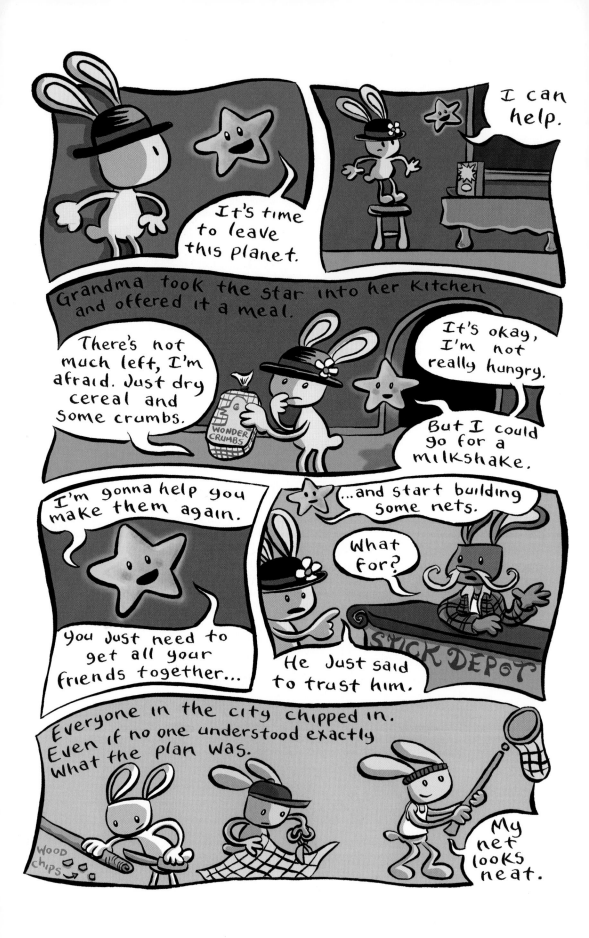

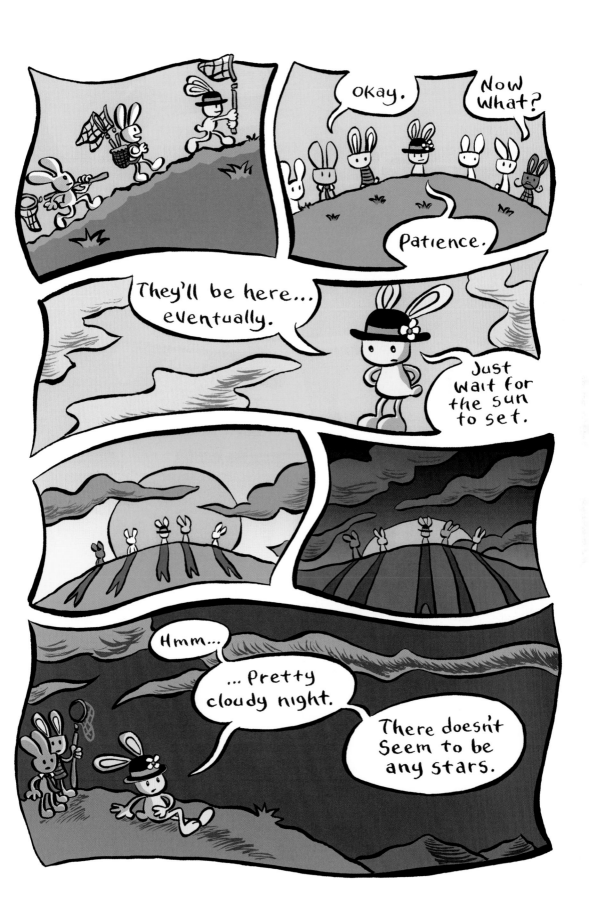

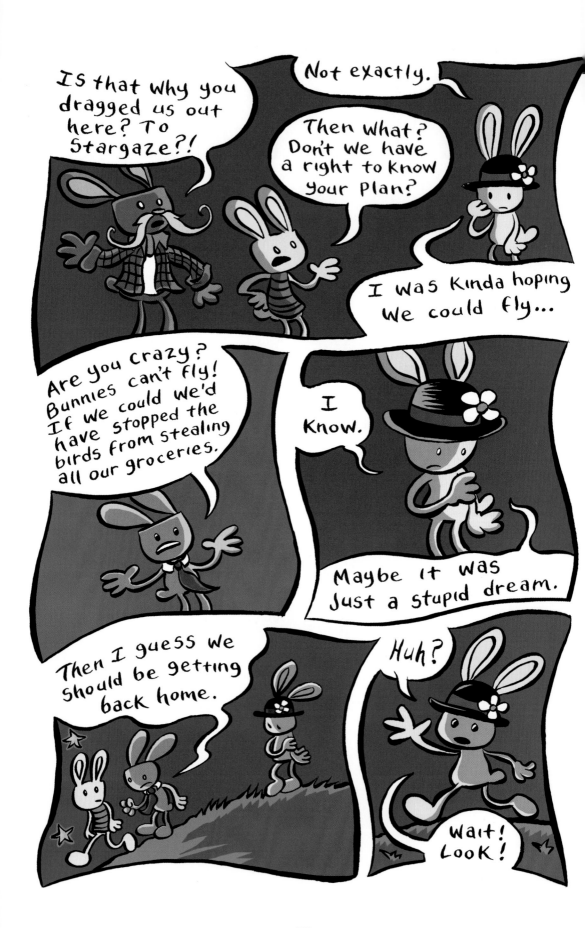

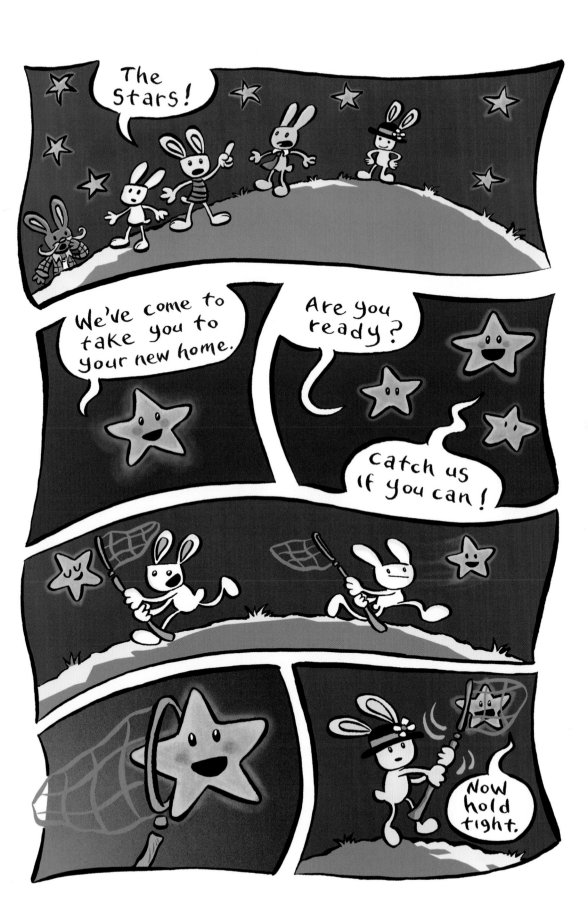

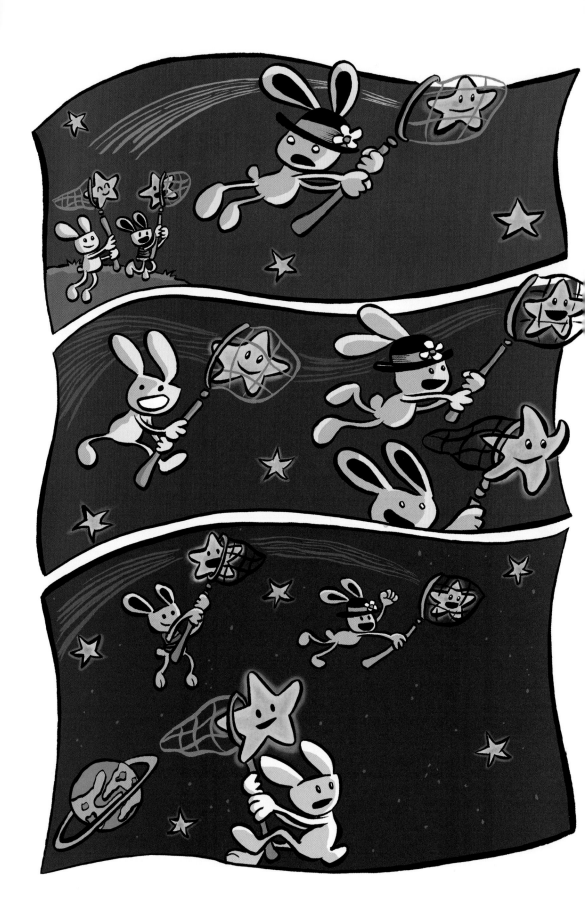

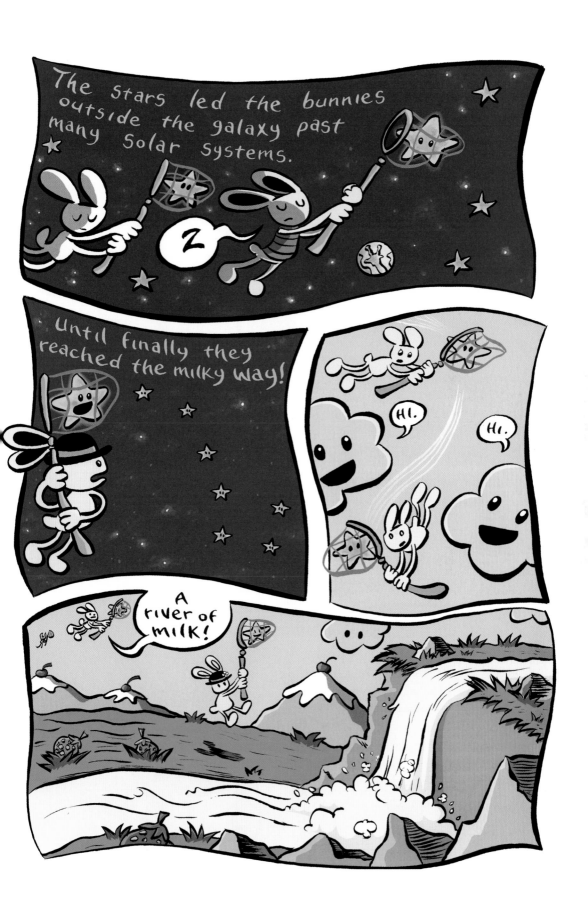

335

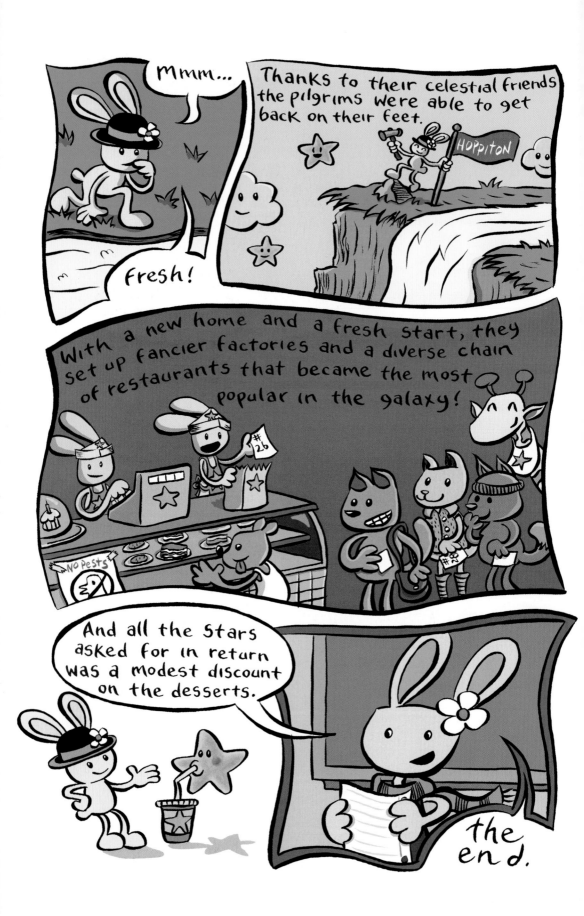

dave

SNOW CAP

by
MATTHEW S. ARMSTRONG

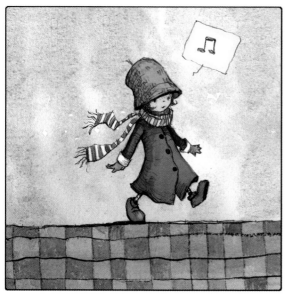
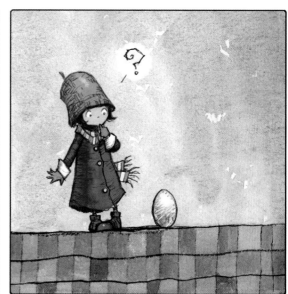
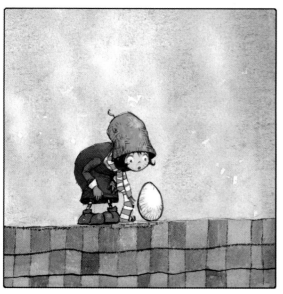
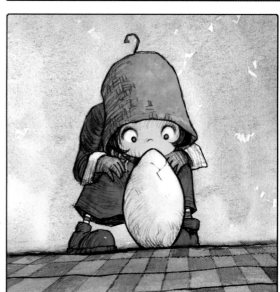

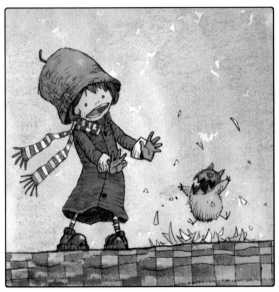
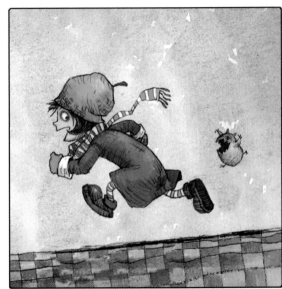
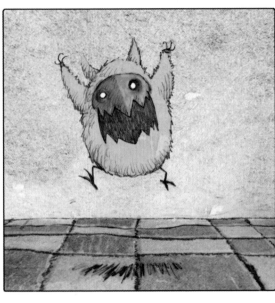
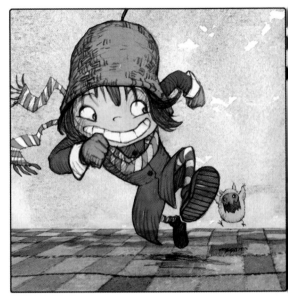

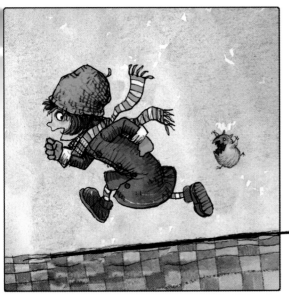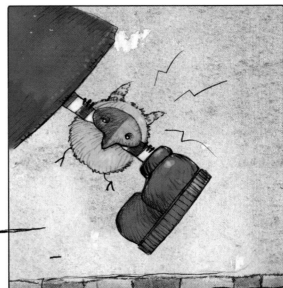

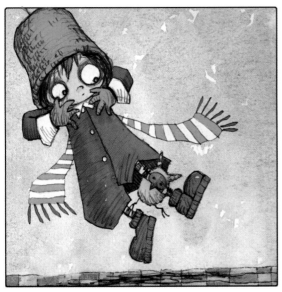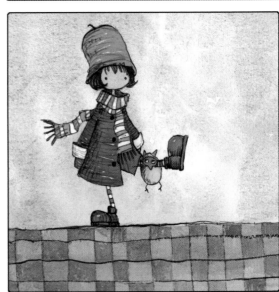

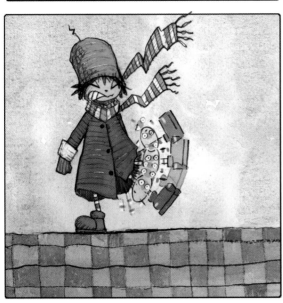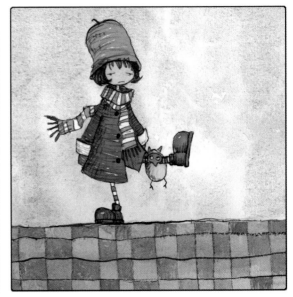

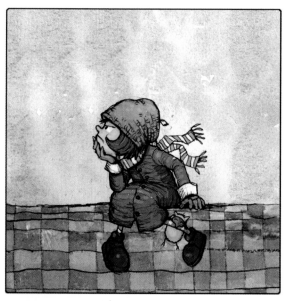
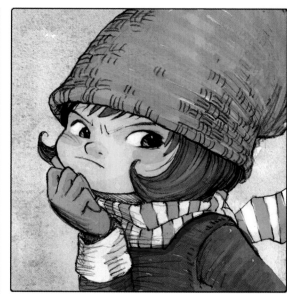
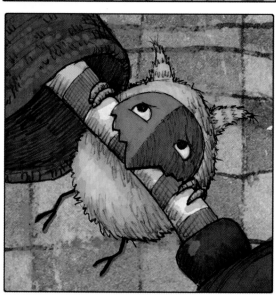
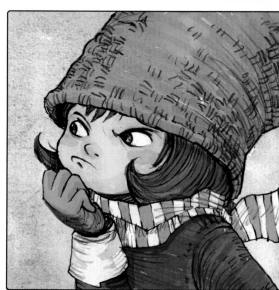
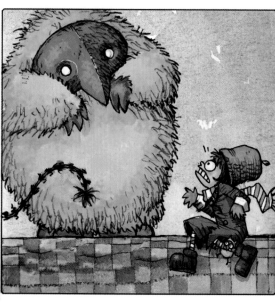
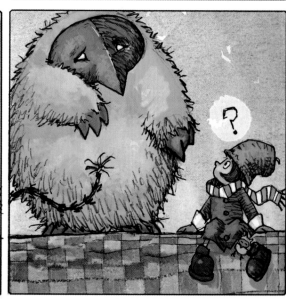

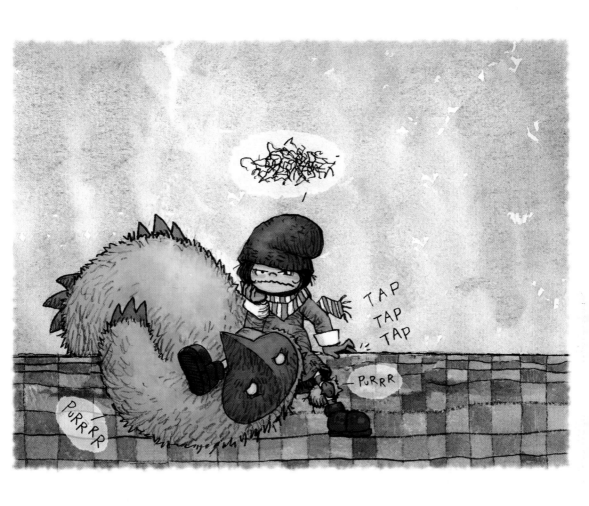

the
END

Lala and the Bean

by Khang Le

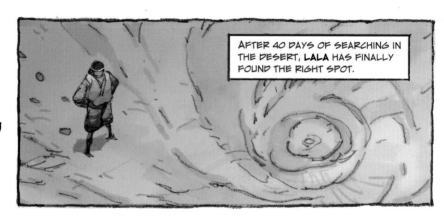

After 40 days of searching in the desert, **Lala** has finally found the right spot.

...

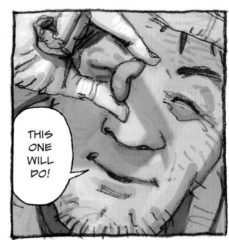

This one will do!

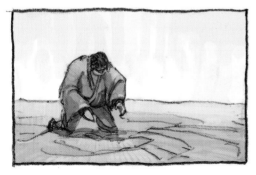

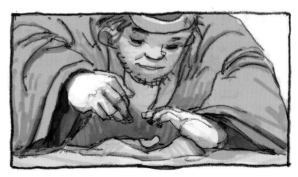

BOW

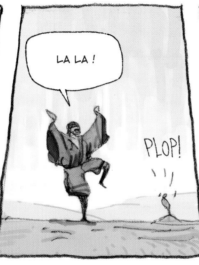

LA LA!

PLOP!

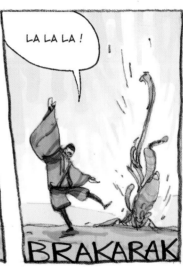

LA LA LA!

BRAKARAK

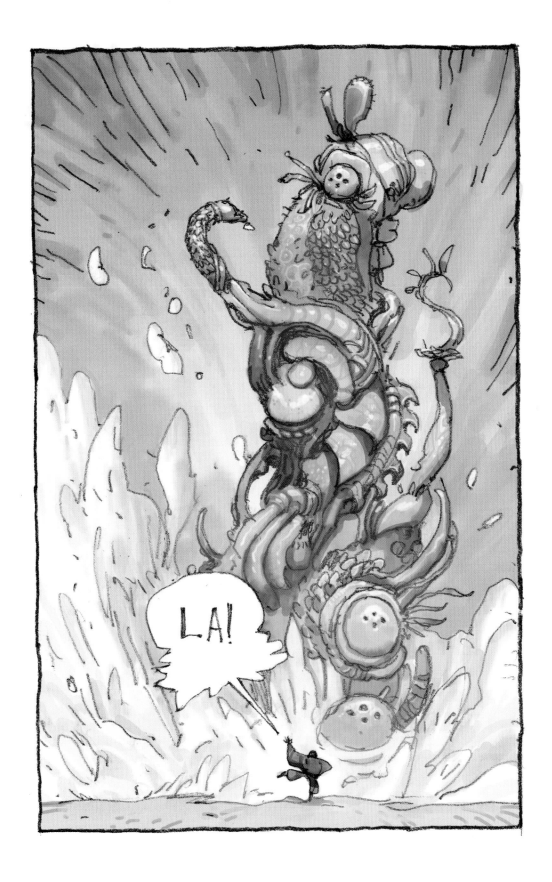

FLIGHT: VOLUME THREE CONTRIBUTORS

From left to right:

Top Row: Michel Gagné, Matthew S. Armstrong, Dave Roman, Matthew Forsythe, Ben Hatke
2nd Row: Catia Chien, Charles Belak-Berger (Chuck BB), Reagan Lodge, Becky Cloonan, Neil Babra
3rd Row: Phil Craven, Joey Weiser, Johane Matte, Kean Soo, Tony Cliff
4th Row: Rad Sechrist, Kazu Kibuishi, Nicolas Séigneret (Bannister), Alex Fuentes, Bill Plympton
5th Row: Rodolphe Guenoden, Yoko Tanaka, Paul Harmon, Israel Sanchez, Steve Hamaker
Bottom Row: Chris Appelhans, Khang Le, Azad Injejikian

Alex Fuentes, a 1998 recipient of the Xeric grant award, was born and raised in California. He was obsessed with *The Twilight Zone* at the age of five and has since accepted the metaphysical. His wife (D.) and daughters (Poppy and Frida) are his biggest inspirations. Unfortunately, he runs with a bad crowd—a graphic design and illustration collective known as Los Fokos. www.losfokos.com

Azad Injejikian is a writer/illustrator from Montreal, Canada. He's successfully tricked a handful of companies into publishing his comic work and looks forward to fooling a couple more before he pushes up daisies. www.guerrilla-comics.com

Bannister was born in 1973. Some thirty-three years later, he's still drawing and has begun telling stories of his own. He lives near the French Alps with his girlfriend, Flo, and works as a freelance artist/comicker. His new book will be published in 2007. A very small portion of his work can be seen at www.bannister.fr.

You might remember **Becky Cloonan** from comics like *Demo, American Virgin,* and *East Coast Rising.* When she isn't drawing comics, she enjoys antique shopping and manipulating the element of lightning. www.estrigious.com/becky

Ben Hatke is an artist/illustrator and creator of the webcomic "Zita the Spacegirl." Ben works out of rural Virginia, where he lives with his wife and two rambunctious daughters. At the time of this writing he is about to embark on a nine-month Italian odyssey to study fine art. He hopes to add "painting churches" to his list of services. Read online about his adventures at www.househatke.com and www.zitaspacegirl.com.

Born and raised in Portland, Oregon, **Bill Plympton** moved to New York City upon graduation from Portland State University with a degree in graphic design. He began his career creating cartoons for publications such as *The New York Times, National Lampoon, Playboy,* and *Screw.* In 1987, he was nominated for an Oscar for his first short film, *Your Face.* After producing many shorts that appeared on MTV and in animation festivals, he turned his talent to feature-length filmmaking. Since 1991, he's made eight feature films, five of them animated, including *The Tune, Mondo Plympton, I Married a Strange Person*, and *Mutant Aliens.* He recently completed his fifth animated feature, *Hair High*, and received a second Oscar nomination in 2005 for his short film *Guard Dog*. www.plymptoons.com

Catia Chien produces illustrations for children's books and is currently working at Nickelodeon on the show *Danny Phantom.* Her work can also be found in art galleries across the United States. www.catiachien.com

Chris Appelhans works as a visual development artist at Laika Studio in Portland, Oregon. He has also recently done visual development work on the film *Monster House,* for Sony Imageworks. www.froghatstudios.com

Chuck BB has a beard. He loves comics, Vikings, and Black Metal. His work is visible in the pulp horror miniseries "Secret Skull," written by Steve Niles and published by IDW. Eventually, all the things he loves will be gathered together to create the epic masterpiece aptly titled "Black Metal." www.reallybigmonster.com

Dave Roman is the co-creator of the Harvey Award–nominated series "Jax Epoch and the Quicken Forbidden" (AiT/PlanetLar), and the Ignatz Award–winning "Teen Boat" (Cryptic Press). He works for *Nickelodeon Magazine,* where he is the Associate Comics Editor, and has contributed to the critically acclaimed *Bizarro World* anthology for DC Comics. Dave draws a webcomic series called "Astronaut Elementary" and has been self-publishing comic books since he was a kid. www.yaytime.com

Soon after graduating from high school, **Israel Sanchez** decided to abandon his dream of a career in public speaking to study art at Cal State Fullerton. He now lives and works as a freelance illustrator in La Habra, California. See more of his work at www.israelsanchez.com.

Joey Weiser was born in 1983 and lived most of his life in Bloomington, Indiana. He later graduated from the Savannah College of Art & Design. His work can be found in several anthologies, and he is currently working on his first graphic novel, *The Ride Home*. His diet is slowly expanding, and his pants are probably falling apart or being repaired as you read this. www.tragic-planet.com

Johane Matte works as an illustrator for a small video game company in Montreal and also on her mini-comic, "Horus," in her spare time. She has three passions—drawing, ancient Egypt, and cheese. You may even say she needs those three elements to survive. http://drawingboard.org/blogs/Nofret/

Kazu Kibuishi is the editor and art director of *Flight:* Volume Three. He is currently working on *Amulet,* an all-ages fantasy graphic novel series from Scholastic Publishing. www.boltcity.com

Kean Soo has accomplished very little in the time between the publication of *Flight:* Volume Two and this latest volume. He continues to spend lonely hours on the outskirts of Toronto, working during the day and drawing comics long into the night, continually slogging through his ever-growing mess of a graphic novel, *Jellaby,* which is currently being serialized on the Secret Friend Society website. He is so very, very lonely. www.secretfriendsociety.com and www.keaner.net

Khang Le works as a concept and environment artist in the video game industry. His work can also be seen in the previous two volumes of *Flight.* www.khangle.net

Matthew Forsythe was born in Toronto and studied political science at McMaster University. He has lived in Dublin, London, and Seoul, where he has worked variously as an illustrator, network administrator, motorcycle courier, and kindergarten teacher. He currently lives in Montreal where he is working on a graphic novel of his online comic, "Ojingogo." www.comingupforair.net

Matthew S. Armstrong is a concept artist/writer for SCEA. At night he scribbles all manner of rubbish instead of sleeping. His artwork can be found in or on children's books, cards, games, book covers, movies, and body parts. He lives in Utah with his benevolent wife and spirited daughter. www.matthewart.com

Michel Gagné was born in Quebéc, Canada, and has had a highly successful career drawing characters and special effects for animated and live-action feature films such as *The Iron Giant* and *Osmosis Jones*. His independent short film, *Prelude to Eden*, is a favorite among animation students and teachers, and has played in festivals throughout the world. Michel and his wife created Gagné International Press in 1998, and he has been writing, illustrating, and publishing books and comics ever since. www.gagneint.com

Neil Babra is a cartoonist and illustrator (among other things) from Pennsylvania, now working and residing in the San Francisco Bay Area. He is currently working on a graphic novel project. "In Due Time" is his third entry in the *Flight* book series. www.neilcomics.com

Paul Harmon lives and works primarily from his home in the Westwood area of Los Angeles, California. Creating comics has been a childhood dream come true for the artist. He recently completed the first part of his debut series, "Mora," and is currently working on the sequel, as well as illustrating the ongoing series "Sea of Red" while juggling freelance work in animation. Paul Harmon loves foreign films, cooking, music, Japanese toys, and coffee drinks. www.dogmeatsausage.com

Phil Craven is twenty-eight and hails from the state of Georgia, where he went to grad school at the Savannah College of Art and Design. These days, Phil draws storyboards for DreamWorks Animation. He maintains a keen interest in soccer and cereal. www.bluepillow.net

Rad Sechrist is a twenty-four-year-old freelance artist living in Orange County, California. He was also a contributor to *Flight:* Volumes One and Two. If you happen to be in the area and like to skateboard, feel free to send him an e-mail. www.radsechrist.com

Reagan Lodge was born in 1984 and grew up near the Pala Indian Reservation on the outskirts of northern San Diego county. He got an F in art class and really had no idea what he wanted in life until he started drawing when he was sixteen. Unable to afford college, Reagan instead got his career started as a conceptual artist for Armor Holdings, a defense technology contractor, and now seeks work in the gaming or film industries. *Flight:* Volume Three marks his first try at comics, as well as the introduction of his characters Wyit and Sidna, who he has some big plans for. www.reaganlodge.com

Rodolphe Guenoden studied animation at the Gobelins in Paris, and has worked for sixteen years in the animation industry as a 2D animator and storyboard artist on such films as *Fievel Goes West, Prince of Egypt, Road to El Dorado,* and *Sinbad.* Rodolphe lives in Los Angeles with his wife, their kids, and a cat. He loves drawing women and has always wanted to draw comics. www.rodguen.com

Steve Hamaker is the colorist for the new editions of *Bone* by Jeff Smith, published by Scholastic Books. He currently resides in Columbus, Ohio, and is busy drawing more talking animal stories for future comics. www.steve-hamaker.com

Tony Cliff is native to urban areas in and surrounding Vancouver, British Columbia, where he spends much of his time in animation studios, most recently having been seen as one of two lead animators on the new *Pucca* TV series. Diet consists mainly of caffeinated sugar-water and cheese. For educational material and conservation information, please visit www.tonycliff.com.

Yoko Tanaka is a gallery artist who also loves to make picture books. This is her first comic based on her real life. Along with her boyfriend, she loves cooking and eating, which often gives her a lot of inspiration for painting. Her nicknames are Yoki, Gnocchi, and Monkey. www.yokotanaka.com

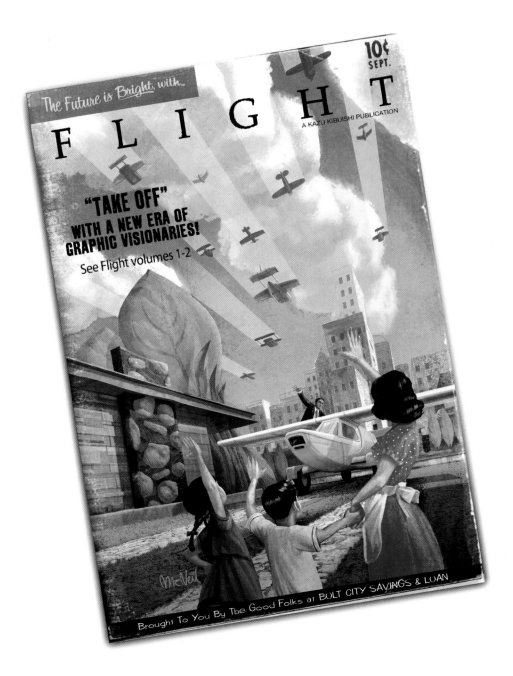

Illustrator Bob MacNeil created the coolest piece of fan art I have ever seen. Along with this image, he posted a lengthy response in our forums to let us in on the backstory of how this image came to be. (The original post is reprinted on the facing page.) Watching the effect *Flight* has had on the illustration and comic communities over the past couple of years has been an incredibly rewarding experience. It continues to remind us how fortunate we are in being given the chance to pursue such endeavors and inspires us to continue producing these heartfelt stories. I'd like to thank everyone for supporting this project—both the artists who build it and the readers who fuel it. Here's hoping we can stay aloft for many years to come.

—Kazu

Thanks guys,

...for the positive feedback! This, for those of you who don't realize it already, is a painting I did...with, of course, *Flight* in mind. The backstory behind it is as follows: (attn: long drawn out description coming at ya!!!) just kidding...

I have had a number of recent tragedies that have left me fed up with practically everything I do (particularly speaking, of course, about professional situations, etc.). The tragedies are the losses of three very close family members (to cancer), one of which happened to be my mom, Joann. These all happened within less than a year of each other, and they all left me cold to producing anything creatively. My mom was an artist, who never really found her way creatively, and now will never have that chance. I myself have also found that my creative goals seem to keep evading me as well. During all the chemo treatments I went to with my mom, and dealing with the overwhelming sadness she had towards losing her sister and her niece (my aunt and cousin to the same disease she was fighting), I sort of began figuring "Why the hell do I keep trying?" "Why don't I just throw in the towel and consider some other career avenues?" Things aren't going the way I planned, life is just hitting me with one bad curve ball after another, maybe I should give up art and try something new, before I miss my proverbial window at happiness (basically depression started getting the better of me).

Then *Flight* comes along! and it sort of re-inspired/jump-started my inspiration engine. (I have been a longtime comics fan, but separated myself from it, because I really felt the quality was plummeting, and combined with the fact that I set off on a corporate based art career...comics sort of became a lost love.) However, with the advent of *Flight,* to see such wonderful tales of imagination and heartfelt creativity, from creators who are relatively unknown, has...I guess you can say lifted me from my doldrums. (Yes the comics world may have life in it once again!) *Flight 1* was the very book which I was reading, during all the terrible times I went through, and now after all the negativity has subsided, it remains a favorite source of inspiration to me. It kind of served as my way of getting away from everything then and now it's my way of getting back to the reasons I became an artist in the first place (to pursue my dreams of becoming an artist who tells a good story with my work). And because of that, *Flight* (the books, the concept) will always hold a special place for me.

So this painting is a tribute to all the *Flight* artists, and it's also my way of saying thanks for making me remember who I really am. Actually, I was, and still am hesitant about showing it, because of being so down as of late, I feel it's not really that good...maybe I'm not in touch with what's good anymore. The positive responses, however, are very appreciated!

My mom's passing was a slap in the face to my reality, that threw me for a spin... and *Flight* is the hand that reached out to me, re-instituted some clarity in my life and invited me in, for a big warm mug of inspiration!

Thanks! (Now I'll stop rambling...)

Bobby

for Will Eisner